Arts, Media, and Justice

Colin Lankshear and Michele Knobel
General Editors

Vol. 60

The New Literacies and Digital Epistemologies series
is part of the Peter Lang Education list.
Every volume is peer reviewed and meets
the highest quality standards for content and production.

PETER LANG
New York • Washington, D.C./Baltimore • Bern
Frankfurt • Berlin • Brussels • Vienna • Oxford

Arts, Media, and Justice

MULTIMODAL EXPLORATIONS WITH YOUTH

EDITED BY LALITHA VASUDEVAN AND TIFFANY DEJAYNES

PETER LANG
New York • Washington, D.C./Baltimore • Bern
Frankfurt • Berlin • Brussels • Vienna • Oxford

Library of Congress Cataloging-in-Publication Data

Arts, media, and justice: Multimodal explorations with youth /
[edited by] Lalitha Vasudevan, Tiffany DeJaynes.
pages cm. — (New literacies and digital epistemologies, 1523-9543 ; vol. 60)
Includes bibliographical references and index.
1. Arts—Study and teaching (Secondary)—United States.
2. Arts and youth—United States. I. Vasudevan, Lalitha, editor of compilation.
II. DeJaynes, Tiffany, editor of compilation.
NX280.M865 700.71—dc23 2013005249
ISBN 978-1-4331-1854-8 (hardcover)
ISBN 978-1-4331-1855-5 (paperback)
ISBN 978-1-4539-1106-8 (e-book)
ISSN 1523-9543

Bibliographic information published by **Die Deutsche Nationalbibliothek**.
Die Deutsche Nationalbibliothek lists this publication in the "Deutsche
Nationalbibliografie"; detailed bibliographic data is available
on the Internet at http://dnb.d-nb.de/.

The paper in this book meets the guidelines for permanence and durability
of the Committee on Production Guidelines for Book Longevity
of the Council of Library Resources.

© 2013 Peter Lang Publishing, Inc., New York
29 Broadway, 18th floor, New York, NY 10006
www.peterlang.com

Printed in the United States of America

Contents

Figures

Foreword

Visible Youth

Glynda A. Hull
University of California, Berkeley

More than a half century ago Ralph Ellison's *Invisible Man* (1947/1995) brought to greater consciousness the invisibility of being African American in the United States. "I am invisible," Ellison's narrator explained, "simply because people refuse to see me.... When they approach me they see only my surroundings, themselves, or figments of their imagination—indeed, everything and anything except me." If much has changed, a great deal has remained the same. In a recent book on mass incarceration in the United States, Petitt (2012) adapted Ellison's title to call attention to how social science research over the last fifty years has continued to render African American men invisible. In this instance the failure to see has been the product of a data collection infrastructure that has systematically undercounted incarcerated persons, thereby concealing the true extent of continuing decades and repeated generations of racial inequality.

How difficult we find it, as individuals, citizens, and societies, to stand outside received perception, to escape customary ways of seeing or not, to open our eyes to alternate impressions of events, people, history, and possibility. In *Arts, Media, and Justice: Multimodal Explorations with Youth*, Vasudevan, DeJaynes, and their contributors in effect take as their project to teach us to see more clearly, making visible youthful populations that customarily reside for most people either in the institutional shadows of group homes, the court system, and detention centers, or in the stark light shone by media to feed a societal fascination with youthful deviance. Vasudevan and DeJaynes do in fact teach us, not didactically but through persuasive illustration via a kind of ethical synecdoche: they reveal how the youth themselves learn to see, inventing senses of who they can become and by representing and enacting those possible selves consciously and artfully.

There is, of course, a long and mostly unsatisfying history in social science research of attempts to understand youth gone awry. Early on these young people were psychoanalyzed as "wayward" or "dissocial" (Aichhorn, 1955), and more recently they have been reduced to alarming sets of risk behaviors that threaten their own and our own futures (Lerner, 1995). There are also those who have taken pains to defend "at risk" youth against stigmatizing categories, pointing out and rightly so how they have been disenfranchised socially, culturally, and economically (Giroux, 1996; cf. Dwyer & Wyn, 2001). Sometimes we bend too far in this extreme, of necessity defending, but also unintentionally mischaracterizing young people, casting them merely as caught in webs that have rendered them unable to act. The institution of schooling has itself been taken to task as a major culprit, both in general terms for the stubborn, indefensible gaps that persist in achievement and graduation rates, demarcating time and again racial and socio-economic divides, as well as more specifically in terms of its cultures of social reproduction. Who can fail to be appalled by, in fact to feel abject despair over, Ferguson's ethnographic account in *Bad Boys* (2001), her depiction of how a group of eleven- and twelve-year-old African American males were designated by school personnel as "bound for jail" and "criminally inclined," and the struggles of these young men to imagine their futures within the imaginative deficits of those around them?

I locate Vasudevan and DeJaynes' book in different and productive scholarly and activist traditions. Theirs is a hopeful and forward-looking book, alert and alive with "second chance" philosophies and traditions. Their authors tell the stories of youth, teachers, and community workers who are, in the face of difficult circumstances and serious constraints—"limit situations," as Freire (1970) would say—envisioning new trajectories. "The notion of a second chance," wrote Dan Inbar, "is derived from the basic belief that everyone has the right to attempt success and mobility, the right to try again, to choose a different way, and that failures should not be regarded as final" (1990, p. 1). What a wonderful idea, a democratic idea, this notion that we all have a right to change our minds, to try a new path, and to set out again. It makes more tangible the ideal of equal opportunity, and it emphasizes the value and possibility of agency and some freedom of choice. In significant ways, with its thousands of community colleges and alternative schools, its vast system of

job training programs, and its equally vast, if largely uncoordinated col-lection of after-school initiatives, youth organizations, and alternative-to-detention efforts, the United States epitomizes a society that values a second chance for every citizen. In other ways, since such opportunities are virtually always under-funded, under-staffed, and under pressure, it does not. The likely import of second-chance institutions is further dwarfed by the extent of the disadvantages attending mass incarceration (cf. Pettit, 2012).

And yet Vasudevan, DeJaynes, and their contributors manage to keep their balance on the tight wire, persistently, patiently, expertly seeking the small but potent curricular, pedagogical, and conceptual freedoms available in spaces that offer a fresh start—in their case, in programs devised for youth, primarily young men of color, as alternatives to incar-ceration. They carefully negotiate the constraints of bureaucratized sys-tems of delivery and reporting and, of course, the tremendous stresses on their young people, who are balancing precariously themselves, be-twixt and between youth and adulthood, detention and freedom, a past, the present, and a future. In this admirable and intrepid endeavor Vasudevan, DeJaynes, and colleagues rely on certain affordances. The participants in their programs have by and large made a decision to con-struct new beginnings. In the words of Maxine Greene (1990), they've become able "to perceive alternative possibilities" (p. 37), usually by vir-tue of the crossroads on which they stand, and this is huge. An equally important affordance, and one that contributes to the crucial processes of self-imagining, of seeing oneself and one's possibilities anew, is a cur-ricular focus on art, creativity, and representation.

There are periodic calls for an aesthetic turn in education. Dewey (1934/2005), for example, saw artworks not merely as aesthetic objects, but rather as focal points of processes of sense-making and "worldmak-ing", to adapt Nelson Goodman's (1978) phrase—art as receptive and productive experience in itself as well as a meeting ground on which multiple life experiences might be better understood and reconciled (cf. Eisner, 2002). This, I believe, is the notion of artful practice that perme-ates *Arts, Media, and Justice.* Increasingly, engagement in artistic prac-tice, like engagement with literacy, is likely to occur digitally and multi-modally as well as cross-contextually and cross-nationally, as global youth seize opportunities to artfully interpret and transform their shift-

ing social worlds (Hull, Zacher, & Hibbert, 2009). Vasudevan, DeJaynes, and colleagues are especially alert to moments of youthful artistic engagement that include political and social awareness, critique, and participation, as well as moments of self-fashioning. They go an important distance in making youth visible by documenting their journeys to see.

References

Aichhorn, August. (1955). *Wayward youth: A psychoanalytic study of delinquent children, illustrated by actual case histories.* New York: Meridian Books.

Dewey, J. (1934/2005). *Art as experience.* New York: Perigree Books.

Dwyer, P., & Wyn, J. (2001). *Youth, education and risk: Facing the future.* New York & London: Routledge.

Eisner, E. (2002). *The arts and the creation of mind.* New Haven, CT: Yale University Press.

Ellison, R. (1947/1995). *Invisible man.* 2nd Vintage International Edition. New York: Vintage International.

Ferguson, A. A. (2001). *Bad boys: Public schools in the making of Black masculinity.* Ann Arbor: University of Michigan Press.

Freire, P. (1970). *Pedagogy of the oppressed.* New York: Herder and Herder.

Giroux, H.A. (1996). *Fugitive cultures: Race, violence, and youth.* New York: Routledge.

Goodman, N. (1978). *Ways of worldmaking.* Indianapolis: Hackett Publishing Co.

Greene, Maxine. (1990). Revision and reinterpretation: Opening spaces for the second chance. In Dan E. Inbar (Ed.), *Second chance in education* (pp. 37–48). London: Falmer Press.

Hull, G., Zacher, J., & Hibbert, L. (2009). Youth, risk, and equity in a global world. *Review of Research in Education, 33,* 117 –159.

Inbar, Dan E. (1990). Introduction: The legitimation of a second chance. In Dan E. Inbar (Ed.), *Second chance in education* (pp. 1 –15). London: Falmer Press.

Lerner, R. M. (1995). *America's youth in crisis.* Thousand Oaks, CA: Sage.

Petitt, B. (2012). *Invisible men: Mass incarceration and the myth of Black progress.* New York: Russell Sage Foundation.

Acknowledgments

This volume grew from seeds planted over several years and came to fruition, first and foremost, through the involvement and participation of the youth who are at the center of this collected work. It is their engagement and collaboration with educators and researchers that we sought to bring to new audiences. Two conference presentations at the University of Pennsylvania's Urban Ethnography Forum served as further catalysts in transforming nascent conversations and inklings into robust chapters.

We thank our contributing authors for their time, for their efforts through various stages of revision and dialogue, and for the grace with which they dedicate themselves, each day, to the pursuit of creating just educational spaces with youth.

We are grateful for the encouragement of our series editors, Michele Knobel and Colin Lankshear, whose invitation has allowed us to bring these conversations together in a volume that we hope will engage a wider set of audiences. And we thank Sophie Appel and Stephen Mazur for their editorial assistance, guidance, and inordinate patience.

Glynda Hull has offered an invitation, in her elegant foreword, for readers to embrace the small moments that comprise much of this volume. And Yolanda Sealey-Ruiz's afterword holds questions for readers that will linger long after their engagement with these pages. For their graceful writing and critical engagement with this text, we are deeply thankful.

We owe a debt of gratitude to our friends, family, and colleagues who recognize that editing a book is a time-consuming and often lonely process. We are therefore thankful to have been given the time, space, and support to work together on this endeavor.

We are deeply appreciative of the staff at the two organizations where much of the work described in this book took place; they had faith in our work and they set a high bar for caring and engaged pedagogy that the practitioner-authors aimed to match in their research and teaching practice.

Finally, we thank the young people with whom we continue to work and learn every day; your words, images, films, performances and, most of all, curiosities about the world move us to do better, to be better, to hope for better.

Chapter 1

Becoming "Not Yet"

Adolescents Making and Remaking Themselves in Art-Full Spaces

Lalitha Vasudevan & Tiffany DeJaynes

> *The key is curiosity, and it is curiosity, not answers, that we model. As we seek to learn more about a child, we demonstrate the acts of observing, listening, questioning, and wondering.*
>
> —*Vivian Paley, 1986, p. 127*

This is a book about hopefulness. Each chapter is penned by authors who care deeply about children and youth, whose lives intersect with those of young people in myriad ways, inside and outside of formal institutional settings. All of the contributors to the volume also reflect and espouse a commitment to a view of young people as engaged learners that resonates with Paley's words in the opening epigraph rather than a troubling view of adolescents, which Lesko (2012) describes as being derived from a persistent and deficit cultural construction of adolescents, and teenagers in particular. She writes:

> Typically, teenagers appear in our cultural talk as synonymous with crazed hormones, as delinquents, deficiencies, or clowns, that is, beings not to be taken too seriously. They are most often spoken of with familiarity, sometimes with affection, and regularly with some hostility or displeasure. (p. 1)

Contrast this view of young people, so sedimented in ample cultural tropes and texts—some of which we discuss below—with Paley's (1986) comment, in the same article from which the epigraph comes, about an educator's response to a child, any child; in the example below, the child is Frederick who has introduced the topic of his mother's birthday into classroom talk:

Any serious observation made about a birthday is worth following up, not in order to give Frederick the facts and close the subject, but to use this compelling material as a vehicle for examining his ideas of how the world works. If I am to know Frederick, I must understand, among many other things, how he perceives his mother's birthday and his grandfather's permanence. (p. 126)

Paley is responsive and expresses a desire to take a young person and his "ideas of how the world works" seriously. The chasm between this attentive and respectful engagement with youth and Lesko's astute depiction of the persistent mischaracterizations of adolescents, which reverberate multiplicatively in research and policy that has court-involved youth as its focus, is the departure point for our introduction to this volume.

Arts as Inspiration for Seeing Youth Anew

"I am what I am not yet." With these seven simple words, Maxine Greene evokes the shared sentiments of possibility and anticipation, hallmarks of human encounters with one another and with the world. Her words reflect the spirit in which this book was conceived and the ethos within which the authors have crafted the stories contained in its pages. These are words that form an antithetical backbone to the staid, sociohistorical and biologically deterministic assumptions about youth that place them in a precarious position in the broader social imagination (Lesko, 2012). Adolescents are viewed as a population to be feared and protected. Yet, we wonder about the extent to which youth are seen outside of the staid labels that Lesko traces intergenerationally.

Court-involved youth is a term used throughout this volume and is meant to call attention to young people whose institutionally imbricated lives reflect ongoing and unsettled negotiations between the systems of law, education, and child welfare. The lived experiences of court-involved youth are brought together in this volume with the recollections, representations, and interpretations of the teachers, first-time as well as seasoned researchers, and teaching artists who have authored the stories that are contained in the following pages. They are engaged collaborators with youth, and have themselves been inspired routinely by works of art that reflect modes of expression beyond writing or speaking, to include film, photography, painting, music, dramatic performance, and more. As such, these multimodal expressions are woven

into their communicative practices, inquiries, and resultant depictions of young people in ways that reflect an underlying commitment to seeing youth differently; or, perhaps seeing youth with the same dignities accorded to most adults. In this sense, multimodality—or the orchestration of meaning and communication across multiple modes, using various media, and in a variety of genres—and the arts share a deep kinship particularly in how the meaning making practices of youth are understood.

The arts have the ability to inspire the as yet uninspired or render visible the unseen. Expression through the arts opens up spaces of possibility, particularly for youth, to engage and nurture the work of the imagination and enact their "deliberative agency" in the ways in which they (re)write themselves (Dimitriadis & Weis, 2001). Art can provide aesthetic simulacra for the range and variation of human experience, while simultaneously coaxing forward the hidden or "inward significance"[1] of things. "Art," Dewey (1932/2005) writes, "denotes a process of doing or making" that involves creating "something with some physical material, the body or something outside the body, with or without the use of intervening tools, and with a view to production of something visible, audible, or tangible" (p. 48). We purposefully invoke a plural connotation of Dewey's invitation and thus talk about "arts" to include performative, visual, musical, mixed media, and the verbal arts as they are situated in educational contexts outside of school; at the same time, we heed the caution that "the product of art is not the work of art" (Gadsden, 2008, p. 31). In other words, our attention to arts in this volume is not constrained by the resultant artifacts of artful engagements such as singing, painting, or dancing but in fact stresses the importance of engagement as a site of art; and arts as providing sites of engagement.

Possibility and anticipation, the tropes that Greene's words above encapsulate, also follow children into their adolescence, the same ones that all too often become subsumed within the metaphorical shift in schools from nurturing to molding, from guiding to directing. Within formal sites of education, like schools, possibility is too quickly translated into "potential" for which the acceptable modes of output fall within a narrow range. More focused on academic achievement[2] than the cultivation of self, schools have become largely places where engagement with the arts is endangered. Some strong advocates of funding and support of the arts in schools tout research that signals correlations

between gains in student achievement with increased "arts education." Eisner (1998) cautions arts educators away from this tendency noting,

> That questions about the contributions of the arts to academic achievement are raised by those for whom the arts are personally marginal is understandable: When the arts are not a part of your own life it is hard to know what they can contribute to it or to the lives of others. What is troublesome is the image of arts educators who know what the arts have to offer trying to give the customers what they want, whether or not there is evidence to support it. (para 4)

While this is an ongoing dilemma for arts educators, those of us who work as educators and researchers who teach and research *with* the arts experience similar challenges in translating the ineffable nature of education, relationships, discovery, and imagination that arises out of an arts-infused space or ethos into language that fits easily into preexisting categories of educational outcomes or replicable results.

Thus we tether our discussion about arts to the dialogue raised by Glynda Hull and her colleagues Amy Stornaiuolo and Urvashi Sahni (2010) in their research on the ways that adolescents communicate about and across their differences through the exchange of digital artifacts via a social networking site; the authors identify the aesthetic qualities of communication and their affordances for creative expression, play, and imagination. That is to say that this volume is a complementary endeavor to the long history of efforts made by the broader community of arts educators. We attempt to do so by shifting the gaze toward the ways in which artistic endeavors themselves are spaces in which to cultivate the self, to establish relationships with others, and to experience various forms of belonging. Research by Hull and colleagues (2010) and others (Beck & Malley, 1998; Osterman, 2000) has shown how forms of belonging and cultural citizenship in the lives of youth are expressed through diverse modes of interaction that include practices beyond the linguistic-heavy modes favored within most formal education and institutional contexts—that is, a recognition of participation beyond verbal contributions alone, that includes forms of play and laughter; or a sense of kinship to a community signified by a choice of clothing (see Johnson & Vasudevan, 2012 for a extended discussion of adolescents' embodied communicative practices). Access to multiple ways with which to express a sense of belonging can catalyze social arrangements different from the ones

that are readily found in many classrooms. These new social arrange-ments may include collaborative production of a radio broadcast that calls on the participation of the adults and youth involved (e.g., Soep & Chavez, 2005), the emergence of a central character in a play forged from an improvised performance of a young person's musical talent during theater rehearsals (see Fernandez, this volume), or the dialogic space of curriculum extending into reflective and interest-based blogs that allow teenagers to be seen as knowers in new domains by their teacher (DeJaynes, 2010).

Rather than lapse into a characterization of schools as inhibiting forces to art-full engagements, we turn our attention to questions that take up Greene's proposition, ones that are implicitly woven into the narratives in this volume: In what ways do arts-based and digitally-mediated spaces inspire inquiry that renders visible the unseen? How do multimodal and participatory approaches to education create new spaces for understanding the literate lives of adolescents? What are the aesthetic contours of literate practice beyond reading, writing, speaking, and listening? And how are they nurtured and sustained through the arts? How do arts-based research and teaching practices create condi-tions to know youth in new ways?

These are questions that reflect an understanding of education as what Olga Hubard (in this volume) calls a "joint growth project." She ad-vocates an educational posture that recognizes that "all young people can be art-full meaning makers and active constructors of culture if they are only provided with a fertile space." Such spaces are not only fertile for creative practices of cultural production, but they also allow new questions to flourish that reflect a different inquiry agenda than one fo-cused solely on student achievement. Graeme Sullivan (2011), in an es-say about the troubling trend of increasingly narrow definitions of learning within educational institutions at a time of unparalleled global-ized hybridity and creativity, underscores the need for narratives that invite a second glance:

> Artistic and academic communities, at their best, keep the social imagination open by bringing a creative and critical impulse to bear on what is at hand. A curious tension is created when presumed knowledge blinkers what we see and limits how histories and circumstances can be seen anew. Although we can't change the past, we can certainly question what histories might mean and

reassess those narratives that have been privileged and those that have been ignored. (p. 1183)

As Sullivan implies, such narratives wither without fertile spaces that are generative of a practice of seeing youth as more than just students, and outside of the slippage into deficit storytelling that rises out of adherence to a "success or failure" model of education (Varenne & McDermott, 1998).

This volume was borne out of a collective interest in and commitment to the many contours of "possibility" in pursuit of ongoing inquiry into the many ways that youth communicated their affiliation and affinity—for community, for friends, for family, for institutions—through their multimodal and embodied practices and postures. Thus, the chapters that follow also explore how youth repositioned themselves within their own educational trajectories through their active shaping of the various arts-based projects in which they were involved. Before launching into a description of these projects, we present some sociohistorical context for the nature of court involvement that lies in the background of the chapters in this volume.

The Landscape of Youth, Justice, and Education

The first Juvenile Court was established in 1899, in Cook County, Illinois, as a measure of order and as an institution that could address the needs of arrested youth differently than the adult criminal courts had done previously, with a purported emphasis on rehabilitation rather than penalty (Bilchik, 1999; Platt, 1977). This endeavor was one aspect of the broader Child Saving movement that was prevalent in the late nineteenth and early twentieth centuries, which had at its center a mission to protect children and youth. This was also a time when, not coincidentally, the United States was experiencing a massive influx of new immigrants whose ethnic, linguistic, and cultural practices were regarded by members of this movement as barriers to "Americanization." Child Savers were comprised largely of women who expressed a desire to help children and youth, who were living in what were determined to be "less than desirable" home situations gain education and employment. Schools became one bastion of these sustained cultural assimilation efforts; the Juvenile Court became another.

It was during this period of growth and strain in the United States that the term delinquency, characterized as a phenomenon that draws "energy away from youth" (Platt, 1977, p.7), gained prominence among educators and self-proclaimed child advocates. Platt, whose study of the child saving movement provides a less altruistic picture, describes how "the juvenile court system brought attention to and thus 'invented' new categories of youthful deviance, particularly behavior in which the actor was seen as his own 'victim'" (p. 145).

These categories of deviance and delinquency did not remain within the purview of the courts, alone. Rapidly, schools also became saturated with labels, many of which continue to be in existence today, including both formal assignments of intellectual or behavioral capacity (e.g., "educable mentally retarded") and less formalized but no less conse-quential identifiers (e.g., "delinquent" or "troublemaker") (Duncan, 2005; Ferguson, 2000; Fine, 1996; Hall, 1996; Hudak & Kihn, 2001). However, even outside of the assignment of labels, young people become court-involved as a result of increased neighborhood policing, status of-fenses such as truancy and curfew violations, random checks for identi-fication, and the rise in zero tolerance policies in schools that authorize school officials to impose mandatory punishments for a wide range of infractions that echo mandatory sentencing laws that are currently in effect in some form across all fifty states in the US.

Studies of "delinquency" and education use terms like "deviance," "problem behavior," and "abnormal" and draw heavily from survey data, school statistics, and juvenile justice data to substantiate correlations between school factors and what they deem to be "delinquency" indica-tors (Smith, 2000). They assert, broadly, that disengagement from school, dropping out, low levels of academic performance, and school-related discipline problems showed "high correlations" with "delin-quency" (Gottfredson, 2001; Smith, 2000). More specifically, the story that the statistics tell is one of noticeably high rates of "delinquency"—often manifested in high rates of school-based suspension, incarceration, and stints in juvenile detention facilities—that peak in the context of ur-ban schools. But there are other stories—of creativity, of inquiry, of al-ternative pursuits and performances of education—that also exist and must be told in the voices of the youth and educators at the center of these embodied and enacted counter-stories.

Locating Arts within Media and Justice

In this book we have brought together perspectives that remain at a far remove from one another in dialogues about youth, including theoretical perspectives about literacies and aesthetics, media and justice. At the heart of our discussions about these many theoretical and empirical interstices are the lives of court-involved youth with whom the authors in this volume have spent time learning about, seeing, and remaking their immediate worlds largely through sustained commitments to creating spaces for art-full expression and exploration in sometimes unlikely spaces.

Young people who become involved with the justice system experience a plurality of consequences that result from their arrest and incarceration including unemployment, economic hardship, discrimination, and inequitable and interrupted access to education. Thus, attempting to interrupt the cycles of court-involvement, the contributors to this volume convened as an intergenerational group committed to working in and creating spaces for adolescents to critically reflect on their lives, identities, and imagined futures as they seek and create a sense of belonging in additional aspects of their lives.

While research on the "school to prison pipeline" (Wald & Losen, 2003) has done much to demonstrate the perilous trajectory that school infractions can lead to—namely incarceration and court involvement—we are less informed about the movement of youth in the opposite direction. That is, what happens to youths' education while they are incarcerated, attending corrections education programs or alternatives to incarceration or detention, and after they are released back to their communities after detention (Youth Justice Board, 2009)? For many of these youth, traditional public schooling is no longer an option and, for many, their previous schooling experiences did not result in successful graduation. This collection aims to look beyond institutional walls and calls attention to the paths these young people forge and follow in their pursuit of a life free from institutional control with the support of arts-infused spaces and programs. In doing so, the projects and experiences that are described both echo and complement the efforts of programs such as Rehabilitation through the Arts (RTA), whose mission is to provide incarcerated men and women with opportunities for rich forms of creative expression "as a springboard to education, family reconciliation

and ultimately, successful re-integration into community life" (RTA Website, n.d.). Unlike these programs, however, the authors in this volume were positioned not only as facilitators of artistic and creative inquiries, but as pedagogically engaged researchers, as well. They embodied the dynamic spirit of practitioner inquiry by immersing themselves in reflective dialogue with youth and one another to systematically improvise their curriculum and pedagogical approaches to meet the ever-shifting needs and interests of participants and the programs in which they worked (Campano, 2007; Cochran-Smith & Lytle, 1993). In doing so, they developed deeply emic understandings about and also with their youth participants, as well as the nuanced narratives unfolding within their respective contexts. Thus, concerted efforts were made by the authors to move beyond the oft-used approaches to study the lives of court-involved youth—beyond surveys and the analysis of performance measures—to include not only interviews, but also other multimodal methods that create multiple points of entry for the youth participants into the study including group discussions, photography, and theater (e.g., Hull & Nelson, 2005; Mahiri, 2004; Winn, 2011). The methodological ethos adhered to by the authors in this volume reflects attention paid to the production of various kinds of artifacts as well as actively attending to the in-between moments of aesthetic performance such as laughter, play, and singing.

By intentionally assuming such responsive methodological postures, the authors in this volume were also enacting forms of justice. That is, in their work they draw on and respond to varying traditions of justice, from an adherence to the power of photography to creating spaces in which to enact formative justice (Dzula, this volume), to a commitment toward everyday acts of social justice through curriculum and pedagogy (Dattatreyan & Stageman; Kerr, this volume). Thus, our discussions about *justice* in this volume are predicated upon understandings of that word as both goal and means; that by attending to justice, one strives to create more just experiences. The pedagogical lessons from this work build from an implicit embrace of justice that is suggestive of philosophical (de Montaigne, 1991; Rawls, 1971) and educational (Fine, 1994; hooks, 2003) foundations to a consideration of the arts and media as central, as vital, and as essential in the daily lives of youth. In the background of this collected work sits the legal context of the juvenile court, whose everyday presence evokes questions of intentionality and rights as they were situated within the alternative and out-of-school contexts

in which the authors were located. Moral and philosophical considerations, therefore, were meted out through pedagogical considerations: What are we trying to accomplish together? Who is being heard and silenced? For what purposes are we engaged in this work? Who will benefit from our endeavors?

All of the work with youth that is reported on in this volume was explicitly concerned with bringing together diverse communicative resources and young people's curiosities and in so doing, seeking to write new narratives about youth. The projects offer different starting points for thinking about arts as a site of justice; and throughout the volume the authors express an appreciation for youth as contributors to the world, as cultural producers, and agentive partners in creating meaningful moments.

Multimodality and literacies

A central premise of much of the arts and media-based work in this volume is that meaning is made multimodally, that is through the intentional and incidental engagement of multiple modes of expression for the purposes of communication and representation (Jewitt & Kress, 2003). The multimodal lens taken up in many of the chapters, sometimes in subtle ways and other times explicitly, propelled the authors to attend mindfully and discursively to a range of modes of meaning (e.g., visual, aural, gestural) and modalities of expression and communication (e.g., pen, camera, microphone, the body). In the pedagogically responsive spaces cultivated by the authors, they harness the dynamic possibilities of arts and media resources to support youth in authoring selves through theater, photography, and film and tease out the affordances of these resources in designing pedagogical spaces and composing texts with youth. Many researchers have documented the value of utilizing multiple semiotic resources for authoring and representing powerful stories (Hull & Nelson, 2005; Pahl, 2006; Thomas, 2006); moreover, digital composing makes especially visible the depth and plurality of composing resources (Vasudevan, DeJaynes, Schmier, 2010). Facilitators built into their programs and projects a range of meaning-making tools—from still and video cameras to pens, paper, and their bodies—and openly explored the representational possibilities of these mediating resources.

Pedagogy and play

Following from an embrace of meaning as constructed and represented through multimodal practices is a spirit of playfulness and experimentation that imbues many of the pedagogies employed by chapter authors. Play and storytelling share an intimate bond as co-pilots of young people's imagination and creativity as children imagine possible lives, rehearse multiple scenarios, and aesthetically declare their place in the world through stories (Paley, 2004; Wohlwend, 2008).

Play that is "central to the rhetorics of creativity in childhood" (Marsh, 2010, p. 21) is all the more significant as youth move into and out of institutionally sanctioned spaces where room for play has significantly narrowed. Amid overly routinized school structures, heavy assessment demands, and increasingly few institutional spaces for any creative authoring to occur, a growing body of research documents a transformative communicative landscape replete with acts of self-authoring and self-representation (Hagood, 2008; Lankshear & Knobel, 2006; Pahl, 2006; Staples, 2008; Wissman, 2011).

In this spirit, the authors in this volume invite humor and improvisation into pedagogical spaces in ways that are responsive and attentive to the playfulness and creativity of youth. Often, youth use humor, playfulness, and imagination to navigate daily discourses and approach new technologies and cultivate new literacy practices with a similar ethos of experimentation and play. Given the space for creative engagement, youth develop "a sense that they are controlling their own representation, that they are in control of their own cultural identity, and are creatively shaping and molding language, style, and self into something new" (Carlson & Dimitriadis, 2003, p. 21). Youths' unrehearsed engagements with technologies such as video cameras, audio recorders, and mobile phones created spaces for: playing with multiple forms of participation, role playing with imagined characters, and manipulating digital artifacts for myriad social and educative purposes. Multimodal play, therefore, is not a distraction but is in fact a space in which to craft new narratives of being and belonging.

The authors in this volume attend to playfulness and aesthetic dimensions of literacies, as a means of opening multiple entry points for youth into activities and experiences and a wealth of representational possibilities. Enabling multiple kinds of participation for youth bespeaks

a commitment to justice, as it highlights a sense of becoming and a commitment to knowing youth and their multiple stories, a commitment to multiple forms of authoring and (re)authoring the self.

Even as this volume is premised upon a set of hopeful assumptions about the creative capacities of youth, as a collection of engaged researchers and practitioners who continue to work alongside adolescents, we are not blind to the challenges of this work. Nor do we intend to put forth utopic conceptions of adolescents within the ensuing discussions of the arts, media, and justice. Found in the interstices of work between adults and youth that is collaborative and collegial (Soep & Chavez, 2005) are stories that call into question the all too often unchecked conventional wisdom about adolescents, and about court-involved youth in particular.

As the projects and work described in the following chapters illustrate, the spaces for authoring and audience that arts and media provide also offer ways to see youth beyond the labels put onto them. As Paley notes, "These labels don't describe the imagination. A storyteller is always in the strongest position; to be known by his or her stories puts the child in the most favorable light" (p. 54). If, as Greene posits, "We come to know by means of linguistic formations over time" (2001, p. xvi), then we must continue the pursuit of research and practice that constructs, as Greene puts it, "true words"—and, we would advocate, true images—about the possibilities, dilemmas, curiosities, tensions, and creativities that reflect the experience of being a young person beyond the scope of the easily categorized label, including "court-involved."

Locating Arts in the Spaces of Research with Youth

The chapters that follow are replete with robust portraits of young people's explorations of self and others, and the world beyond their perceptible lines of sight. The authors, in both explicit and unspoken ways, assume a multimodal sensibility in their work with youth as well as in their written representations. Seven of the eight chapters that follow offer glimpses into work with court-involved youth from two programs in New York City that were the main partners in the two participatory research projects described below. The authors weave together interview transcripts; youth-authored plays; and youth-produced writing, photographs and video to explore the intersection of the arts, media, and

justice. Each offers implications of artistic spaces for teaching, learning, and researching with youth. The last chapter is by Olga Hubard, who has been a critical friend to both research projects and the people involved, and who herself strives to create opportunities with and for youth to engage with the world from new planes of seeing.

Reimagining Futures at Voices

The Reimagining Futures Project is an ongoing, participatory collaboration in which arts-based and media workshops are designed, implemented and documented using ethnographic methods. The project is situated in Voices,[3] an alternative to detention program (ATDP) that provides after-school activities, community supervision, and legal services for adolescents, aged 11-16, who are referred to the program by the New York County Family Court. The organization currently has two locations in New York City. Participants at Voices attend the program for varying lengths of time, averaging approximately six to eight weeks and there are three tiers of participation that correspond to the frequency with which participants are required by the courts to attend the program. Often, but not always, the frequency of participants' mandated attendance in the program decreases as they meet various benchmarks such as regular attendance, fewer or no disciplinary concerns at the program or at school, and progress in the program. Voices also partners with several programs designed for adolescents including a teen pregnancy awareness class and an organization that holds periodic information sessions about adolescents' legal rights.

The Reimagining Futures Project is carried out by a core team (Kristine Rodriguez Kerr, Melanie Hibbert, Ahram Park, Eric Fernandez, Lalitha, and youth interns from Journeys' employment internship program). As a team they collect artifacts and other forms of data about their work with youth: participant-produced multimodal artifacts including short videos, collages, writing reflections, and animations created using the online animation software Xtranormal; audio recorded group conversations around a variety of topics (e.g., global events, personal educational trajectories, imagining future realities) that have involved approximately 100 participants over the course of three years; of the approximately 100 participants who have participated in Reimagining Futures workshops, a smaller subset is the focus of more in-depth

analysis involving interviews and case study work. Team members write field notes about workshops, observations of the program during non-workshop days, and ongoing interactions with participants and staff. Each member of the research team also composes occasional analytic notes that reflect on particular aspects of the data collected.

The project team maintains a private, password-protected project blog to which field notes are uploaded, reflections that include ongoing analysis are posted, resources are shared, and on which the team conducts interim workshop planning. Reimagining Futures is a project that aims to understand the ways in which Voices attends to the social and emotional well-being of the youth participants and also to explore how youth participants experience and navigate their court-involvement within Voices. This dual-sided goal is carried out through an approach called multimodal storytelling (Vasudevan, 2008) that comes to life in the experiences shared by the first four authors in the book, including Eric Fernandez, who has the unique experience of transitioning from a youth participant in the Education In Between Project (described below) to becoming a founding member and co-researcher in the Reimagining Futures Project.

Education in Between at Journeys

Journeys is one of several incarceration alternatives available for court-involved youth in New York City, aged 17 to 23, and has a legacy of youth advocacy and innovation reaching back over 40 years. The youth population at Journeys mimics the trends of "minority" youth overrepresentation found in jails and detention facilities around the country. While acknowledging that the term "minority" is problematic in the way that it adheres fixity to the meaning of one's physical and social characteristics, we use it in this instance to echo the language used in reports of criminal justice statistics, and to underscore the overrepresentation of African American and Latino males, ages 18-25, who are under some form of correctional control (Koen & Washington, 2006; Mauer, 2003; Noguera, 2008; Skiba, 2004; Sullivan, 2011).

In the program, approximately 55% of the youth are identified as African American, 40% are identified as Latino, and the remaining 5% are identified as having other ethnic and racial backgrounds (although these percentages have fluctuated over time). The program uses a case man-

agement approach to facilitate a customized implementation of the wide range of services available for youth. These services include an employment and internship program, academically focused GED and college preparatory classes, drug and alcohol treatment, counseling, and a robust catalog of arts offerings into which, more recently, media integrated workshops and classes have also been incorporated. The tenor of arts at Journeys is largely influenced by the program staff, many of whom bring backgrounds as artists to their work with youth. Thus, arts electives have included classes in painting, sculpture, mosaics, and two that are explored more in depth in this text: theater and digital photography. Occasionally, Journeys has also joined with other organizations or individuals to provide unique opportunities for the youth, such as animation workshops.

For five years between 2004 and 2009, the literacies, pedagogical relationships, and educational trajectories of court-involved youth who are mandated to attend Journeys were the focus of a longitudinal, multi-sited, ethnographic study conducted under the auspices of the Education In Between Project. During that time period, Lalitha worked, at different times, with then-graduate students Mathangi Subramanian, Melissa Reburiano, Kristine Rodriguez Kerr and Mark Dzula (the latter two are also authors in this volume) to ethnographically and multimodally document various aspects of youths' experiences as part of Journeys. This intentionally collective and responsive methodology resulted in a way of working that included conducting interviews, writing field notes based on extensive hours of observation (of program offerings, staff meetings, and excursions), and occasionally facilitating workshops or classes at Journeys. In doing so, they developed working relationships with the program staff including the teachers, counselors, case managers, the director, and volunteers who passed through as part of various organizations that Journeys had partnered with for the purpose of supplementing the services it provided its participants.

Journeys staff and members of the research team have presented together at national conferences, co-authored publications, and have convened once again to contribute to this volume. Four of the chapters in this book touch on the authors' experiences working with, or, in the case of Eric Fernandez's chapter, being a participant at Journeys (Gabriel Dattatreyan and Dan Stageman; Mark Dzula; and Todd Pate, this volume). Much of the data discussed in these chapters was gathered or produced

within the auspices of the Education In Between Project that were readily shared with program staff; yet the authors each bring to transcripts and related documents their own interpretive lenses, personal histories, and memories.

Members of the Journeys staff founded Voices. Both share an ethos of care that is evident in the ways organizational staff, from entryway security guards to the teachers and the program coordinators engage in a practice of "unknowing" and thereby undoing of the essentializing and reductive perspectives that often circulate about court-involved youth (Villenas, 2010). This ethos permeated the pedagogical, interactional, and even administrative practices that were evident in these organizations between adults and youth, and in various ways between the youth themselves (for more information, see Vasudevan, 2010; Vasudevan et al., 2010; Vasudevan & Rodriguez Kerr, 2012).

Through the work represented in this volume, we communicate a narrative of education about youth in general, and about court-involved youth in particular, that interprets their actions and discursive practices as meaningful, productive, and participatory. We do this by demonstrating how within alternative education spaces in particular, the arts and a multimodal sensibility can foreground creativity and cultivate a more complex understanding of relationships and belonging between learners and their environments than currently evident in schools and even after-school programs (Gadsden, 2008). The chapters in this book explore the visual arts, dramatic arts, and literate arts, and draw on frameworks of multimodality, aesthetics, and literacies to render the communicative and representational landscapes that are being interpreted throughout the studies from which they draw. Such a focus is particularly significant in a moment when the research surrounding digital epistemologies and new literacies has dramatically expanded and deepened and as we have seen the emergence of increased mobile technologies and new spaces of representation, while at the same time the spaces for artistic endeavors within educational contexts is rapidly diminishing.

An Introduction to the Chapters

The chapters in this volume illustrate the pursuit of both exploration as well as cultivation of the interstices between arts, media, and justice. By creating pedagogical spaces that are informed by a commitment to pro-

viding youth with multiple ways to participate—that is, through the engagement of more than a single mode of communication or expression—the authors worked as facilitators of creative workshops who brought with them assumptions about the participatory and democratic properties of the arts.

Whether their primary role was one of teaching or researching, each took up a reflective and critical stance to understanding their engagement with youth in the various arts and media projects they brought their hearts and selves into. Working in this hyphenated space (Fine, 1994) propelled authors to interrogate their own positionalities and make visible their heart-full teaching and meaning-making practices

These chapters call us not only to consider the construction of educational spaces that are just, but also invite us to question our understandings of audience, authoring, and spaces. We introduce the chapters below in conversation with one another rather than in the order they appear as certain intentionalities are evident across the projects presented. The contributors to this volume tell their stories of work with youth in a variety of formats, playing with representation in much the same way that they created spaces for youth to play with conventions for telling stories: authoring themselves into the pieces, communicating with a range of audiences, and opening up a range of spaces for inquiry and dialogue about arts, media, and justice.

Audience

As one response to questions raised above about how youth are known and what images especially circulate court-involved youth, the authors illustrate how arts-based, media spaces create bridges to new audiences and place young people on different metaphorical horizons on which to be viewed anew. The chapters and the projects encapsulated within them make visible the experiences and perspectives of youth—often in their voices, rendering visible unexpected planes of interaction, creativity, and wisdom, thereby, beginning to dislodge entrenched tropes of deficit assumptions of youth. The arts help to nurture individuals and their relationships with a wider community and a wider world.

In building the curriculum for these projects, the contributors to this volume considered to whom they wanted to render these stories visible (educators, social workers, judges, spiritual leaders, teacher educators,

counselors, community arts programmers). The initial audiences for the art were youth themselves, community members, program staff, and arts curators of various kinds. Improvised and staged theater performances, read alouds of thoughtful and playful written narratives, photography exhibitions, and makeshift film screenings of rough cuts imbued the various learning spaces with a sense of intentionally making their stories heard and seen by others—whether peers, teachers, case managers, families, or members of their larger communities.

These projects were pitched to audiences who were asked to take up active positions, to look deeply, listen closely, and open themselves to observing and understanding the stories of youth anew. Thus, youth and facilitators regularly engage in art and art-making practices in conversation with audiences who are invested in seeing the world through their eyes. Arts have the capacity to invite audiences to re-examine seemingly familiar ideas, to consider perspectives again and often hear, see, and know in previously unknown ways.

E. Gabriel Dattatreyan & Daniel Stageman, facilitators of the Theater Initiative at Journeys, describe how youth participants worked and played to author original narratives of their own pasts that were transformed into stage plays. These unsanctioned stories of street life, designed around the provocative themes of honor and desire, created dilemmas for audiences hoping for reductive redemption and/or growth narratives. Through a unique structure of audience talk-backs at performances, the theater program brought together multiple layers of audiences to discuss and confront the tensions of representing young people, especially those involved in the justice system, in an effort to truly hear their stories and experiences.

Olga Hubard, a critical friend to the research teams at Journeys and Voices, reconsiders data from an earlier study in light of her conversations with authors in this volume. In re-seeing her work pondering museum art with youth, she questions what it means to hear young people's readings of artworks in new ways, with new ears, outside of the scope of existing tropes of interpretation. Hubard asks educators and all those who work with youth to strive to see though the fresh eyes of youth, relishing in the wisdom of youth as we engage in artistic endeavors with them. She also challenges curators, school-based, and out-of-school educators to invite youth to be active audiences of museum artworks by in-

viting their often-keen insights and perspectives into serious, artistic conversations.

Eric Fernandez's essay, a reflection on a collection of personal writings across his experience as participant in Journeys, actor in the Theater Initiative, and, eventually, as member of the Voices research team makes visible the transformative power of valuing youths' stories and experiences. Fernandez's essay chronicles his desire to enter conversations about justice and the arts that he felt were missing his voice through sharing his writing publicly as an engaged intellectual. His piece is about speaking his truth and seeking out spaces in which his voice will be heard by a range of audiences. He engages in discussion about how education through the arts matters and why it's so necessary for court-involved youth, including the youth who are under multiple forms of court-mandated supervision, whom he now counsels in his role as a Youth Advocate.

Authoring

Akin to this notion of audience is the position authoring takes in the projects chapter authors lead. In authoring, youth are invited to see themselves anew and to write new selves into being by harnessing their personal interests and life stories—fictional, autobiographical, and somewhere in between—to remake or reposition themselves. The youth in these studies make visible what too often remains unseen and cultivate the work of imagination, their own and that of their audiences. The invitation to story—through words, images, sounds, and movement—highlights the intersecting voices of youth and educators in constructing meaning. The writers in this volume also ask what it means to attend seriously to youth as authors, artists, and cultural producers.

Kristine Rodriguez Kerr reports on a writing group she led at Voices that encouraged creative writing, both personal and public, and, in doing so, represents youth stories through their own words and understandings. Youth participants in her study made themselves known through rewriting and revising memoirs and autobiographical fiction, sometimes even (re)storying events of their lives, reconsidering decisions, and taking up new identities. Kerr highlights the value of genres like fanfiction and other unschooled literacies to reinscribe writing with much more than school-based meanings. In her workshop, writing became a tool as

well as a site for self-cultivation and authoring, an important shift, especially for youth with interrupted school trajectories.

Melanie Hibbert sees play and improvisation as essential components of media production with youth. By focusing on creative, playful film production Melanie offers a portrait of youth as cultural producers who use play as a means of artistic expression, (re)storying selves, and authoring unsanctioned and unscripted narratives. She offers a series of vignettes from a single afternoon to illustrate the way that youth authored their stories and played with their interpretations of lived realities in the context of a video production workshop at Voices. Her workshop drew upon youth lives and digital composing repetoires, leaning into a playful aesthetic for filmmaking and storytelling. As youth experimented with genres of popular culture, hastily sketching storylines, improvising, and producing, they took up various roles (cameraperson, actor) and storied themselves as knowledgeable and critical media producers.

Mark Dzula focuses his ethnographic and photographic lenses on the artistic practices of Juan, one particularly astute young man in his workshop at Journeys who takes up photography as a means of authoring his world, documenting his neighborhood and those who support and care for him. As Juan experiments aesthetically in technically complex, stylistically "wild" artistry, he cultivates a sense of himself as an artist. Dzula posits that by recognizing and responding to youth as cultural producers and already as artists or professional peers, we engage them more critically in modes of communication. That is, in the spirit of formative justice, or the autonomy to author one's own life, the opportunities for a young man like Juan to expand his communicative palette to include photography presents him with increased invitations for storytelling, audiences, and making visible the unspoken.

Spaces

In many of the projects, spaces that allow for "safe" vulnerabilities on the part of both adults and youth invite inquiry, sharing and communion, enabling a "reflective loyalty to the known" by scaffolding "reflective openness to the new" (Hansen, 2010). Many contributors to this volume openly wrestle with what it means to create spaces where the honest selves of both youth and facilitators can be known and welcomed. In

these spaces, labels of criminality and court-involvement were interrogated and complicated.

Todd Pate's essay bespeaks his background as a dramaturge, creatively walking us through the world of improvisation, writing, and performance with the Theater Initiative project at Journeys. As the writer-in-residence for the project, Pate offers insights into how honest stories were constructed through trust and the daily search for meaning that makes art. In creating a space where youth and facilitators were compelled to acknowledge their fears and become open together, he sought to deeply listen to and hear youths' stories, making his teaching self vulnerable and modeling his desire to create a space where youth could "see with their hearts," exploring and overcoming fears to courageously embody art.

Ahram Park's essay reflects upon the power of building pedagogic spaces that invite youth to join in and make themselves known to relatively unknown others for the purpose of identifying possible common aims. A photography project at Voices, documenting the surrounding neighborhood, serves to open up a space for engagement, sharing, and dialogue. Facilitators and participants come to know one another better through the informal sharing of stories of families and respective cultures brought about by a walk to document the stories of the community surrounding Voices. Park reflects not only on the critically engaged and dialogic space of the neighborhood walk, but also interrogates why, upon returning to Voices, their classroom became silent. Park argues that, by inviting participants to look closely, the presence of cameras serves to mediate seeing and sharing amongst youth and facilitators, as they attend to sights, objects, even sounds, and the stories imbued in them.

Conclusion

In an age when talk of local and global forms of participation and influence have become de rigueur in educational discourses, we want to urge that attention be given to the small, pedagogical moments that can nurture new relationships, new understandings across differences, and invite youth to embrace and engage with new questions about who they are and who they might become. Mollie Blackburn and Caroline Clark (2007), in their edited volume advocating for the political and social engagement of literacy research, urge that "this moment demands that we

attend to local literacies even more deeply, but in ways that make ex-plicit the connections of the local to the global" (p. 2). Theirs is a chal-lenge to educators and researchers to see and value the immediate, the nearby, and the intimate contours of meaning-making moments to broader communicative terrains; to see the big in the small. As a collec-tion of engaged researchers and practitioners, we strongly advocate for the design of educational spaces and educational research that attends to lived and embodied performances of education that youth carry with them as they move through and across the walls of various institutions, geographies, and discourses. Thus, we offer a final prefatory note to this volume.

This book does not provide summative or definitive prescriptions. Found in the ensuing pages are beginnings, initiations of dialogue through portraits of artful engagements that we hope will spill over into readers' ongoing inquiries and emerge re-envisioned in their curricular or research practices. We believe, much as Sullivan asserts here,

> [A]rt can reveal what we don't know by changing what we do know. Therefore looking forward so as to look again at the past and present requires a creative capacity to reveal a critical insight—and this is within the reach of communities open to imaginative collaborative action. For as Maxine Greene said, "art can't change the world, but it can change someone who can." When an invitation to curiosity is taken up, it awakens a new awareness of the possibility to see things differently and to act on the urge to do something about that vision. (2011, p. 1184)

Thus, this book has grown out of ongoing conversations, conference presentations, and multi-level mentorship between and across re-searchers and participants, adults and youth, graduate students and youth researchers, and faculty and graduate students. The authors en-gage in an active juxtaposition of positionalities such as practitioners and researchers, researchers and youth participants. In this way, inter-disciplinarity is both method and pedagogy that serves as the guiding force behind the collective effort out of which this collection was born. All of the chapter authors have, in some way, collaborated in the re-search and documentation, implementation, and representation of the projects that are at the heart of this volume. And together, we hope the conversation continues.

Notes

1 "The aim of art is to represent not the outward appearance of things, but their inward significance."—Aristotle.

2 Student achievement is identified as performance on external measures of proficiency or competency—such as New York Regents Exams—that have greater social currency in educational policy discourses than locally formed, emergent forms of assessment that privilege the emic perspectives of educators and their students.

3 All names of participants and organizations are pseudonyms.

References

Beck, M., & Malley, J. (1998). A pedagogy of belonging: Reclaiming children and youth. *Journal of Emotional and Behavioral Problems 7*(3), 133–137.

Bilchik, S. (1999). *Minorities in the juvenile justice system.* Washington, DC: Juvenile Justice Bulletin, U.S. Dept. of Justice.

Blackburn, M. & Clark, C. (2007). *Literacy research for political action and social change.* New York: Peter Lang.

Campano, G. (2007). *Immigrant students and literacy: Reading, writing, and remembering.* New York: Teachers College Press.

Carlson, D., & Dimitriadis, G. (2003). Introduction. In G. Dimitriadis & D. Carlson (Eds.), *Promises to keep: Cultural studies, democratic education, and public life* (pp. 1–35). London, UK: Routledge Falmer.

Cochran-Smith, M., & Lytle, S. L. (1993). *Inside/Outside: Teacher research and knowledge.* New York: Teachers College Press.

DeJaynes, T. (2010). *Knowing ourselves and making ourselves known: Exploring multimodal literacies and learning with adolescents.* (Unpublished doctoral dissertation.) Teachers College, Columbia University, New York.

Dewey, J. (1932/2005). *Art as experience.* New York: Penguin.

Dimitriadis, G., & Weis, L. (2001). Imagining possibilities with and for contemporary youth: (Re)writing and (re)visioning education today. *Qualitative Research*, 1(2), 223–240.

Duncan, G. A. (2005). Critical race ethnography in education: Narrative inequality and the problem of epistemology. *Race, Ethnicity, and Education, 8*(1), 93–114.

Eisner, E. (1998). *The kind of schools we need: Personal essays.* Portsmouth, NH: Heinemann.

Ferguson, A. A. (2000). *Bad boys: Public schools in the making of black masculinity.* Ann Arbor: University of Michigan Press.

Fine, M. (1994). Working the hyphens: Reinventing the Self and Other in qualitative research. In N. Denzin & Y. Lincoln. (Eds.), *Handbook of qualitative research* (pp.70–82). Newbury Park, CA: Sage.

Fine, M. (1996). Why urban adolescents drop into and out of public high school. *Teachers College Record, 87*, 393–409.

Gadsden, V. L. (2008). The arts and education: Knowledge generation, pedagogy, and the discourse of learning. *Review of Research in Education, 32*(1), 29–61.

Gottfredson, D. C. (2001). *Schools and delinquency.* New York: Cambridge University Press.

Greene, M. (2001). Foreword. In G. Hudak & M. Kihn (Eds.), *Labeling: Pedagogy and politics* (xvi–xvii). London: Routledge.

Hagood, M. C. (2008). Intersections of popular culture, identities, and new literacies research. In J. Coiro, M. Knobel, C. Lankshear & D. Leu (Eds.), *Handbook of research on new literacies.* New York: Erlbaum.

Hall, S. (Writer), & Jhally, S. (Producer) (1996). Stuart Hall—Race: The Floating Signifier. DVD. Northampton, MA: Media Education Foundation.

Hansen, D. (2010). Cosmopolitanism and Education: A View from the Ground. *Teachers College Record, 112* (1), 1–30.

hooks, b. (2003) *Teaching community: A pedagogy of hope.* New York: Routledge.

Hudak, G. M., & Kihn, P. (2001). Labeling: Pedagogy and politics. London: Routledge.

Hull, G., & Nelson, M. E. (2005). Locating the semiotic power of multimodality. *Written Communication, 22*(2), 224–261.

Hull, G., Stornaiuolo, A., & Sahni, U. (2010). Cultural citizenship and cosmopolitan practice: Global youth communicate online. *English Education, 42*(4), 331–367.

Jewitt, C., & Kress, G. R. (2003). *Multimodal literacy.* New York: Peter Lang.

Johnson, E., & Vasudevan, L. (2012) Seeing and hearing students' lived and embodied critical literacy practices, *Theory Into Practice, 51*(1), pp. 34–41.

Koen, D. (Director), & Washington, O. (Producer). (2006). *Beyond the Bricks* [Documentary]. United States: Washington Koen Media Productions.

Lankshear, C. & Knobel, M. (2006). *New literacies: Everyday practices and classroom learning* (Second edition). Maidenhead and New York: Open University Press.

Lesko, N. (2012). *Act your age! A cultural construction of adolescence* (Second edition). New York: Routledge.

Marsh, J. (2010). Young children's play in online virtual worlds. *Journal of Early Childhood Research 8*(1). pp. 23–39.

Mauer, M. (2003). The crisis of the young African American male and the criminal justice system. In O. Harris & R. R. Miller (Eds.), *Impacts of incarceration on the African American family* (pp. 199–218). New Brunswick, NJ: Transaction Publishers.

Montaigne, M. (1991). *The essays of Michel de Montaigne* (M. A. Screech, Trans.). London: Penguin. (Original work published 1595)

Noguera, P. (2008.) *The trouble with black boys and other reflections on race, equity and the future of public education.* New York: Wiley and Sons.

Osterman, K. F. (2000). Students' Need for Belonging in the School Community. *Review of Educational Research, 70*, 323–367.

Pahl, K. (2006). An inventory of traces: Children's photographs of their toys in three London homes. *Visual Communication, 5*(1), 95–114.

Paley, V. G. (2004). *A child's work: the importance of fantasy play*. Chicago: University of Chicago Press.

Paley, V. G. (1986). On listening to what the children say. *Harvard Education Review 56*(2), pp. 122–132.

Platt, A. (1977). *The child savers: The invention of delinquency* (Second edition). Chicago: University of Chicago Press.

Rawls, John (1971). *A theory of justice*. Cambridge, MA: Harvard University Press.

Research Through Action (RTA) Website: http://www.rta-arts.org/

Skiba, R. (2004). Zero tolerance: The assumptions and the facts. *Education Policy Briefs, Volume 2, Number 1, Summer 2004*. Center for Evaluation and Education Policy, Indiana University.

Smith, Brian J. (2000). Marginalized youth, delinquency, and education: The need for critical-interpretive research. *The Urban Review, 32*(3), 293–312.

Soep, E., & Chavez, V. (2005). Youth radio and the pedagogy of collegiality. *Harvard Educational Review, 75*(4), 409–434.

Staples, J. M. (2008). "Hustle & Flow": A critical student and teacher-generated framework for re-authoring a representation of Black masculinity. *Educational Action Research, 16*(3), 377–390.

Sullivan, G. (2011). The culture of community and a failure of creativity. *Teachers College Record 113*(6), pp. 1175–1195

Thomas, A. (2006). Blurring and breaking through the boundaries of narrative, literacy, and identity in adolescent fan fiction. In M. Knobel & C. Lankshear (Eds.) *New literacies sampler* (pp. 137–164) New York: Peter Lang.

Varenne, H., & McDermott, R. (1998). *Successful failure: The school America builds*. Boulder, CO: Westview Press.

Vasudevan, L. (2010). Literacies in a participatory, multimodal world: The arts and aesthetics of Web 2.0. *Language Arts, 88*(1), 43–50.

Vasudevan, L., DeJaynes, T., & Schmier, S. (2010). Multimodal pedagogies: Playing, teaching and learning with adolescents' digital literacies. In D. Alvermann (Ed.), *Adolescents' online literacies: Connecting classrooms, media, and paradigms* (pp. 5–25). New York: Peter Lang.

Vasudevan, L., & Rodriguez Kerr, K. (2012). Re-storying the spaces of education through narrative. In E. Dixon-Román & E. Gordon (Eds.), *Thinking comprehensively about education: Spaces of educative possibility and their implications for public policy* (pp. 107–122). New York: Routledge.

Vasudevan, L., Stageman, D., Rodriguez, K., Fernandez, E., & Dattatreyan, E. G. (2010). Authoring new narratives with youth at the intersection of the arts and justice. *Perspectives on Urban Education, 7*(1), 54–65.

Villenas, S. (2010). Knowing and *unknowing* transnational Latino lives in teacher education: At the intersection of educational research and the Latino humanities. *High School Journal, 92*(4), 129–136.

Wald, J., & Losen, D. J. (2003). Defining and redirecting a school-to-prison pipeline. In J. Wald & D. J. Losen (Eds.), *Deconstructing the school-to-prison pipeline: New directions for youth development, 99* (pp. 9–15). San Francisco: Jossey-Bass.

Winn, M. T. (2011). *Girl time: Literacy, justice, and the school-to-prison pipeline.* New York: Teachers College Press.

Wissman, K. (2011). "Rise up!" Literacies, lived experiences, and social identities in an in-school "Other space." *Research in the Teaching of English, 45* (4), 405–438.

Wohlwend, K. E. (2008). Play as a literacy of possibilities: Expanding meanings in practices, materials, and spaces. *Language Arts, 86*(2), 127–136.

Youth Justice Board. (2009). *Strong families, safe communities: Recommendations to improve and expand New York City's alternative to detention programs.* New York: Center for Court Innovation and the Center for Courts and the Community. Available: http://www.courtinnovation.org/sites/default/files/YJBreportfinal_20091.pdf

Chapter 2

Writing with Court-Involved Youth

Exploring the Cultivation of Self in an Alternative to Detention Program

Kristine Rodriguez Kerr

Beginning in the late 1990s, an increase in policies that aimed to hold youth more accountable significantly changed the United States' approach to juvenile crime. In 2008, there were an estimated 2.11 million arrests made of persons under the age of 18 (JJDP, 2009). Our current juvenile justice system "has juveniles being confined in numbers that cannot be accounted for by criminal activity alone and should give pause to any civil society" (Bell, 2000, p. 188). Altering the focus of the juvenile justice system, zero tolerance policies across the country expanded through the incorporation of mandatory expulsion, revival of status offenses,[1] and increase of police presence in schools. Particularly in urban areas, an increase in police presence at schools has resulted in "schools have[ing] become a major feeder of children into the juvenile and adult criminal courts" (Dohrn, 1999, p. 162). Abdicating their responsibility to counsel and discipline, school officials and teachers often occupy an uncomfortable middle ground in a rigid discipline system (Akom, 2001). Pointing out that zero-tolerance policies *shift* rather than *solve* problems, Ladson-Billings (2001) states "zero tolerance is a simplistic and cruel response to a complex problem that requires careful thought and action" (p. 79). Rather than turning adolescent misbehavior into teachable moments, zero tolerance policies remove problem students from the school community. And yet, these students must go somewhere.

Increasingly obvious in a generation of mass incarceration of youth, young people who become involved with the justice system often experience a plurality of consequences that result from their arrest and incarceration (Ladson-Billings, 2001). These consequences—interrupted access to education, unemployment, economic hardship, discrimination—

contribute to an increased likelihood of re-arrests and future entanglements with the justice system. If youth do in fact live in the discourse of "growing up" (Lesko, 2001), the progress of future—the progress from education, to work, to family life—is disrupted by incarceration. Entry into the juvenile justice system is a disjunctive moment that breaks with normative coming-of-age narratives and social expectations, forcing youth to focus on the present and think differently about their future. For too many of the staggeringly high number of court-involved youth, the disjunctive moment of their arrest begins a court-involved trajectory that allows little alternative to pre-existing narratives of who they are and what they can accomplish.

Describing the conditions of incarceration and confinement in a system "rife with institutional racism," Bell urges juvenile justice professionals to oppose "legislative agendas that continue to demonize young people of color" (2000, p. 190). Rather than the continuation of get-tough-on-juvenile-crime tactics, Bell argues for interventions that support juvenile offenders with a focus on their strengths rather than their deficits. Programs that focus on youths' strengths open the possibility for shifts in the youths' perceptions of self and allow for the development of possible selves that are generative of trajectories away from court supervision and control. Striving to provide spaces that hold youth accountable for their past actions while offering the necessary support for the cultivation of future selves, alternative-to-detention programs (ATDP) for youth have gained increased attention and support in recent years.

Uniquely positioned in an after-school space between the institutions of education and justice, ATDPs strive to decriminalize youth and return, instead, to goals that aligned more closely with those of the original juvenile courts—goals that focused on the rehabilitation rather than the punishment of youth (Dohrn, 1999). ATDPs attempt to interrupt the cycle of incarceration by providing space for youth to reflect on their lives without disrupting them (CASES, 2010). For court-involved youth, opportunities and programs that allow them to work towards understanding self, coming to terms with past actions, and imagining possible futures outside of the justice system are critical.

The following chapter documents the experiences of several court-involved youth in Voices,[2] an ATDP located in New York City, throughout

their involvement in a six-week creative writing workshop. At the time when these writing workshops were initiated, I was in my third year as a co-facilitator of biweekly workshops focused on digital arts and literacies situated within this ATDP. In the previous years, we held workshops of varying length focused on digital storytelling, video and music production, photography and collage, drawing, performance, and more. My request to begin a creative writing group within Voices was instantly supported by staff members. When explaining the writing workshop to participants, Ted—an average height, slender, 12-year-old African American male participant—asked two simple questions that helped to shape a collective understanding of our workshops: "Why writing? What do I get out of it?"

At this point, Ted had been a Voices participant for two weeks. In the digital workshops he was sometimes engaged and sometimes not. When he was engaged, he would ask questions, listen closely, share personal stories, and respond thoughtfully. He enhanced the workshops because he so fully participated. When he wasn't engaged, he was undisruptive, often choosing to sit alone or in another room. When he chose to sit in another room, it was disappointing not only because his absence in our workshop community was felt, but also because his sullen attitude was often triggered by an event in school that carried over into this after-school space. Ted did not shift emotions easily and there seemed to be no way to get Ted out of a bad mood if that was how he arrived to Voices. His youthful appearance was offset by his serious, soft-spoken nature. He was not quick to smile and he wanted to be taken seriously. When he spoke, other participants listened.

In asking his two questions the word "writing" left his mouth like it was a chore—in a similar way that a young person might ask, "Why do I have to make my bed? Or eat this broccoli?" For Ted, writing was a chore to be done in school hours and it did not have a place in our creative afterschool work. Ted's questions reflected his school-based experiences with writing and "the narrow, decontextualized skills-based orientation that dominates many national literacy curricula" (Baynham & Prinsloo, 2009, p. 18). In what I am certain was a long-winded response to Ted's two simple questions, I explained how I wanted this creative writing workshop to be a space where he could write and share work without worrying about grades or judgment; a space where he could be creative

and experiment with writing and storytelling; a space where he could hear, share, and reflect on stories that were worth telling. In support, a Voices staff member who heard the conversation commented that he would want to join something like that if he could. Quiet for a moment, Ted nodded his head and said he'd be interested in trying it out. Sparked by Ted's two simple questions, a collective ethos of creative engagement with writing shaped our workshops and, as you will read, allowed Ted to craft fanfiction pieces that portrayed his understanding of sports, the world, and knowledge about himself.

Positioning writing workshops as one way for youth to make themselves known through authoring, I aim to document how court-involved youth in this space were encouraged to develop critical awareness about themselves and the world, and imagine new possibilities for who they are and who they might become outside of the justice system. Through storytelling and creative writing, we worked to push beyond skill-based orientations and position writing in our workshops as a way for youth to make themselves known, to know themselves better, and to share and examine their understandings of the world. In this way, we engaged in the "practice of writing" as an exercise for the cultivation of the self.

Theoretical/Conceptual Framework

At the heart of New Literacy Studies (NLS) is a sociocultural lens through which literacies began to be reconceptualized as multiple and socially situated practices. Characterized by the methodological influences of anthropologists and sociolinguists who relied on ethnographic methods, NLS researchers sought to develop understandings about the practices of individuals and communities (Heath, 1983; Street, 1984; Gee, 1996, Freire, 1997). Operating within this theoretical tradition, I seek to understand literacy in practice and located in the social contexts of Voices.

While each of our workshops was introduced as practice for a particular creative writing skill—i.e., practice for writing dialogue, practice for developing authentic characters, practice for writing vivid descriptions, etc.—participants were encouraged to engage in writing texts that made sense to them, rather than adhere to an imposed genre or style. Moje (2000) believes it is important for teachers and researchers to un-

derstand how "unsanctioned" literacy practices, ranging from tagging and graffiti writing to poetry, narrative, journal and letter writing, may provide adolescents, especially those who are marginalized, with ways of "constructing and maintaining thought, identity, and social position" (p. 252). Although alternative and unsanctioned literacies used by adolescents continue to remain largely ignored in school settings in favor of a single, standardized definition of literacy, creating space for alternative literacy practices within our workshop allowed us to work with the strengths that students already possessed, acknowledge their existing meaning making tools, and further distinguish the writing work done in our workshops from the school-based writing that many of our participants complained about.

Participants were told to not worry about spelling and grammar in first drafts, but instead to do the work of getting their thoughts down on the page. Some students chose to write first while others talked through their ideas out loud before engaging in writing work. Even though most participants chose at some point to write about personal experiences, this was in no way a requirement of our workshops. Students were encouraged to write fictional pieces; however, for many young people, their public and private worlds are inextricably connected. While personal stories are at times discouraged in school-based writing, workshop participants took up the freedom of our afterschool space to create texts that bore witness to their lived experiences. These are the stories they wanted to write. Through conversations that arose from sharing these texts as well as the work of revising and revisiting texts, participants were opened "to the richness and healing potential of the interplay of personal and public discourse" (Anderson & MacCurdy, 2000). Through the crafting of texts, our workshops became what Miller describes as "a place to see and re-see the components and possible trajectories of one's lived experiences and to situate and re-situate that experience within a world of other thoughts and other embodied reactions," (as cited in Anderson & MacCurdy, 2000, p. 15). In this way we engaged in the "practice of writing" as an exercise for the cultivation of self.

Writing as an exercise for the cultivation of self provides a space for reflection that helps to guide an author's understanding of his/her own thoughts, relations to others, and place in the world. "More than a training of oneself by means of writing, through the advice and opinions one

gives to the other: it also constitutes a certain way of manifesting oneself to oneself and to others" (Foucault, 1997, pp. 216). Writing, and revising writing, provides an author with space to reflect, imagine, and advise oneself with distance. In striving to write with this kind of self-reflective distance, an author is able to see his/her thoughts from a higher level (Hadot, 2010).

Hadot (2010) argues that this practice of writing allows the author to *be* in a different way. "This is a new way of being-in-the-world, which consists in becoming aware of oneself as a part of nature, and a portion of universal reason" (Hadot, 2010, p. 211). The purposes, and therefore the rewards, of these writing exercises are then not solely to cultivate an understanding of one's individual identity, but also to push to improve how one knows and engages with others and the world. Particularly for court-involved youth, who have often been the object of school failure narratives (Ferguson, 2000), the opportunity to take up the identity of successful writer, storyteller, and workshop participant is not only important, but aligns with the larger, above-mentioned goals of Voices.

Methods & Data Analysis

This six-week writing workshop was conducted at an ATDP located in an office space in New York City. As part of a court mandate, youth must attend Voices from 4:00pm to 7:00pm every school day. Participants, between the ages of 12–16, report to the program for a period of four to six weeks depending on their individual court cases. At the end of their mandated time periods, students' cases are reviewed by their original judge and, depending on their attendance and participation, they are either assigned to more time or they are allowed to stop attending. For participants who are no longer required to attend but are still interested in *hanging out*, they can continue to come and be a part of any program Voices offers for as long as they are interested.

Introduced to participants by Voices staff, the writing workshop was positioned as a unique and elite opportunity within the program. Participants were selected based on interest and encouraged by staff to "get their voice heard." Intentionally keeping the number small so as to better facilitate sharing and discussion of student work within the workshop time period, no more than five participants were involved in the workshop at any one time.

From the initial group of five, two participants left (one graduated the program, the other was no longer interested) and were replaced within the subsequent weeks. Therefore, our workshop number was always five participants, one facilitator/researcher, and one youth intern.[3] In total, three female participants and four male participants were involved in the workshops. Meeting once a week for 90 minutes, our workshops focused on different creative writing techniques, which included in order: creating and writing from idea books; practice writing descriptions; practice writing with voice; developing authentic characters; practice writing dialogue; and a final revision workshop in which participants were asked to select one work from the previous weeks to revise and continue developing. In the last 15 minutes of each workshop, participants were asked to write "letters to themselves," which they folded, taped, and dated. These letters were collected and returned to them, unopened, at the end of the following workshop, one-week later. In this way, participant-writers were able to engage in public writing to share with the group and private writing for themselves.

Participants were encouraged to reflect on and create portraits of their lives in a variety of creative ways. As a group, we wrote, read, discussed, and revised writing, while spending time talking about a variety of topics that were relevant to their lives. Frequent themes for both writing and discussion focused on romantic and platonic relationships, school, family, Voices, and sports.

Data collection and analysis was an ongoing, simultaneous iterative process that occurred throughout the study. The following types of qualitative data were collected: observation notes collected during workshops, two semi-structured interviews, and a minimum of two written artifacts per participant per workshop (totaling over 60 pieces of participant writing). Each forty-five-minute, semi-structured interview was audio recorded and transcribed verbatim. Observation notes were typed up immediately after each workshop. As the writing workshop progressed, I actively negotiated my roles of researcher, facilitator, and participant during each workshop. To better reflect on these multiple roles, I kept a researcher journal throughout the workshop.

In addition to triangulated, descriptive data, I engaged in member checking with participants through written feedback and in one-on-one interviews, and peer debriefing through conversations with the youth

intern who was present at every workshop. Ultimately, I believe that in one space, multiple perspectives exist and I have strived to have those perspectives and participants' voices represented transparently.

In the following section, two themes that emerged from the data are discussed. First, I look at fanfiction as a way for three participant-writers to share knowledge of the world and themselves. Next, I explore how participant-writers wrote themselves into their stories and, through this fictionalization of the self, worked to make themselves known in new ways.

Fanfiction: Sports Stars as a Vehicle to Share Knowledge of the World and the Self

> I write about Kobe because he is the best. I mean, he's not as good as me, but—just now, and everything, he's the best. And everyone likes—even if you don't like him—everyone likes Basketball…or most people do anyway. And they know him. And they'd be interested in that. So that's why [I wrote about him] (Interview, April 7, 2011).

In the above quote, taken from a post-workshop interview, Ted explains why he chose to write about Basketball star Kobe Bryant. Joining the writing workshop in the third week, Ted sat quietly at the corner of the table, with his sweatshirt hood pulled up over his head. In this workshop, participants were encouraged to develop two characters by writing down what they knew or imagined about their characters. Ted announced he was going to write about "Kobe and LeBron," two NBA stars. In writing down and sharing what he knew about both basketball players, Ted was able to showcase his expert knowledge about the sport. For the next three weeks, in every workshop that Ted was a part of, he wrote with Kobe Bryant as his main character. Casting this sports star as a heroic character in several fictitious, often morally charged scenarios, Ted was able to leverage his expert sports knowledge in creative ways that allowed for both humorous and serious reflection.

The following section explores Ted's writing as "fanfiction," a valid literacy practice in the context of the multiliteracies framework (New London Group, 1996). Fanfiction is described as the *raiding* of mass culture by fans who use media texts as the starting point for their own writing (Jenkins, 1992). In most cases, the fans of a particular television show or movie will write and post online elaborate stories involving

their favorite characters. For example, one Harry Potter fanfiction site boasts over 65,000 individual stories, posted by fans, about the character Harry Potter (Harry Potter Fanfiction, 2011). Although he did not post his stories to a larger online community, Ted's fanfiction was public writing that he was able to share with and receive feedback from our writing workshop group. Ted volunteered to read his Bryant stories out loud at every opportunity.

In their study of online fanfiction, Chandler-Olcott & Mahar (2003) became interested in how adolescents use various tools and draw on various discourses (including those from popular culture) in their literacies. Ted used both historical and current knowledge of basketball to craft stories involving his favorite player. In the following selection from his writing, we can see Ted weaving in his expert knowledge of basketball in the dialogue between Bryant and LeBron:

> LeBron: Yo, Kobe, teach me how to get that shot of yours down pat.
>
> Bryant: Hell no. You wack. You've been in the league for six years and don't have a ring yet.

Sports knowledge, a discourse that is typically privileged by students but marginalized by teachers within formal learning communities such as school or classroom contexts, was encouraged and ultimately increased Ted's engagement and achievement in the writing group.

In Ted's script, the conversation escalates into an argument in which LeBron threatens to "pop off" that is, physically hit Bryant. As the hero of the piece, Bryant defuses the argument before it becomes physical:

> Bryant: You serious? You really want to do this? Man, it's not worth it. Look, you know my game is nice and I was just kidding—you have potential.
>
> LeBron: Wow, that sounds good coming from you Kobe. I ain't gonna lie. Your game is nice.
>
> Bryant: So, no problem then. As a matter of fact—good game tomorrow.

In addition to showcasing his sports knowledge, we can see Ted exploring and imagining the moral aspects of Bryant's character. Through Ted's writing we get a sense of not only his sports knowledge, but also his value system. As Ted's main character, Bryant continuously makes

good decisions. When challenged by another participant in the work-shop to defend his choice to have Bryant end the argument, Ted ex-plained, "He's [Bryant's] a good guy. He's not going to mess around. Why should he?" (Field notes, February 24, 2011). Through his writing we can see how Ted believes a "good guy" should act in difficult situations. It can be argued that this type of moral story reflects knowledge of moral actions in the world.

Through crafting and sharing his fanfiction, Ted was able to share expert knowledge and world knowledge. In addition, Ted was able to craft an identity as a particular kind of loyal fan—a loyalty that was chal-lenged when Bryant was criticized in the news media for making homo-phobic remarks during a game. When asked in the same interview what he thought about Bryant's remarks, Ted replied,

> I mean, I guess he messed up. But that doesn't matter to me. People mess up and he was heated. You could see, he was wooo. And he didn't do anything that bad. I mean, even if he did, he'd still be my favorite. People mess up sometimes. You don't just give up on them for that. He's still Kobe (Interview, April 7, 2011).

This statement has particular importance for a court-involved youth involved in an ATDP program as Ted goes on to say, "Yeah, I messed up. I wouldn't be here if I didn't." (Interview, April 7, 2011). Perhaps through his loyalty to Bryant, Ted is echoing a type of forgiveness he desires for himself.

Ted's fierce loyalty to his character Kobe often caused sports debates within our group and propelled other male writers to author their own fanfiction stories. Following Ted's example, two other male participants, Melvin and Jared, both engaged in similar fanfiction writing. Creating space for dialogue and continued writing, fanfiction appeared to serve as "social glue" (Beach, 2000, p. 9) and sports writing developed as a sub-genre within our workshops. Melvin crafted a story around Derek Jeter and the Yankees. Jared crafted a dialogue between Michael Jordan and Jordan's father. In both additional cases, participant-writers were able to share knowledge about sports and world knowledge.

Two other writers chose to write about characters that played bas-ketball, although their characters were entirely fictional. Peter, the in-tern, and Jennifer each wrote about ideal high school male characters who were important parts of their high school basketball teams. In cre-

ating authentic dialogues and situations for their characters, at least a preliminary understanding of basketball was required. The fanfiction writers—Ted, Melvin, and Jared—took the lead in providing feedback and expert advice about the sport for our group. The following vignette, taken from field notes, depicts Ted and Jared's emerging roles as sports experts within our workshop community:

> Jennifer's romantic story involved a high school basketball player. During the writing activity, she whispered to Ted, asking for basketball knowledge—she wanted to know what position her star character should play? Ted, sitting next to her, could have quietly answered, but instead loudly repeated her question "what's the most important basketball position?" This sparked Jared to stop writing and respond. Ted answered Jared. After a few minutes of exchange between the three [Ted, Jared, and Jennifer] about different positions and importance, including where Ted and Jared liked to play, I told them all to get back to work [as this was a designated 'writing-only' time for our workshop and the conversation could and did continue when Jennifer shared her piece later in the workshop]. (Field notes, March 17, 2011).

Coming together as a writing community, workshop participants valued one another's knowledge and used our time together to work through ideas. In asking Ted his opinion on a basketball-related question, Jennifer highlighted his role within our group as an expert. From reluctant participant to workshop writer and sports expert, Ted's use of fanfiction allowed him to be repositioned within our group.

Ted was able to not only craft interesting stories, but he was able share his knowledge about the athlete, the sport, and ultimately his position as a sports fan. Beyond the choice of selecting what he perceived to be an interesting character, Ted chose to write about Bryant because he was a fan of the player. Melvin and Jared wrote about Jeter and Jordan for the same reason. For Melvin, being a fan of the Yankees was not only an identity he put forward in his writing, but it was an identity he wore often in clothing choices and a hat that, despite being worn every day, had a flat brim with all the new stickers purposely left on it to prove it was authentic Yankee gear. Melvin himself was an "authentic" Yankee fan, as he explained to our group that his dad and everyone in his family were Yankee fans.

Before ending this section, I would like draw attention to these young men's sports enthusiasm to highlight the tender age of this group. While

they were court-involved youth, they were also very much 12-, 13-, and 14-year-old boys who carried ideal notions of sports heroes. I offer this portrait of these young participants to contrast what Dohrn (1999) recognizes as a trend that has escalated in the last few decades: the criminalization of youth. Without negating that these youth have broken the law, it is also important to recognize and support their existing interests outside of the justice system. Likewise, it is equally important to provide avenues for narratives that portray the youthfulness of court-involved youth to be more publically accessible. The following section highlights the lives of these youth outside of the justices system as I explore how workshop participants chose to write about their own lived experiences.

Fictionalization of Self: Writing with the Self as a Character

Often in our writing workshops, students used their own personal narratives as starting points for their work, crafting and reshaping their personal narratives into fictional or creative pieces. Before beginning this section, I would like to reiterate that the sharing of personal narratives was in no way a requirement of our workshops. While not required, however, personal narratives were also not discouraged. Topics, such as family discord, illness, school suspensions, and loss of a loved one, that are often pushed out of school-based writing and conversations were given space within the Voices afterschool workshop. For many young people, their public and private worlds are inextricably connected. Workshop participants chose to document and share their own experiences. Jennifer wrote about visiting her great grandmother in the hospital; Ron wrote about an argument with his stepfather; Jared wrote about being suspended from school; and Patricia wrote about Voices. Hall (1973) argues that we are all authors of a continual autobiography and in discussing ourselves as characters we are selecting/highlighting aspects of ourselves for others to consider. Beyond spoken storytelling, writing provides a tool to produce formal, carefully structured displays in which the author, audience, and characters are given distance from each other. That is, written stories set up distance from self, distance from situation, and the potential to imagine different outcomes and pleasant futures. Engaged in what Scollon & Scollon (1997) term the "the fictionalization of the self," the following section explores participant-writers' works as they turned to their own lives for creative inspiration.

When writing about past experience, several participant writers made the decision to use third person. As authors they are themselves, as characters they are he or she. For example, Ron decided to write about his spring break from his uncle's point of view: "My nephew, had spring break recently and told me it was fifty good and fifty bad—but that's bull because he's always half sure and never fully decided on anything. He told me..." Although Ron is writing about himself and his own spring break, the main character is a different person. It is a decontextualized person. It is a person who exists in relationship to the text and the events told in it. In this way, there is an "essential distance of authorship from the text. This person bears a third person relationship to the author and this consistent maintenance of the point of view is one of the hallmarks of written text" (Scollon & Scollon, 1997, p. 70). For Ron, it was easier to critique his actions over spring break through the voice of his uncle.

Likewise, it was easier for Ron to receive feedback from the group as a third person character. In a different story, Ron outlined an argument between a character named Blinky and Blinky's stepfather:

> It was a very windy but warm and mellow day, when Blinky was on his way with his mother and stepfather (who he didn't get along with). BOOM! The axle disconnected itself from the other half. Good thing they weren't speeding. So, Blinky's mother had to catch the store and she didn't want kids with her and Blinky's stepfather had to stay with the car—so that he could wait for the tow truck. So, Blinky's mother left him with his stepfather. That was the wrong thing to do. Blinky wanted to play on the sidewalk and his stepfather said no, so when Blinky went to get out of the car—insisting that he was going to the sidewalk—POP. His stepfather smacked him right across Blinky's face. Blinky got back in the car and called his grandmother, Nana, who he hadn't seen in a while because of a confrontation between his mother and grandmother over his stepfather. When Nana asked what was the matter—Blinky paused. Then he said 'nothing, Nana.'

After volunteering to read the story out loud for the group, Ron immediately explained that it was a true story about himself and his own future stepfather. Once Ron explained this was a true story, he was given split feedback by the group. That is, feedback for the character Blinky as well as feedback for what course of action he should take in real life. The following is taken from field notes:

I was surprised when Ron admitted to the group that he *was* the character Blinky and that the story with his stepfather was real. I had a hunch this was the case because he kept slipping in "I" when he was reading out loud. Telling the group that it was a real story impacted their responses—they were more willing to engage and give advice. Jared suggested hitting him [the stepfather] back next time, Jennifer suggested telling his grandmother the truth, and Laura told him to just forget it—although, she thought that would make his story boring (Field notes, February 17, 2010).

Through his writing, Ron was able to make himself and his family relationships known to the group. While the advice Ron received from the group clearly ranges from what can be considered bad advice to good advice, ultimately we were able to discuss each suggestion and came to different courses of action for Ron and his character-self, Blinky. By interrogating the merit of different possible actions, as well as questioning the cause of the original argument, our workshop discussion enabled Ron to reflect, imagine, and receive advice with distance. Engaged in writing as a practice for the cultivation of self, Ron was able to see his own story from what Hadot (2010) argues is a higher level.

While Ron created distance from self through fictional characters, other participant-writers chose to write powerfully in the first person. While Scollon & Scollon (1997) suggest "that the first person becomes rather overpowering when the author has to recount details of suffering or pleasure," it also allows authors to question personal motives, actions, and decisions (p. 70). Several participants wrote first person pieces that directly questioned past actions while negotiating complex notions of good and bad. Melvin wrote the following lyrics to a rap song that he later performed for the group:

How do you know what side is the right side/ and which side is the wrong side? / Which side is the best side? / Wrong from right? / Feeling tight / Words on the page/ Moments of rage / As I write these deeds in bold / I'm feeling cold / Felt satisfaction / as I watched marijuana selling transactions / from fiction to fact / I know deep down this is wack / if it kills me then I'm living / if I choose to live / I have to be chillin' / what will I do?"

Similarly, in a longer piece written by Laura, she writes "Every time I turn around trouble slaps me right in the face. Then, the good side of me grabs me by my left ear and asks 'why am I letting the bad side of me pull me back?'" Laura continues to question herself and her motives

throughout the piece. In this way, we can see Melvin and Laura actively trying to understanding themselves, their past actions, and imagine how they might change in the future.

While Laura was reading her text out loud, it was overheard and praised by a Voices staff member. After the workshop this piece was photocopied and hung on the wall by the staff member. In the following weeks, Laura became known at Voices as "a writer." Foucault (1977) argues that in addition to an author fictionalizing himself as a character, he fictionalizes himself as an author as well. In this way, Laura was able to reposition her identity within Voices as a successful writer with important stories to tell.

In an interview, Jennifer expresses a similar self-repositioning as well as an outward attempt to make herself known within the group as good writer.

> Well, um. I like it. Usually. Like, it's, it's like, I like what I write. So I want to share it. But, you don't know if it's good and so, you just have to do it. And sometimes, I don't know what I was trying to say. But...but, I like when you print out my stuff. And hand it out. Cause, like then, I know it's alright. And, I always tell them it's me (Interview, March 22, 2011).

Not only does Jennifer self-identify as a writer, but she also publicly claimed pieces of writing handed out to the group anonymously. In this way, she is working to make herself known to the group as a successful writer—an identity she is coming to terms with herself.

Conclusion

"My favorite place is [Voices] because they are like a family to me. Every time I come they just lighten up my day. [Voices], to me, is a big family that likes to help children succeed in life and wants the best out of people. When I walk through the door, it is like everything is going to be okay. Soon, as I leave, it is like the whole world is against me."

—Patricia

Seeking to contribute to a small, but growing, collection of qualitative research that strives to understand how court-involved youth are making sense of, negotiating, and reflecting on their time within ATDPs, the above mini-case study invited youth into a writing workshop as a way to understand and document their experiences through their own words. Taking

up the invitation to write creatively through fanfiction, participant-writers were able to share knowledge about themselves and the world. Through the fictionalization of the self, that is writing with themselves as characters, participant-writers were able to make themselves known in specific ways to the group. Writing in this way also allowed for reflection on and interrogating of their own past actions through what I believe were honest attempts for participant-writers to understand themselves better. Through storytelling and creative writing, we worked to push beyond skill-based orientations and position writing in our workshops as a way for youth to make themselves known, to know themselves better, and to share and examine their understandings of the world.

In focusing on court-involved youth as writing workshop participants, my aim is not to add to the common narratives of failure, but rather, I hope to "focus on those who are identified as failures as an opportunity to see them heroically manage their culture, as actors facing facts and thereby to affirm their freedom from a world that may break them but never quite makes them" (Varenne & McDermott, 1998, p. xiv). ATDPs have emerged as places that can provide supports necessary for personal transformations. ATDPs offer opportunities and programs that allow youth to work towards understanding self, coming to terms with past actions, and imagining possible futures outside of the justice system.

Implications for teaching and curriculum extend beyond court-involved youth, as I believe positioning writing as a tool for self-cultivation in classroom learning would be similarly powerful, particularly for students who are disengaged with traditional school literacies. While writing for the cultivation of self should not replace skill-based activities, it encourages a creative engagement that not only has the potential to increase participation but also offers writers new ways to understand themselves, communicate that understanding, and interrogate their world knowledge. Particularly for marginalized students, such as the court-involved students in this research, the possibility for productive disruption of normative definitions of what it means to be literate is significant.

Notes

1 Status offenses are actions prohibited only to minors; that is, while an adult may perform these acts without penalty, for a young adult the same action holds significant consequences that may result in an arrest. An example of a status offense

would be the possession of a cell phone in school, during school hours. Often ambiguously defined, other status offenses include property offenses (defacing school property), disorderly conduct, breaking curfew and loitering, and liquor law violations (Sickmund et al., 1997).

2 Program name, as well as all participant names that appear in this paper, are pseudonyms.

3 The youth intern was a high-school-age participant from Voices' sister-organization for court-involved youth age 17–24. As part of his internship with our research team, he attended each workshop and fulfilled multiple roles as researcher, participant, mentor, and co-facilitator.

References

Anderson & MacCurdy (2000) *Writing and healing: Toward an informed practice.* Refiguring English Studies. Urbana, IL: National Council of Teachers of English.

Baynham, M. & Prinsloo, M. (2009). *The future of literacy studies.* New York: Palgrave MacMillan.

Beach, R. (2000). Using media ethnographies to study response to media as activity. In A. Watts Pailliotet & P. Mosenthal (Eds.), *Reconceptualizing literacy in the media age* (pp. 3–39). Stamford, CT: JAI Press.

Bell, J. (2000). Throwaway children: Conditions of confinement and incarceration. In V. Polakow (Ed.), *The public assault on America's children* (pp. 188–210). New York: Teachers College Press.

Center for Alternative Sentencing and Employment Services. CASES (2010). Retrieved March 18, 2010 from http://www.cases.org/.

Chandler-Olcott, K., & Mahar, D. (2003). Adolescents' anime-inspired "fanfictions:" An exploration of mutilieracies. *Journal of Adolescent & Adult Literacies. 46*(7), 556–566.

Dohrn, B. (1999). Justice for children: The second century. In G. H. McNamee (ed.), *A noble social experiment? The first 100 years of the Cook County Juvenile Court 1899–1999* (p. 98–102). Chicago: Chicago Bar Association.

Ferguson, A. A. (2000). *Bad boys: Public schools in the making of black masculinity.* Ann Arbor: University of Michigan Press.

Foucault, M. (1977). *Language, counter-memory, practice.* Ithaca, NY: Cornell University Press.

Foucault, M. (1997). *Ethics: Subjectivity and truth,* ed. Paul Rabinow. New York: The New Press.

Freire, P. (1997). *Pedagogy of the oppressed.* 20th Anniversary Edition. Trans. Myra Bergman Ramos. New York: Continuum Publishing.

Gee, J. P. (1996). Discourses and literacies. In *Social linguistics and literacies: Ideology in discourses* (pp. 122–148). 2nd Ed. London: Taylor & Francis.

Hadot, P. (2010). *Philosophy as a way of life,* ed. Arnold Davidson. Oxford: Blackwell.

Hall, D. (1973). *Writing Well.* Boston: Little, Brown.

Harry Potter FanFiction. Fanfic. (2011). Retrieved April 28 2011 from http://www. harrypotterfanfiction.com/.

Heath, S. B. (1983). *Ways with words: Language, life, and work in communities and classrooms.* Cambridge: Cambridge University Press.

Jenkins, H. (1992). *Textual poachers: Television fans and participatory culture.* New York: Routledge.

Juvenile Justice and Delinquency Prevention. JJDP. (2009). Retrieved on May 17, 2010 from http://www.ojjdp.ncjrs.gov/.

Ladson-Billings, G. (2001). America Still Eats Her Young. In W. Ayers, B. Dohrn, & R. Ayers (Eds.), *Zero tolerance: Resisting the drive for punishment in our schools* (pp. 77–85). New York: The New Press.

Lesko, N. (2001). *Act your age!: A cultural construction of adolescence.* New York: Routledge.

Moje, E. (2000). "To be part of the story": The literacy practices of gangsta adolescents. *Teachers College Record*, 102, 651–690.

New London Group. (1996). A pedagogy of multiliteracies: Designing social futures. *Harvard Educational Press Review*, 66(1), 60–92.

Scollon, R., & Scollon, S. (1997). *Narrative, literacy and face in the interethnic communication.* New Jersey: Ablex Publishing Co.

Sickmund, M., Snyder, H. N., & Poe-Yamagata, E. (1997). *Juvenile offenders and victims: 1997 update on violence, statistics summary.* Washington, DC: Office of Juvenile Justice and Delinquency Prevention.

Street, B. (1984). *Literacy in theory and practice.* New York: Cambridge University Press.

Varenne, H., & McDermott, R. (1998). *Successful failure: The school America builds.* Boulder, CO: Westview Press.

Chapter 3

Video Production and Multimodal Play

Melanie Hibbert

Introduction

A black television with a large CRT monitor sits on a dusty cart by a window in a white cinder block classroom. Seven teenagers, all involved in an after-school program, sit in chairs in the back of the room, giggling and teasing each other. The teens wait in anticipation to watch an improvised horror movie they created that same afternoon. Once the RCA cables are hooked up to the camera, and the digital videotape has been rewound, an adult supervisor flicks off the overhead fluorescent lights. I press "play" on the camera.

My involvement with Voices, an after-school program that operates as an alternative-to-detention program (ATDP), has spanned almost two years. Throughout this time period, I have collaborated with Voices participants ages 11-16 in media workshops, whose focus has ranged from mixed media collages to digital photography to video production to web design. In these after-school spaces—free from school constraints such as grades, strict discipline codes, and mandated standardized testing—we have experimented with various technologies including flip cams,[1] audio recording devices, digital cameras, as well as "lo-tech" instruments such as our voices, pen, and paper for storytelling workshops. I facilitate workshops at Voices but I am also a participant-observer, a graduate student who has been conducting ethnographic research as part of a larger, multi-year inquiry into arts, media, and justice.

Due to the transient nature of Voices participants, implementing long-term curricula or projects has proven to be impractical. Each individual adolescent operates on his or her own timeline in accordance with judicial order and input from the program staff, and while some are involved with Voices for months, others are transferred to other pro-

grams, become remanded back into police custody, start internships arranged through Voices, or have fluctuating attendance based on school and family obligations. In response, I, along with project colleagues, have developed short-term workshops that last 60 to 90 minutes and often include short tutorials at the start on how to use various digital media tools. The rest of the activity is "self-contained" although potentially related to a larger project, such as digitally mapping the surrounding neighborhood of Voices.

I have found that the short videos created during these "self-contained" workshops—particularly videos that result from play and improvisation, featuring sketchily produced storylines or interactions with people on the outside streets—have often succeeded in garnering enthusiastic participation, meeting programmatic outcomes, and engaging youth in making media. The video production process includes multiple points of entry into the activity for participants—some prefer to be in front of the camera, others want to direct, while others like to operate the media equipment. It is a collaborative production model wherein roles are fluid; sometimes the actors direct and the camera operators decide to act or the director listens to the audio. This chapter focuses on a vignette of one of these improvisational filmmaking sessions, where a horror movie is created during one rainy Thursday afternoon. It emerges from ethnographic data collected as part of the larger project, including participant observation, field notes and artifact analysis. This case study is considered through the theoretical lens of multimodality, which posits that all communication involves multiple modes such as audio, visual, spatial, linguistic, gestural, etc. (Kress, 2010). Furthermore, analysis is guided by the concept of multimodal play (Vasudevan, DeJaynes, & Schmier, 2010), which provides educators and researchers a way to think about shifting, malleable spaces that allow for humor, experimentation, and production.

Theoretical Framework

Multimodality has a semiotic lineage, drawing upon the semiotic work of Saussure (1983) and the linguist Halliday (1985), particularly the latter's discussion of metafunctions such as field, tenor, and mode; its core ideas relate to expanding and unpacking understandings of literacy and communication. The approach of multimodality posits that in most so-

cial contexts, communication involves multiple modes (Kress, 2010). Kress defines a mode as a socially shaped or culturally given semiotic resource for meaning-making (which can include design and layout as well as image, gesture, etc). Multimodality brings into consideration how different forms of communication work together. Texts are not just products of language recorded but also convey meanings through other modes. It is relevant to point out, however, that language itself is multi-modal, encompassing gesture, tone, words, etc. As Jewitt (2005) notes, even printed texts require the interpretation and design of visual space, color, font or style, and other modes of representation and communication. For this analysis, a multimodal lens helps me make sense of the various design choices, visual compositions, and bodily movements the participants enacted during this short production.

In the context of education, scholars have argued that there is an increasing need for learners to understand reading and writing in multiple modes even though the primary discourse of school is verbocentric (Cope & Kalantzis, 2000). Creating digital artifacts that incorporate words, images, sounds, movement, and other modalities offer expanded possibilities for communication that best expresses a particular message for a given audience, purpose, and context (Cope & Kalantzis, 2000). Hull and Nelson's (2005) multimodal analysis and ethnographic work that grew out of their involvement with DUSTY (Digital Underground Story-telling for Youth) describes how adolescents are able to convey their messages and stories (such as biographies, family histories, or current events) through multimedia and multimodal channels of communication (image, music, sound, video, words, etc). Case studies by Miller (2007) and Ranker (2008) also offer support that multimedia production among students is an engaging literacy practice wherein students become active designers and composers of meaning. Proficiency in multi-modal compositions better equips students for an increasingly digital and multimodal world where such literacy practices are expected and valued (Sheppard, 2010).

Related to the idea of multimodality is multimodal play (Vasudevan, DeJaynes, & Schmier, 2010), which focuses on the ways in which youth compose multimodal texts—a process that is often messy, improvisational, and playful. The notion of multimodal play is particularly relevant in the "messy" context of an after-school program, where structured ele-

ments of school—such as curriculum, assessment, 50-minute blocks of time, and clear student/teacher boundaries—are less present. In our after-school space, a sense of play using a range of creative tools makes new kinds of exploration possible. Vasudevan, DeJaynes, & Schmier (2010) suggest that "through multimodal play—including textual explorations, reconfigured teaching and learning relationships, and the performance of new roles and identities with and through new media technologies and media texts—educators are better able to make pedagogical connections with adolescents' evolving literacies" (p. 7). The concept of multimodal play also places merit on activities that may be perceived as "goofing off" or trivial; in this framework, these modes of performance and exploration are valued as an aspect of developing adolescent literacies.

Context

Alternative-to-detention programs (ATDPs) are positioned as spaces to rehabilitate youth who have been involved in the criminal justice system, a substitution for removing adolescents from their families and communities and sending them to juvenile detention centers. Young people involved in the juvenile justice system often suffer future consequences such as unemployment, discrimination, interrupted access to education, and an increased likelihood of re-arrests. There are also significant economic costs related to incarceration, with corrections expenditures rising to over $50 billion annually. Recognizing the economic and social costs of incarceration, there has been increasing support for ATDPs, which have the goal of rehabilitating rather than criminalizing youth who have been arrested. ATDPs like Voices attempt to disrupt the cycle of incarceration by providing services such as workshops, internships, and mentorships, without removing youth from their families, communities, and schools.

Voices has two locations in New York City, serving youth ages 11-16 who have been arrested. The adolescents who attend are court-appointed to this program, which they attend after school. Voices activities include arts workshops, field trips, discussion and guidance sessions, guest speakers, assistance with homework, and other creative and artistic programming. Participants are enrolled in Voices anywhere from a few weeks to several months, depending on their individual

cases. These are young people who live in different boroughs of New York City, including neighborhoods such as Harlem in Manhattan, Bedford–Stuyvesant in Brooklyn, and the South Bronx. Voices has a dedicated staff, many of whom openly share the hardships they've faced personally and that participants potentially relate to such as teen homelessness and incarceration.

The Voices site from which the data slice in this chapter emerges is part of a larger community space. At this center, the staff members have a separate office, and most of the Voices participants are involved in discussions, workshops, or "hanging out" in two classrooms, which have windows, high ceilings, and white cinderblock walls. Because Voices is a court-mandated after-school program, students are required to check in after school; they are usually at the site from approximately 4:30 p.m. until 7 p.m. four days a week. Later in the afternoon (around 6 p.m. or 6:30), participants are often able to use the gym at the community center.

The participants at this site are youth who have been arrested in the borough where Voices is located. While their court records are not the focus of the overarching project, the offenses of these participants are primarily misdemeanors (i.e., shoplifting, vandalism). The number of Voices participants in attendance at the program at any one time fluctuates; sometimes it can be as low as one participant, and there have been times when it has climbed past 16. This afterschool program offers a safe place for participants to discuss things happening in their lives; it allows for physical activities such as pickup basketball games; it provides snacks in aluminum bowls; it provides workshops that allow participants to try different roles, ranging from storytellers to actors to videographers. In the extended data slice that follows, I offer a protracted look at one afternoon of activity at Voices when youth participated in a videography project. Throughout the duration of this project, the participants were engaged in various types of multimodal play which I describe and discuss in further detail below.

An Afternoon of Horror Video Production

On a rainy Thursday in February 2012, I entered Voices at approximately 4:45 in the afternoon, walking into the entrance carrying video camera equipment. The walls in the entrance were covered with

vibrant black and white photographs, mostly portraits, featuring people on street corners, in swimming pools, at basketball courts, etc. There was a large floor-to-ceiling mural on one wall, with red and yellow shapes painted including faces, fish, leaves, triangles, and arrows. Black text in the painting—written in both English and Spanish—encouraged values such as mindfulness, love, and friendship.

The equipment I brought with me included a Panasonic DVX100, a "prosumer" camera that at one point was cutting edge although was not commonly used by videographers in 2012 (especially because it shoots to digital video tape, not to standard digital or compact flash cards). I also had a Sennheiser shotgun microphone, digital video tapes, headphones, and flip cams. Based on experiences from past workshops, I have often found that the level of "professionalism" of equipment is a powerful affordance for how youth interact with these tools. For example, when using flip cams—a relatively inexpensive, light-weight, pocket-sized video recorder—participants are more likely to casually toss them to another participant, carry them to "dirty" places such as a bathroom, and play with them by twirling the attachment cords around their wrists. As one might expect, participants handle more professional equipment in a different way; this professionalism may be signified by the size (such as a bulkier, heavier camera), the amount of equipment (such as tripods and tripod plates, microphones and headphones), and a higher lens quality, which the user can immediately identify in the camera viewfinder. It should be noted that my own role as a facilitator also influenced their treatment of the equipment; I know I am more "reverent" around better equipment, and prefaced our workshops using Canon 5Ds and Panasonic DVXs by explaining that they are "high-end" and expensive brands, and thus cautioned the participants to be careful. While "messing around" with digital media technologies can be a form of entertainment or socializing, it can also be considered a pathway to job skills and entry into the creative class; this is particularly relevant for less privileged youth who do not have the same social and cultural capital as privileged youth (Ito, 2010). In past interactions with Voices participants, I have observed that teens will occasionally ask about becoming professional photographers or videographers, inquiring into how much it pays, and so on; these questions almost only ever arose when they were using professional-grade equipment.

After entering the community building, I stopped by the staff office, a small space filled with two desks and filing cabinets, where the door cannot fully swing open. I checked in with one of the staff members, talking for a few minutes about the possibility of an upcoming storytelling workshop. Then I headed towards one of the Voices-designated classrooms where participants were sitting at a table, eating snacks and helping a staff member with his scratch-off lottery tickets. This staff member, who easily establishes positive rapport with Voices participants, joked that if one of the participants scratched off a winning lottery ticket he would let them do anything. "I'd be like, it's cool, you didn't make curfew at 9, I don't mind," making everyone laugh. More participants entered into the space as we talked and joked about various topics such as mozzarella string cheese, marshmallow fluff, Chuck E. Cheese, and upcoming plans for the February break from school.

My workshop partner Ahram arrived, and we introduced ourselves to the group and explained two options for the day: we could watch a movie or create a horror movie. There was an interest in producing a video. One participant, Jill,[2] immediately said she wanted to be a videographer; Greg said that he did not want to be on camera at all and also wanted to be a cameraperson. Aaron did not want to participate— "naaaahh" was his response as he left the room. Isaac said, "I want to be Denzel Washington," creating laughter among the kids, indicating he wanted to be the star. Tasha also claimed her production role by asserting she wanted to be "like Barbie," signifying she also wanted to be on camera. The field notes below illustrate the messy, yet playful nature of our brainstorming session:

> The comings and goings of participants was a little distracting, and created a somewhat chaotic atmosphere. Ahram and I tried to facilitate a brainstorming session about what type of horror movie we could create—what type of plot would make sense. Jill mentioned that we could do something like Silent Hill. Ahram and I said we hadn't seen it, and Jill said incredulously, "y'all never seen Silent Hill?!?!" Ahram then looked up the plot summary on her phone and described it to the group. It seemed that ideas and consensus wasn't really gelling as a group, so Ahram and I decided we should just go ahead and start filming. This is something I noticed in previous sessions with video production— brainstorming, preproduction, etc. never really seems to generate that much interest. Getting up, moving around, and improvising always seems to work well—pedagogy of play[!] (field notes, 2.16.2012).

Hence, I instructed Jill in basic camera skills, such as turning on, turning off, how to record and pause recording, and how to zoom, leaving the exposure and white balance settings set to Automatic. Then, we went into the hallway, and began filming a horror film.

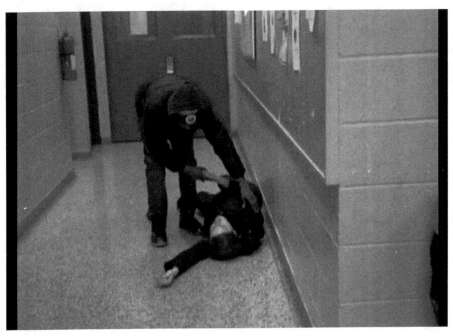

Figure 3.1. Zooming In on the Laughter and Horror
In this screenshot, Isaac discovers me as a body in the hallway.

The video began with an improvised scene, where Isaac ("Denzel Washington") entered through the red doors, and discovered the body on the ground (me). Isaac then performed a dramatic reaction, including shaking, grabbing, and finally yelling, "Someone call an ambulance!" We had to recreate this scene several times due to unsuppressed laughter from the actors and production team—primarily, me, Isaac, and the two participants operating the cameras.

It is noteworthy that the main videographer, Jill, walked towards Isaac and me and zoomed the camera in closer as the action intensified. It is striking that her reaction to more drama was to create a "tighter" frame: a camera shot that has less open space, and is more focused on the faces of the characters. In contrast, Jill framed a wider shot when

Isaac entered through the red doors, so the viewer could fully see both actors on the screen as well as the hallway in which the action takes place. However, when Isaac discovered the dead body and dramatically shouted for help, Jill walked closer to the action occurring and zoomed in the camera angle to focus on Isaac's face to better capture his emotional reaction.

It is arguable that from watching videos and television shows, Jill already had a "camera literacy" which she applied when shooting this video. Without instructions or previous experience, she chose various visual compositions when shooting this video to varying effects. Her camerawork is one example of multimodal composition, where angle and composition are modes for meaning-making. Additionally, while this was not a serious production with clear directives, storyboard, or even a basic script, Jill took on the role of director during the filming. This was demonstrated by the direction "cut!" which she said a few times to indicate that the action should halt, as well as her instructions to Greg (the second cameraperson) to move aside when he walked into her camera frame.

This small data slice is an example of multimodal play; it is experimental and messy, filled with humor. Filming this scene was a low-stakes, trial and error process where participants were able to experiment as actors (Isaac) and directors (Jill). The experimentation was "light-weight"—improvising dialogue, trying different filming scenarios, testing a variety of camera angles—as well as social, as the participants interacted with each other (directing and following), even though it is unlikely they are part of the same friendship groups outside of Voices. In this after-school space removed from high-stakes testing, failing grades, and highly structured time, the participants are able to playfully engage with technology tools and the processes of video production. Although multimodal play and "messing around" may not lead to polished results, it can offer a productive space for youth to explore their creative interests as well as form social bonds with both peers and adults (Vasudevan, DeJaynes, & Schmier, 2010; Ito, 2010).

After filming in the hallway, we walked upstairs to the gym, where a lively gymnastics workshop with elementary school students was occurring. After watching the tumbling activities for a few minutes, we filmed scenes of Isaac discovering the dead body of Darius, which the group

found entertaining; similar to the first scene, there were several takes because one or both kept laughing. Much of the humor derived from Isaac's performances of discovering the "dead" Darius, where he would dramatically begin screaming "OH MY GOD!!!! HELP!" while fervently shaking Darius; these scenes often dissolved into fits of laughter.

Figure 3.2. Switching Roles
Isaac and Darius take turns at the frightening discovery.

Directing and negotiating amongst themselves, Isaac and Darius decided to do a scene where they switched roles to see if it would be easier if Darius discovered a dead Isaac. The participants filmed two versions of the reversed scene, which also deteriorated by their inability to keep straight faces; so they decided to revert to the original scenario. The two participants shared authority in these role decisions. After Darius laughed a few times while playing the dead body, leading to retakes, Isaac said, "come on man!" and suggested that he would play the role of the dead body. Darius agreed, although after Isaac reprised the role of the corpse, he also realized he could not help cracking a smile, Darius asserted, "See?? It's hard!" Isaac agreed, and then wordlessly, without any discussion, the original acting roles were reinstated.

This is another instance where the participants were able to experiment through trial-and-error with their various roles in a space and con-

text of low-stakes, where a scene can "fail" yet be repeated and revised, through switching characters, changing dialogue, and modifying body language. This experimentation emerged in the moment with changes negotiated amongst the participants without any adult input. This is also a space that is collaborative, where multiple participants were able to voice their comments and opinions without fear of retribution. The amount of laughter speaks to the factor of "play" in this activity. It is possible that this type of multimodal play, one that is trial and error with low stakes, has particular relevance to this population who are in a program allowing for a sort of "re-take" based on their arrests.

Figure 3.3. Backup Tools
Greg films the action with this cell phone camera.

During one scene (featured in the screenshot above), Isaac walked around the corner in a way that was humorous, performing for the camera and his peers. He sashayed his hips in a very exaggerated manner, swinging his arms at his sides. He only walked for a few seconds, before he laughed and turned around to begin the scene again. This moment highlights the ways that adolescents can find different ways to participate within media production; some prefer being behind the camera (such as Jill, who was filming), while others prefer to be in front of the camera (such as Isaac, clearly relishing the role as performer and enter-

tainer). Even acting demonstrates the different expressions one can make with the body as a modality (i.e., laying dead on the floor versus dancing in a humorous way). Thus, production itself is multimodal: it requires audio and visual compositions, as well as bodily movements and posturing. In this scene, multiples modes were used for playful interaction and meaning-making, including gesture, movement, audio, and visual approaches.

This screenshot above marks an interesting moment during filming, because the second videographer, Greg, had been using the smaller, palm-sized flip cam while Jill used the larger, more robust Panasonic DVX100. During the course of filming, the flip cam ran out of batteries and the backup batteries were in the downstairs classroom. However, Greg remedied this technical difficulty by taking out his cell phone and using its video camera capabilities as a second camera (in the above image, he is on the far left; he managed to get in the frame for a few seconds). Greg improvised by using an everyday technology (his cell phone) as a backup camera, a moment which draws attention to the near ubiquity of handheld digital tools in the lives of youth and the prevalence of photography and video recording literacies. When analyzing the affordances of various tools, Greg seemed in some way to equate the flip camera with his cell phone, as the tools are similar regarding mobility, the ability to conduct camerawork in a single hand, viewfinder size, and video resolution. One wonders if Greg (or Jill) would have made the same decision if the Panasonic camera ran out of batteries; would she or he have reached for a cell phone?

Greg's role as a second cameraperson was not clearly defined; he was operating under the title "second camera," although no one gave him any directives (unless he walked into Jill's camera frame, in which case she told him to move to the side). Throughout this workshop, he mostly stood to the side of Jill while she was filming, although in one of the climactic scenes he walked up closer to Isaac to get more close-up shots, an action taken up by his own initiative. A more shy and reserved participant, it seemed that Greg felt more comfortable taking up the role of second cameraperson, which does not carry the same weight as first camera/director (even in a low-stakes context). This role allowed him more flexibility and the ability to experiment, such as using his cell phone to record scenes when the flip cam ran out of battery

power or walking up more closely to the actors when he wanted to re-cord closer shots. Greg's participation is an example of how video pro-duction has multiple entry points, allowing for many different kinds of participation, as both performers (such as Isaac) as well as recorders (such as Greg).

Earlier in the classroom, while we brainstormed ideas, Greg had used his cell phone to play games. This highlights the versatility and af-fordances of mobile devices, and their potential for various uses. (It is relevant to mention that cell phones are mostly banned in New York City public school classrooms, making them a tool not usually recognized for educational participation). Unfortunately I was not able to see Greg after this workshop for a second time, but I would have asked him how often he uses his cell phone to shoot video, and what he did with this video after he recorded these scenes at Voices (such as post online, upload onto a computer, delete the next day, etc). Using the camera on a cell phone to record video or take photographs is one form of multimodal literacy; it constitutes lo-fi, digital media production that has the poten-tial for sharing and publication through a myriad of networks (uploading to Facebook, Flickr, YouTube; forwarding to other mobile users, etc.). In ethnographic research on camera phone practices, Okabe (2004) de-scribes camera phone usage patterns as falling under categories such as personal visual archiving (a visual diary); visual notetaking (such as tak-ing a photo of a posted flyer for future reference); intimate sharing (sharing very selective content with just a handful of people); and peer-to-peer sharing (sharing more noteworthy events). I would have been curious to know how Greg's cell phone video would be categorized, and how frequently he uses his cell phone's video functions (daily? weekly? monthly?). Did he decide to share this video through his peer networks? If this video was not deleted soon after this workshop, did it serve as some type of reminder of his role as a cameraperson during an informal video project? Or did it simply become part of a personal visual archive, which Okabe (2005) considers a "resource for personal identity con-struction" (p. 8).

The following screenshot captures a staged confrontation between Isaac (the body discoverer) and Tasha, an unfamiliar girl he meets in the hallway. The dialogue (as with everything else) was improvised. This improvisation has become part of the pedagogy of these multimedia

workshops (along with having them exist as self-contained activities rather as part of a larger unit); pre-planning, especially for video, usually did not generate much interest among participants. I found that getting up, moving around, and actually doing video work was much more successful than discussing ideas, storyboarding, and scripting out potential video work. The workshop elements of improvisation and movement relate to multimodal play, because they allow experimentation with the equipment in a low-stakes, social environment while using tools that involve audio, visual, and kinetic elements. In contrast, the verbo-centric activities of scripting and storyboarding too often involve static work with paper and pencils while sitting at a table; this can often feel "like school," to the dismay of participants.

Figure 3.4. Improvised Acting
Isaac and Tasha confront each other.

Tasha and Isaac's improvised conflict quickly became a back and forth loop of one requesting to see some form of identification from the other: "Let me see your ID. No, let me see *your* ID. I need to see YOUR ID!" It was striking that this quickly became the locus of their conflict, not "Who are you?" or "What are you doing here?" This is likely a reflection of their

school and community lives, where being surveilled and asked for identi-
fication is a common occurrence. Many of the participants talked regularly
about metal detectors and the constant presence of safety officers in their
schools and police in their neighborhoods. In the scene, neither was will-
ing to show the other an ID, and the two continued their back-and-forth
confrontation until Jill said (taking up the role of a director), "cut!" There
was laughter among the participants, and agreement that the scene had
essentially reached a stalemate between the two actors.

In this scene, it appears that the participants took up an everyday oc-
currence and fictionalized it in a playful mode; this was a low-risk space to
recreate and play with the idea of surveillance, questioning the validity of
asking for one's identification. Arguably, the participants are protesting a
power dynamic they encounter in their daily lives in a lighthearted man-
ner; both actors refused to show identification, asking why, and turning
the question back to the questioner. It is possible that both Isaac and Ta-
sha felt disrespected when asked for identification in their daily lives, con-
sidering this act an infringement on their privacy or surmising that they
are targeted based on age or appearance. Rather than demonstrating an-
ger, however, this topic is taken up and improvised in an informal, un-
structured space. This is salient considering these youth are involved in
the juvenile justice system, and this after-school program opens up an op-
portunity for them to question surveillance practices in a playful manner.

For the final scene, we brainstormed on the spot how it should end,
because we had not mapped out a clear story arc or really any type of
narrative beforehand. We decided the scary movie should end with a
twist. Maybe *Isaac*—the one who had been discovering bodies—should
be the killer. It was decided that Isaac would then "kill" Tasha, and we
discussed what the cause of death should be. The participants favored
stabbing, but upon realizing that would require props we did not have
(such as a knife and fake blood), we decided a fake choking would be the
better method. The final scene involved an exaggerated and dramatic
"murder," again involving several takes due to laughter on behalf of the
participants.

After we completed shooting the final scene, Ahram and I arranged
to have a screening in one of the white cinderblock classrooms. There is
something powerful about instantly watching what you have created;
one of the benefits of digital video production is the ability to have in-

stant feedback, to see immediately what you have produced. We all wanted to watch the video, as we had not paused to watch playbacks of any of the scenes. I especially wanted to have a screening considering the likelihood I would not see some of these kids again—as well as the unlikelihood that all of these participants would be together at the same time.

We asked one of the staff members if there was a TV available. He said he was not sure, but he would check. He took the elevator to one of the top floors, and later emerged with a large TV (a CRT model) on a dusty black cart; it was a tight squeeze to fit both him and the TV in the small elevator car, and then there was a moment when we were not sure if the cart would fit through the classroom doorway. (With a few turns and shoves, we managed to push it through). I went to the staff office to ask a staff member if she had any RCA cables. She responded that she wasn't sure what that was, but rifled through her filing cabinet drawer, pulling out a DVD player with several cords and cables. I identified the cable with yellow, red, and white plugs, thanked her, and brought it to the television and hooked up the video camera.

In the classroom, the participants all sat close to each other in one corner, either sitting on a table or in desks, even though the physical space did not dictate that they all sit in one spot. I wondered if the act of production, with its necessity for collaboration, negotiation, and support, had created a sense of rapport and affinity among the group, as a sense of community does not always exist among Voices participants. I rewound the digital videotape and made some audio adjustments on the television. The staff member who brought the television flicked off the lights. "Yo, next time we need to have popcorn," Isaac joked. We then watched the unedited video, outtakes and all. Laughter ensued, especially during the outtakes and scenes where the actors could not help but laugh. At the end of the screening, two participants in particular (Jill and Darius) mentioned that they had fun, and asked if we would be back next week to continue creating videos.

Conclusion

This day of filmmaking demonstrates how multimodal play can help students develop their "semiotic toolkits" (Siegel, 1995) through the production of meanings across multiple forms of communication, such as

video, audio, gesture, posture, etc. In contrast with the narrow, print-based definitions of literacies found in schools, digital multimodal production offers various orientations and methods of production. As Kress writes, institutions can benefit from the insight that humans may have different orientations to modes and ensembles of modes (2010, p. 15). This data slice illustrates how digital video production can offer multiple points of entry for various participants to become engaged in an activity; for instance, Isaac clearly wanted to be like "Denzel Washington" and feature as the star, while Greg chose to have a more behind-the-scenes role as a second cameraperson. Particularly for youth at Voices, who face court involvement and are in conversation with caseworkers about the kinds of people they are becoming, the space to negotiate their identities in a playful form is particularly powerful.

Additionally, this improvised pedagogy and filmmaking process offers support for unstructured, informal, and student-driven learning spaces, which can exist in schools although they more readily occur in informal learning environments such as after-school programs. The improvisational nature of these learning spaces is beneficial to youth because it invites participation and engagement. When there is less structure and less prescription, opportunities arise for creativity and contributions that are valuable yet can't be planned.

Through multimodal play, youth can try out different ideas, embody various roles, and fictionalize everyday realities. This capacity to enact various positions and play within a fluid context offers an opportunity for participants to potentially discover a pathway (such as acting, videography, storytelling, etc.) that resonates with them. Creative experimentation in social, collaborative, peer contexts has the possibility to spark further interests and potentially lead to more serious or professional work as well possibly shaping the ways in which youth identify themselves and construct their self-narratives.

Notes

1 Flip cameras (or flip cams) are pocket-sized, handheld cameras that record digital video; their production was discontinued in 2011 due to the increasing prevalence of mobile phones with high-quality video recording capabilities.

2 All names of participants and program are pseudonyms.

References

Cope, B., & Kalantzis, M. (Eds.) (2000). *Multiliteracies*. New York: Routledge.

Hull, G., & Nelson, M. E. (2005). Locating the semiotic power of multimodality. *Written Communication, 22*(2), 224–261.

Ito, M. (2010). *Hanging out, messing around, geeking out*. Cambridge: MIT Press.

Jewitt, C. (2005). Multimodality, "reading" and "writing" for the 21st century. *Discourse: Studies in the Cultural Politics of Education, 26*(3), 315–332.

Kress, G. (2010). *Multimodality*. New York: Routledge.

Miller, S. (2007). English teacher learning for new times: Digital video composing as multimodal literacy practice. *English Education, 40*(1), 91–83.

Okabe, D. (2004). Emergent social practices, situations and relations through everyday camera phone use. Paper presented at International Conference on Mobile Communication, Seoul, Korea.

Ranker, J. (2008). Composing across multiple media: A case study of digital video production in a fifth grade classroom. *Written Communication, 25*(2), 196–234.

Sheppard, J. (2010). Developing multimodal literacy: The role of collaboration and constraints in the design of new media assignments. *Journal of Literacy and Technology, 11*(1), 43–55.

Siegel, M. (1995). More than words: The generative power of transmediation for learning. *Canadian Journal of Education, 20*(4), 455–475.

Vasudevan, L., DeJaynes, T., & Schmier, S. (2010). Multimodal pedagogies: Playing, teaching and learning with adolescents' digital literacies. In D. E. Alvermann (Ed.), *Adolescents' online literacies: Connecting classrooms, digital media, and popular culture* (pp. 5–22). New York, NY: Peter Lang Publishing, Inc.

Chapter 4

A Memorable Walk

The Negotiation of Identities and Participation through Evolving Space

Ahram Park

"So you *like* working with criminals?" Natalie, a participant at Voices, cocked her head and gestured to the room with her chin as she awaited our answer. I was momentarily taken aback. It was our first day in the Reimagining Futures Project, and my co-facilitator, Melanie Hibbert and I had just finished introducing ourselves to the participants. Natalie's question was not something that I envisioned answering, and placed me in a space that was unfamiliar to me. Prior to my involvement with Reimagining Futures, I had largely spent my time with students who were involved with arts education programs offered by museums and in school-based math and writing workshops. My main research and pedagogical interest at the time centered on the use of social media as a tool for exploring social issues, promoting social actions, and engaging in dialogue. Voices was a new space, not only because all of the participants were somehow court-involved, but also because Melanie and I were working to facilitate a media production workshop that would engage youth as collaborators, not only as students or subjects of research.

I explained to Natalie and to the two remaining participants that I define "criminals" as pedophiles, rapists, or murderers who prey on the innocent, and that I do not see them, the young people at Voices, as criminals. When I asked how they defined criminals, Natalie told us that she agreed with my definition, but maybe there were other definitions as well—specifically, the legal ones that precipitated her participation in the Voices program. Natalie then quickly added that she knew people who committed the crimes that I mentioned, and that they lived in her neighborhood. The other female participant, Hannah, nodded and agreed that she too knew someone in her neighborhood who had com-

mitted violent crimes. As the three participants looked at us cautiously, Melanie and I assured them that our focus at the workshop was not on the reasons that brought them to Voices, but that we, instead, wanted to work on collaborative projects with them using digital video and still cameras. Our goal was to nurture a learning space where youth could explore the ideas of community, storytelling, and identities through the use of multimodal media tools.

As it was our first day, Melanie and I had planned to spend most of the workshop time giving participants an introduction to media production and time for experimentation with cameras. After we gave a still camera to each of the participants, all five of us walked outside. As we walked around the neighborhood in which the program was situated, the participants took pictures of everything that they found interesting. The objects of their focus ranged from street signs and cars to murals and alleyways. Their discussion explored how changing the lighting in the image of an alleyway also changed the interpretation of that photo. Melanie and I both agreed that the day went well, as the participants were enthusiastic and engaged with the media project. But while coming home, I kept going back to Natalie's question about criminals and the way that she labeled herself and her fellow participants using that term. I recalled recent media coverage that told stories of youth who were arrested after throwing a shopping cart off a parking garage and of those fighting with police officers after they were allegedly caught jumping a turnstile at a train station.[1] What remained in my mind were the scathing comments by anonymous bloggers who crucified the teens with their words, scolding them for their stupidity and urging lawmakers for their just punishment. Both Melanie and I agreed that, to us, the youth at Voices, in contrast to the blogosphere's imagery, seemed like any other adolescents we knew trying to navigate the difficulty of being a teenager; Natalie seemed like any other vibrant young woman with different sections of her hair fashionably dyed with bright red streaks, who also enjoyed writing essays about her grandmother and family stories.

But it was clear the questions of identity and labeling were always in the participants' minds. As we were planning our future projects with the participants, Melanie and I agreed that we could not ignore why the youth were at Voices, but figuring out why or how they came to Voices in the first place should also not dominate our discussion. The first project

Melanie and I decided to implement with the youth was the Community Walk. The objectives of the project were to do the following: 1) provide a space for youth to become more familiar with the neighborhood; 2) explore storytelling through digital media; 3) connect spaces and selves; and 4) nurture shareable moments between youth and the community. We were not just interested in whether participants could complete a media project by making a short film, but instead, we wanted to nurture more organic ways of cultivating their identities by exploring how these different modes could also provide a space for authorship and engagement (Jenkins, 2006).

Using a play-and-learn approach, we gave each youth a still camera and took them out around the five-block radius of Voices and asked them to, "Take pictures of whatever stands out to you." It was a chance for them to explore the community and themselves through a different lens and to engage in storytelling through the use of media tools. Through this project, the youth became photographers, historians, and directors who were trying to capture the essence of the neighborhood around Voices. As Hobbs (1998) reflects, the use of digital cameras, videos and audio recorders were not only for the purposes of producing and analyzing media for the sake of teaching media literacy, but to cultivate and reflect on the exploration process itself. The youths' way of using different angles, lighting, and effects impacted how they wanted to showcase their images. Although lesson activities can be planned in a rigorous structured manner, I soon learned that given the rolling attendance at workshops, facilitators at Voices have to be flexible and adaptive to different situations depending on the unique circumstances of each day. By having a flexible planning approach, we were also able to work with both familiar and new youth who participated in our activity at a later date.

Through our community walk, I began to see interesting patterns emerging. Without encouragement or directions the youth began sharing their photos instantly as they walked down the street. Their animated conversation only slowed as they tried to take a picture of the same object, but by using a different angle, effect, magnification, or distance. From playing with the buttons on the camera and twisting the knobs to zooming in on a mural and to changing the color mode to blue,

the participants began discovering how variance of settings could dramatically change the details of an object. While the participants were unearthing the different modes of expression, what struck me was how their conversation with us also flowed naturally as they shared personal narratives. The engaged and participatory nature of the afternoon walk led me to question: What kind of learning environment and relationships are cultivated through movement, informal dialogue, and/or informal space? If learning has different forms of entry, I was specifically interested in using this momentum to continue our group's discussion on identity and community engagement.

In the Field: A Close-up Look at the Community Walk

The following field note excerpt provides additional contextualization of these community walks, which became a common practice in our media production workshops.

One warm and sunny autumn afternoon, Melanie and I walk to Voices, admiring the gorgeous weather. Our topic for today's project is to, "Take a picture of anything that stands out to you." We walk into the building and head to a room where we find youth slumped in their chairs. The room is quiet, cool, and dark. There are twelve youth participating in our workshop today. All the youth are around 12 to 14 years old. Except for four girls, the rest are boys and a couple youth are new to our workshop. We go around and introduce ourselves to the new youth, and quickly explain today's project... youth raise their brows and shoot each other confused looks. Melanie and I elaborate, "It's such nice weather, we'll be going outside today. We're giving each of you a camera, and want you to take a picture of anything that stands out to you. For example, if you could take one snapshot to tell someone: 'This is what this neighborhood is about...' what would it be?" They extend their hands as we pass out cameras and we all trudge out the door.

As soon as we step outside, we are surrounded by the noises of "little clicks" as they take pictures of one another and everything around them. Along with clicks of the camera, their excited voices mingle harmoniously in the air. After taking a photo, they share their image with each other, and momentary silences arise only so that they can take the picture of the same object, but through a different angle, effect, and magnification. As one male participant changes the color mode, the others begin to change the camera angles and play with the zoom key. At times they take a photo of the same mural through different effects. Their voices increase and are infused with enthusiasm as they compare one photo after another. Drawn to their flurried activity, some people passing by ask about our activity. We briefly explain our Community Walk Project. Some smile and continue walking to their destination, while others pose for the camera.

As Melanie leads the group at the front of the line, I stay back making sure we don't lose anyone. I feel like a mother duck looking after my little ducklings. As the youth go around taking pictures, girls who rarely spoke with us begin showing me photos and sharing personal narratives, in particular, a 13-year-old female participant named Lina. I met Lina some time before, but we had never really had a sustained conversation before this day. As we walked, Lina pulled me over to show me a photo that she took from a restaurant window. As I comment on how delicious a chicken looks, Lina smiles as she describes how it tastes. She goes on to explain how various cultures prepare this chicken dish differently. Lina does not mention specific cultures,[2] but she tells me the different preparation techniques and various spices and herbs used in different recipes. Lina and two other female youth recommend that I try the chicken from this particular restaurant maybe even for dinner. I explain that I'm trying to become a vegetarian and have been slowly cutting out meat, poultry, and fish. After many comments and questions, one girl looks at me and jokes, "Without meat, there is nothing to eat!" We laugh and our conversation leads us to talking about good foods that we've eaten and sharing some of our favorite experiences at New York City Street Fairs. It also involves us sharing our stories about our families and our own cultures.

To have this kind of personal conversation with Lina, in particular, was a unique experience. It was a surprise for me, because this was Lina, the same participant who never spoke more than five words to me in the weeks prior to our community walk. Now Lina was sharing her personal stories, not only about herself, but also family stories about her grandmother and sister, while continuously taking photos of objects that stood out to her. For Lina, this walk had become a comfortable and informal time and place where, through her questions and conversation, she identified me as not just a researcher or a facilitator, but also as a participant who shared similar values on the importance of family and culture, while reflecting on those whose support deeply impacts upon our lives.

It was just not Lina who invited me into her world. Many of the boys began to let down their tough exterior and interact not only with Melanie and me, but also with one another and people on the street. While taking the photos, the participants began noting not just the interesting murals and stores that defined the neighborhood, but also, the community members who helped shape and cultivate its identity and presence. The field notes below show how the boys began using this project as a way to interact with members of the community and me.

We quicken our step when we notice that some of the boys in the middle of the line have stopped while crossing the street to show each other pictures from their cameras. Fearing for their safety, we nudge them to move along and remind them to stand on the sidewalk if they are going to stop. The pictures in the camera vary from neighborhood murals to street signs to fruits from a nearby grocery store to people who live in the neighborhood. A couple of youth stick to a theme, and one boy in particular, Micah, takes pictures of senior citizens. At times, Micah stops to ask questions about their lives. When Micah shows us the photos that he has taken, I am speechless. His shots are so poignant. The close-up portraits are highly biographical images where Micah's muses seem as if they are getting ready to share stories about themselves, which, in many cases, they did. The focus on themes seems to resonate with the type of stories that these participants' would like to present of the neighborhood.

Prior to this project, I knew Micah as a funny young man who liked to tell jokes and entertain us with stories of his school life and his neighborhood. During the community walk, he made visible a serious side that I had not seen before. His focus on using portraits as a way of capturing the neighborhood was also highlighted by his interviews with his "subjects." When asking some of the elders he encountered about their past and their history in the neighborhood, Micah responded by relating their life stories to his own; through shared storytelling, he was identifying with these neighborhood senior citizens. At one point, while talking to one elderly man, he recalled his family history and his connection to his own neighborhood. From my vantage point several feet away, I could hear Micah discussing where he was from, the reason he was involved in this community walk project, and other details relevant to his interests.

During our walks, including the community walk, I began to see a pattern of this casual and playful dialogue emerge. When the youth shared photos and engaged me with their personal stories, it gave me the opportunity to build rapport with them. Not only were they sharing their personal narratives, but Melanie and I were also sharing our own personal stories—of childhood, families, and traditions—as well. As we joined the youth with our own recollections, we moved toward developing a trusting learning community, a space inclusive of diverse life experiences.

The Meaning Making

The community walk also contributed to rendering the familiar strange and the strange familiar, for both researchers and our youth participants (Witherell & Noddings, 1991). As researchers, we began to observe how participants began using cameras as a mode for their communication, while the participants were using the camera to look at their surroundings in a new light. The neighborhood changed from a site where Voices was located to a home environment with multiple cultures and heritage. Yvotte, a 14-year-old female participant, commented during one of our walks that using the digital equipment compelled her to pay attention and document the neighborhood and made her focus on particular objects and even sounds that she would normally ignore. At that moment, a blimp passed over our heads and we both stopped walking and looked up. Yvotte and I shared with each other that as little girls each of us had dreamed of riding a blimp as a way of pretending that we could fly, and often looked for other unique objects that captured our imaginations. We both wondered if there were other little girls out there who were also fascinated by blimps and mused about the age that we stop observing and imagining. Yvotte became philosophical as she pondered, "Maybe once you are older, you're too busy with everything else going with your life...that sometimes, especially in a city like New York...you forget little things and just..." and she gestured with her hand. The walk became a lens though which Yvotte considered her surroundings and where her imagination soared. The playful nature of the walk helped Yvotte, Melanie, and me to think more creatively about how we could use this media production workshop to engage other participants in storytelling and craft lasting experiences with the project and the community through group projects (e.g., community food and event description blog).

The community walk provided us with great dialogue and bonding moments, some of which were lost when we returned to Voices. Below is a field note excerpt that describes the conclusion of one of our walks and the dramatic shift that took place as our time exploring the neighborhood came to a close.

> As we head back to Voices, based on their conversation and enthusiasm during the walk, I'm excited about the discussion that may take place. I momentarily imagine the youth sharing their photos with one another and telling us a little bit

about their experience and the meaning behind it. My fantasy soon bursts when
we get back in to the room and there is complete silence. Even when prodded with
open-ended questions, the youth answer in almost monosyllables. Even after we
have them pick one photo to share with the group and recall comments that the
participants shared during the walk, their responses remain brief. Their most
lively action is a shrug of their shoulders. Their comments to each other's photos
are brief and often monosyllabic. It is torturous for us as facilitators not to be able
to reignite their creative and imaginative energies in the space of the classroom
at Voices. As Melanie and I head home, we cannot fathom what has happened.

The magic of sharing and the process of exploration were lost as
their conversation, animated and overlapping just minutes before, be-
came almost nonexistent. The silence made me wonder if I had taken the
same group of youth back to Voices with me. This sudden shift caused
me to examine further our situation, roles, and environment in an at-
tempt to make sense of what was happening in that moment when the
youth entered the room at Voices and the dialogue was lost. How does
movement or embodiment play a role in participation? What are the
connections between space, personal identities and social roles? How
are learning, relationships and roles transferred from informal to formal
space? It seemed that there were subtle elements that were generating
the silence, thus it was important to begin to examine how each variable
might have had an impact on the dramatic change from outside to inside.
At the same time, I continued to wonder about what we as a group could
do to create a more engaging space that would transfer across bounda-
ries regardless of external distractions.

The Road to Evolving Space

I re-examined the ideological and physical space of Voices and began to
ponder how it may have contributed to the silence, exploring how move-
ment and space foster or hinder dialogue. In "Being Across Homes," Hu-
bard (2011) teases out the notion of identities and social roles that are
shaped by our environment. Through interviews, Hubard's participants
reveal that they adapt and negotiate their identities and interaction as
they move from one culture to another—mostly due to social norms and
expectations. Although our Voices participants were not traveling from
New York City to Mexico, the participants were interchanging their roles
as they interacted within various spaces. From the time when the par-
ticipants were walking down the street to when they were sitting in the

classroom, they seemed to redefine their identities and negotiate different social roles to adapt to the various spaces at Voices.

The rooms at Voices are spare and sparsely adorned. The multiuse room, where we were meeting, often served as a makeshift classroom, half-table desks folded and leaning against the wall were often rearranged to host a teacher-directed learning space or circled up for game play, discussion group, or workshops. Sitting in a circle as we do in our media workshops offers its own limitations. The circle, designed to facilitate active sharing and collaboration, has its own social constraints. This format focuses everyone's eyes on the speaker, which creates a high level of social pressure, and is likely evocative of the young people's schooling experiences. It reminds me of being in school; beginning in kindergarten, no matter how casual the environment, even when we sat in circles, we were always taught to listen quietly to the person talking, to speak loudly, and to raise our hands if we wanted to participate. I wondered if the youth visualized and identified this room at Voices as just another form of a classroom—a space where formality and structure are valued, and where quiet behavior and thoughtful speech are important. Even Micah and Lina, who were both open to sharing information and even igniting conversations about the images amongst other participants, fell quiet in the room. Although they held the cameras in their hands with the picture lighting up the LCD screen, both stayed silent when it was their turn to discuss their photos.

I had seen this space enlivened in the past. On our exuberant Game Nights, when we all sat in a similar circle in this very room and played different board games, the situation felt different. One afternoon, we played Taboo. There were seven youth in the room. Two females and five males, and four Voices staff members. Barry, who was trying to describe the word on his card, looked at the Voices staff members in the room and me and apologized, "Excuse me for a moment for the next word that I'll use." Barry turned back to his teammates, "This is the term to describe a white person." "Cracker!" immediately yelled out his teammates. All the participants burst out laughing. I could not help but laugh as well. This is the fastest that they'd gotten the correct answer. The two Voices staff members were not amused, and admonished Barry. They told him that the use of the word and descriptions like that are not appropriate, not only at Voices but elsewhere, as well. Barry pointed out

that he apologized beforehand. The staff admonished him, saying that his knowledge that the word was inappropriate made it more unacceptable. As the staff members turned to look at the other participants to talk to them as well about language use, the youth shifted in their chairs and became quiet. Barry's point is taken away for the use of the term.

Although Voices encouraged an open space, which welcomed youth's experiences and creativity, the struggle to balance shared communal knowledge with traditional forms of teaching and learning dominated some of the experiences within this space. For instance, in another Game Night at Voices, we were in the room playing Scrabble. There were nine youth in the room: one female and eight males, and Beth, a Voices staff member. As a group of five boys sat on the side, the three remaining boys, the girl, Beth, and I were playing Scrabble. Eric put down a "Y" making his word "*Yah.*" Beth told Eric that "*Yah*" was not a word. Immediately the whole room yelled, "*Yah*[3] it is!" Beth thought for a moment before telling the group to use English words that we normally use. The boys made a case that "*Yah*" is used on the street and amongst themselves on a daily basis. Beth clarified that it should be proper words that can be found in a dictionary. Not slang. Eric chose another letter from his stash, formed another word on the board and the game continued.

While adhering to the unspoken norms established by the staff members at Voices out of respect and an understanding of our position as workshop facilitators, Melanie and I also strove to cultivate our own space with participants, one where creative thinking, social learning, and inquiry-based workshops were nurtured. However in this negotiated space, there was also a balance between encouraging youth's knowledge and perspectives and providing them with understanding of the world beyond their immediate scope of experiences. Although the participants were encouraged to reflect and build their own meanings of activities such as community walks or Game Nights, it was also important to draw upon the insights of Voices staff members as well as to respect the organization's values.

These playful Game Nights in the often "silent classroom" described above became an entry point for youth to engage in conversations not just with me but also with each other. Our other Game Night experiences have afforded a space where boys shared stories about their mothers or provided a glimpse into their interests. We were confused to see the

community environment where stories and laughter were shared generate such silence. Could the evolving space where the room becomes a health education classroom, dialogue workshop site and a recreational space have had a role in the silence? If so, how does space impact learning and relationships? It led me to wonder if the participants were also negotiating their identity to fit in with the social context of the room. Maybe sitting in a circle in this room reminded them too much of being at school where they were focused on a class and where they were being graded on their participation and response. Thus, perhaps they were less engaged because they were not sure *how* they should respond. In the next two sections, I continue to explore these questions as they shaped my practice as a Reimagining Futures facilitator at Voices.

Negotiating Teacher-Researcher Identity Across Space

Along with pedagogical questions about how spaces are cultivated and sustained, I also questioned how I carried my positionality back into the Voices space. My contemplation of how the youth presented their several different selves across different spaces brought me to ask: Could I also be unconsciously changing my roles? Could the participants be tuning in to my behavior? Do I also walk around the neighborhood as a participant and switch to become a researcher or a facilitator when sitting in the rooms at Voices? The space of our community walks offered powerful opportunities for participation and engagement, because being out in the neighborhood provided a common ground for understanding and acceptance. Through peer-to-peer learning, participants acquired new knowledge and refined their existing skills in an innovative manner. As an engaged ethnographer, perhaps I was involved in more informal or peer-like learning during the walk, while unwittingly switching to the role of a researcher and facilitator in the room, thus, perhaps unintentionally encouraged the silence. And this unconscious change in my role may have transferred to the participants, creating a more formal space similar to that of a classroom at school.

Different modes of entry into an activity or workshop like ours can cultivate a participatory culture, which can better foster creative expression and contribution by all participants (Jenkins, 2006). However, there are occasionally barriers to this approach that may stem from a variety of factors including habituated roles such as teacher and student or fa-

miliarity with physical contexts such as classrooms, to name two. In the conclusion to this chapter, I explore further the questions that continue to linger about how to foster greater participation amongst all participants—including youth, facilitators, and program staff—in order to promote creativity, civic engagement, and identity development.

Conclusion

By asking participants to, "Take a picture of anything that stands out to you," Melanie and I invited youth to call upon their creative and observational resources. It was our way of providing a space for artistic expression and for storytelling through digital media. For some participants, this invitation led to more serious reflection and awareness of their surroundings as they met and questioned people in the community and investigated historical artifacts and cultural events that defined the neighborhood. Within this space, participants opened up to one another and to us by sharing stories and looking at commonalities of their own neighborhoods. As one youth shared his neighborhood's "go green initiative" of planting flowers on every block, other participants chimed in and shared that their neighborhoods also had similar green projects initiated by the members of the community.

Through my involvement in these multiple spaces, I was able to witness the ways that the community walk project provided a space for youth to reclaim their identities outside of the boundaries of the word "criminals," and instead as siblings, neighbors, photographers, directors, and cultural arbiters. And through the use of caring dialogue, we aimed to create a safe space where all opinions and contributions were valued by an audience. Although I strongly believe that the informal space of movement—in this case, the community walk—and the social affordances of media tools catalyzed a space to share a dialogue and nurture learning moments in an organic manner, I still question the following:

- How can I use my role as a participant, researcher, and ethnographer to encourage youth to connect and engage in both formal and informal spaces?
- Can caring dialogue create an impact regardless of programmatic time constraints?
- How is multimodal storytelling reflected through participation?

The learning opportunities such as the moments described above can be fostered through multimodal storytelling, dialogue, and creative expression; however, it is important for me as an educator to establish the kind of space where participants can be creative and be valued for bringing their own knowledge to the group—where multimodal storytelling can be practiced. One way is by embracing the affordances of media tools. The use of cameras was an organic way for participants to engage in socialization and storytelling. From Natalie to Yvotte to Micah to Lina and many others, youth used the experience to discover the environment around Voices, uncover and relate to multiple perspectives around the community, and take up a whole set of complex and nuanced identities. As I continue this work, I seek to continue exploring the value of pedagogical spaces where youth can make themselves known and be known more deeply, dream, and share, often with a camera in hand.

Notes

1 During this semester, there was much mainstream media coverage and footage uploaded on newspaper and video-sharing websites that depicted local urban teens in general as uncivilized, uncouth youth. As some of the stories as mentioned above became sensationalized and discussed for months, I wondered how the comments and the labels were impacting the teens and their families.

2 During my conversation with Lina, I was too caught up with listening to her stories to ask her follow-up questions about which culture and how she has come across these recipes. After the community walk, there were other points in our conversation where I wish I could've asked more questions, but some of the topics (e.g., family) felt too personal to approach during this new "bonding" time.

3 *Yah* is slang, used to express agreement.

References

Hobbs, R. (1998). 7 great debates in the media literacy movement. *Journal of Communication, 48*(1): 16–32.

Hubard, O. (2011). Being across homes. *Teachers College Record, 113*(10).

Jenkins, H. (with Clinton, K., Purushotma, R., Robison, A., and Weigel, M). (2006). Confronting the challenges of participatory culture: Media education for the 21st century. The John D. and Catherine T. MacArthur Foundation.

Witherell, C, & Noddings, N. (1991). Prologue: An invitation to our readers. In *Stories lives tell: Narrative and dialogue in education* (pp. 1–12). New York: Teachers College Record.

Chapter 5

Fear, Innocence, Community, and Traditions

Eric Fernandez

In my essay I will touch on themes of fear, community, and innocence. In recent years (as early as age 17) a heartfelt passion for providing mentorship and advocacy to youth awakened in me. My involvement in "work with youth" comes from a direct, hands-on approach of *learning from experience*. In the words of citizens of inner-city, urban communities, "I'm street smart." This is a statement I stand behind, with confidence. The skills of observation, reflection, creative writing, and developmental dialogue have given me the ability to employ practical approaches in my work with youth, including in my current role as a Youth Advocate. Now, years after I first began to think about advocacy for youth and after working in the field, I have recently become a student in school—and not only a student of my life experiences—learning more about the fields of Youth Services, Psychology, Economics, Sociology, Criminology, Criminal Justice, Child Education, and more. This is only the beginning, as I'm moving forward, evolving and becoming a better mentor and educator with and for youth.

Following a general framing about urban youth and the stories and challenges that follow them throughout their lives, I will provide two examples from my own life about the impact of arts and storytelling in bringing about transformative thinking. The first example comes from my experience as a member of a theater program and the second draws on my experiences as an ethnographer and youth advocate.

Stories of Youth

Within inner-city communities, I consistently sense a confined fear that youth encounter throughout their lives; it is often expressed in unproductive and aggressive ways. The populations of youth who are born

into inner-city communities due to family financial limitations too often become distracted by pools of emotions and abnormal thought processes, which subconsciously extend from an act of confusion. This distraction causes cloudiness as youth seek redirection in their lives. The cloudiness overcomes youths' ability to advocate for support systems that enable their progression. The following excerpt from my field notes at Voices demonstrates this observation:

> Sam has an interesting family background. He's in foster care (ever since a very young age). Reason? His parents were involved in drug distribution, which caused him being taken away and put into the Foster Care system. His foster-mother passed away recently, and he doesn't know his birth-mother. *The thing that struck me the most, and is still with me is how initially he said that his "mother" died...he clarified that he's talking about his Foster-Mother. All the while his biological mother is still alive.* [...] He has limited communication with his birth-father, who has made attempts to rejoin Sam's life, but Sam doesn't want that, being that he has gone throughout his life "without knowing him." That's something that may never change, I think, given the attitude and tone in Sam's voice. Sam stated preferring to confide in friends over family, for advice. I didn't question his responses much, given his situation...
>
> It's interesting how there's a tendency where adolescents either have a disliking of, or simply not having strong relationships with their siblings [...] Their reasoning is something to pay attention to...
>
> Today my main focus was to try to get a clear perspective on where participants stand with having a Father Role in their lives. I didn't expect these responses, but I appreciate [the thoughts] they shared. It still shocks me that I'm able to tap into these touchy subjects, and they say to me specifically "I really don't mind talking about it." Even after I stress to them that I'm not forcing onto them.
>
> (E. Fernandez) Field notes, 10.26.2011, Reimagining Futures Research Blog

My field notes offer just one example of the "tricky" conversations with youth that have been so revealing about how youth make sense of their experiences. We all—in one form or another—fear the unexpected. This fear either makes us or breaks us. For a lot of youth this fear extends into abnormal behaviors, which disallow appropriate ways to support progression and sometimes lead to involvement in the juvenile justice system. The abnormality of the choices that youth in inner-city communities come to make becomes thought of as the norm. Unfamiliar with the light that lives amongst urban communities, youth too often feed into a dark vulnerability that enables them to fall victim to their un-

clear actions. Most of the time, youth aren't provided with appropriate supportive resources that allow interventions for redirection and self-development.

In my experience working with at-risk youth in the Child Welfare system—ranging from Alternative to Detention Programs (ATDPs) to Foster Care—youth are taught to be over reliant on the people in their lives, which can be counter-productive. Youth often lack sufficient knowledge of the skills associated with communication and independence. Youth within urban communities are not always capable of communicating what their needs are, which results in their allowing others to do for them. This is counter-intuitive to the possibility of success in the lives of youth.

The unfamiliarity of having a steady support system—it can be direct family or a committed and dedicated adult figure—causes subconscious inappropriate behaviors, the kind that cause youth to become involved with family courts. It's becoming clear to me that youth use selfishness for survival, as well as a cry for attention. Again, the lack of communicative skills allows a build-up of stress and negative thoughts, which result in *acting out* and committing aggressive stunts as a way of filling the gaps in their lives.

I strongly believe the familiar adage that what children see, they are bound to follow. I have learned this is a way of life for youth, especially those who feel "disadvantaged." This, to me, says that youth are always looking for validation as to what's right or wrong. Once a youth gets a sense that something is "okay," it's difficult for them to unlearn what is *their norm*. However, it's not impossible.

Often youth find themselves questioning whether this is how life is meant to be. All that comes about are questions, and unfortunately the youth has no connection with someone who can intervene and challenge this entrenched way of thinking. As it happens with all of us, the youth grows into a world where they prefer to "stick with" what they know, to hold onto familiarity amid much uncertainty.

Fortunately enough, sometimes youth are allowed the chance to try new things and even hear positive reinforcements for their experimentation with new ideas. Youth may become acquainted with—either by teaching themselves or being taught by someone else—different ways to express themselves and tell their stories. This is where art is used in

powerful ways. In some form or another, we all use art as an extension of what we feel inside. This can be singing, writing, dancing, video producing, etc. As one who works directly with youth and as someone who has experienced the transformative power of art-making, I believe that art is essential to youth development, and is already important to younger generations.

As a facilitator who develops and implements ways to engage youth in expressing their stories—through my teaching practices, as well as personally—I have used arts and digital media to promote sharing and learning. Offering youth the role of authors allows them to embrace their capabilities as leaders. Through my work, I'm honored to be able to see that for some youth sharing their stories and learning different modes of expression allows them momentary respite from or re-seeing of the dark moments in their lives. For others, a natural talent is at last revealed. During these encounters of storytelling, youth are reminded of how they can extend their unfamiliarity into a positive expressive mode. Multiple modes of expression are fine ways of allowing youth to acknowledge for themselves the endless possibilities that can be made available to them.

This is what happened for me. I was offered development and a re-introduction to multiple modes of expression, artistic and creative tools which I continue to engage in, cherish, and pass along to the youth I work with. At one point in my life, I used my writing to create rap lyrics, which I performed live by creating remixes to music of already established industry musicians such as Lil Wayne (Hip-Hop/Rap) and Ne-Yo (R&B). I then transitioned to essay writing as a participant of Journeys.[1] This program emphasizes youths' and young adults' skills and abilities through the development of independent living skills—focusing on exploring life essentials such as educational socialization, employment experience, and self development. The program offers individuals the chance to experience people who feel for their situations, and see to it that they're given the appropriate amount of attention that's needed.

Performing in the Theater Initiative

At Journeys, I participated in a pilot theater program called Theater Initiative. This program allowed me the chance to engage in multiple roles throughout its existence: participant, actor, research assistant (a role for which I kept field notes about the second cycle of the Theater Initiative),

and program staff (Director's Assistant.) The Theater Initiative was home to relationships, emotions, and realism. A space that began with barriers of insecurities led to program participants (myself included) engaging in practices of enacting different life experiences through story. At the end of the first cycle, the final product resulted in a crafted artifact, a play, that was created in the span of four months and performed for crowds of over 200 across three nights of performances. Audience members ranged from participants' families and friends, Journeys staff, and others, as public performances were staged at a mainstream Broadway theater, as well as in college and high school settings in New York City.

The Theater Initiative ran for two consecutive cycles between 2008 and 2009. During the first two cycles as an actor/program participant I worked with other young actors approximately aged 17–22, engaged in traditional acting activities such as auditions, improvisation, and rehearsals. The uniqueness of this project was the collaborative development of the plays. Actor and playwright Todd Pate documented the live improvisations and transcribed the live acting into an excellent script. The development process allowed the program participants therapeutic reflections on past and then-current life experiences. After being given prompts by the Program Director, Dan Stageman, the actors, without initially being asked, incorporated their life experiences into their improvisations of character roles. Many of these improvised characters that were born out of rehearsals moved on to become the actual characters in both plays, which were developed as a result of the theater program—*Bird's Eye View* (July 2008) and *Brazil* (December 2008). As personal connections developed with the actors and their characters, the members of the project began to build personal connections with the happenings throughout the project and even began to trust one another.

> Trust is the number one key to success, and in the past two days the participants have learned to use that key to become better actors. ...There was alot mentioned [by the facilitators] about how the participants got to talk about things they desired and how [that] turned out to being an emotional period. With that being stated we now know that the participants have built a certain amount of trust and respect for each other.
>
> (E. Fernandez) Field notes, 10.16.2008, Theater Initiative Research Blog

As the scenes developed, actors were asked to incorporate or create a distinct quality for the characters. During the development of *Bird's Eye View,* one other participant and I, as poetic rappers, performed some of our lyrics during rehearsal, which stayed with our characters. Discussions and debates were developed by the actors about the topics that came out of the improvs including one about the reality of how most musicians, especially in the Hip-Hop community, play different roles to the public. Often, that "role" is portrayed as being aggressive, when in reality most musicians are level-headed and down-to-earth individuals. These hip-hop debates were brought to life through our use of clay masks that were created for certain characters in the play. The masks allowed the actors to be distinctive when they were portraying a different characterization of their characters in different settings.

Each day brought unexpected outcomes; some days brought laughter, others brought tears. The emotional connection to what was being produced, in terms of a play, allowed us to acknowledge the reality that our stories were important and being told through the mode of theater presentation. This was a process within itself, which developed over time. At first there was skepticism, then confusion, then comfort, and lastly embracing the power of one's reality.

Becoming an Ethnographic Researcher
& Youth Advocate

As I noted above, prior to the second cycle of the Theater Initiative Project, I was offered and accepted the role of being an Ethnographic Research Assistant, where I was to document each session with field notes. This was an amazing opportunity; however I didn't completely understand what the position entailed in its entirety until later. My initial introduction to the new cycle of theater program participants was as the experienced program alumnus who could offer advice and tips. As I was no longer just "a participant," I believed that my role was to have the participants see me as staff, and to an extent, not their peer. I initiated this thought process by distancing myself from the participants and putting up boundaries. This distanced approach didn't work well, especially in developing positive relationships with young people. For this reason, I decided to change my approach to take on this new role.

As I was figuring myself out in this new role, I learned what it means to reflect and began developing reflective teaching and mentoring practices. I realized that the very thick wall of boundaries I kept around me kept me from developing personally under my new role. Through my experience negotiating this new role, I came to understand the tension young people often feel when introduced to something or someone new. Individuals often over-analyze one another or situations, which is understandable, but these self-protective walls don't allow for productive personal and community growth. The following excerpt from my field notes demonstrates the work I was doing:

> What a great session we had. I for one can personally state that I had a blast. I got a chance to be active on the stage, hurray for me. [...] I carry myself as a mentally and emotionally stable person and I almost shed an actual tear because of how emotion stricken that scene turned out. I pictured myself in that moment because of how I connected and was able to relate to that story. It touched me internally and had me thinking about how I haven't had that Father figure in my life, and the scene also allowed me to see sort of the same situation being acted out in front of my eyes. Just like Dan, I was amazed to see how we could actually have four characters on stage, and interact so greatly.
> (E. Fernandez) Field notes, 10.20.2008, Theater Initiative Research Blog

Later, after I learned and tried a more open approach, I still didn't allow the participants to over-step boundaries; however, I openly drew upon my own life experience and my history as an alumni theater participant. Making my experience more visible allowed me to build rapport with the participants and provided me the opportunity to engage more fully as an acting advisor as well as a Director's Assistant. This was the initiation of my developing a unique leadership and teaching style, which I carry with me to this day as a mentor to other young people. Approaching something new with an open mind and heart allows for more possibilities and smoother progress.

The Reimagining Futures (RF) research project focuses in part on studying the lived experiences of adolescents who have encountered the juvenile justice system and initially developed out of discussions, which included me, another Journeys alumnus, and Lalitha Vasudevan. The project grew with the addition of research assistants including Kristine Rodriguez Kerr, James Alford, Melanie Hibbert, Ahram Park, and three youth interns from Journeys' employment internship program. As a

group, we brainstormed, gathered and shaped ideas on how to approach this research. The research study initiated by "hanging out" at Voices, and, for me, transitioning into a person who practices open-mindedness and observes carefully. We "hung out" and eventually developed workshops with the young people, who were restlessly facing the possibility of juvenile detention while their cases were pending in Family Court. As part of my participation in the research team, I proposed and developed a Theater workshop at Voices. During the workshop, participants were asked to analyze the two scripts from the Theater Initiative and connect the story lines. The participants engaged with the challenging storyline of *Brazil*, in particular, although some expressed discomfort and silliness about the topic of addiction, reactions that I interpreted as immature. The following excerpt from Kristine's field notes highlights one such moment:

> At the end of the scene, the students were eager to explain that [the character that S (a Voices staff member) had portrayed] lied to Eric about his mother. There were some giggles about the phrase "crack head"—but Lyon, who had come into the room for the conversation quickly addressed the giggles saying that addiction is a serious thing in all families. During the conversation about how each character may have felt, students seemed better able to understand Eric's character.
> (K. Rodriguez Kerr) Field notes, 1.18.2011, Reimagining Futures Research Blog

Over the course of several sessions that followed this initial theater workshop, the youth learned that I was part of the script development process. One participant asked me about acting in the Theater Initiative; he wanted to know if I was as good an actor as Denzel Washington. I responded that maybe I could get to that level one day. These were the kinds of organic, innocent, and fun remarks that I reminisce about; I cherish these memories as I think back to the greatness of my experience at Voices. I strongly believe that we as people seek validation in the growth process and need attention and affirmation, even if it's as simple as someone taking the time to ask us to share how our day went. Youth especially need support by caring and trusted others. Youthful inexperience and exuberance should be embraced as opportunities for successful dialogue.

Therefore, as part my participation in the RF Project research team, I also proposed and developed a Critical Dialogue workshop at Voices.

The purpose of the Dialogue workshops was to allow the Voices participants to openly discuss what they, and I, felt was crucial and important to them. These raw discussions allowed the youth to express themselves and discuss the realities of their belief systems of how society views them and how they react to being looked down upon. As in-depth as the discussions became, I learned that the dialogue allowed an extended forum for therapeutic conversations. The dialogue workshop created the space for youth to come to peace with their mistakes and look forward to the future. The following is an excerpt from field notes:

> I had the opportunity to have an honest conversation with T [a Voices participant]. Although I partly interrupted her from completing homework, I was able to [catch a] ... glimpse of who she is as an individual. Close to the ending of the conversation I asked what made her put her life story on the table; she responded that the fact [that] I sat and actually listened allowed her to openly discuss what she felt. That warmed my heart; I really appreciate the fact that she feels this way. This falls in place with the mission of this project...to *allow adolescents to be heard.*
>
> [...]I questioned (out of curiosity) what she had written. T's response was so thorough, but brief: about her parents and how she was abused at a young age...
>
> As for her writing, she explained how a lot of her writing material is inspired by real events in her life. She has 6 start-up ideas (written) in the making, so far! ...from love, group influences, medical problems, sexual violence, etc. She said that she spends a lot of time reading, and whenever she has an idea she rushes to paper to note it down. As I said to her, she's "a writer at heart"... I left very excited and appreciative of this experience.
>
> (E. Fernandez) Field notes, 11.16.2011, Reimagining Futures Research Blog

My approach to the dialogue workshops, which I continue to implement in my current work, was to constantly ask questions of the participants' responses. Critical dialogue—conversation pertaining to the direct issues youth are currently experiencing—enables them to confront their realities, share and discuss their beliefs, as a way of questioning their assumptions. This approach to dialogue allowed both the participants and me—all whom may or may not already know each other—a clearer understanding of where each individual is coming from, which itself allowed greater group bonding. Through these discussions, participants connected with one another by verbally sharing their stories. For example, an ongoing concern amongst Voices participants was the nature of

how they felt perceived by others in the world. The following is an excerpt from one workshop, which followed an earlier conversation about stereotypes that was initiated by one of the program staff in response to the youths' concern:

> 8 participants… engaged the discussion: surrounding the thought and meaning of what a stereotype is. The participants [mildly] engaged in answering and retaining the message I planned to relay, which is to "not fit into the stereotypical beliefs of the media, news, and or their local settings."
>
> […] first response "young black people always get arrested"… said Sam. Lavelle responded "young black people in the trains, always act out," and then added "white people are scared of and always talk down on black people." Lavelle then shared a story of him sitting "next to a white lady in the train" and her calling him "ignorant, for no reason, I was talking to my friend next to me" and he followed by yelling at the woman. I then stopped him as he tried to detail more (to get attention and laughter), and I expressed how that's a perfect example of how one can fit into a "stereotype."
>
> (E. Fernandez) Field notes, 9.14.2011, Reimagining Futures Research Blog

A complete analysis of this workshop moment is outside of the scope of this essay, however it illustrates one of the many ways in which, through Critical Dialogue, I strive to allow youth to embrace topics of discussions that are often labeled "inappropriate." From my practice, these discussions—often considered "inappropriate" in schools and classrooms—are what inner-city youth yearn to engage in. These discussions that are immediately relevant to the lives of the youth provide a way of connecting the youths' emotion to their beliefs and issues. These kinds of discussions are a way to help youth develop alternatives and examine how their emotions too often control their reactions. I embrace their trains of thought and reactivity, and we thoroughly talk through how and why things happen. By being an attentive audience for youths' reflections, and by bringing in clarity and understanding, I embrace them and work to allow a re-introduction to youthful innocence.

Through the four years (and counting) of my involvement in the RF Project, I am honored to have experienced many strands of youth development that have been a part of the success of allowing youth to embrace their stories. Those core stands which have developed throughout this project are engagement with the arts through writing, media, and dialogue. Because of my study and observation of Journeys, as was well

my personal experience, I believe that arts and media should be utilized as a form of a therapeutic expressive mode that allows youth to take ownership of their actions. While not an answer to the juvenile justice system, arts and media exploration, if offered with genuine care and critical dialogue, can counter recidivism. The arts enable youth to confront and better understand their realities and build better futures. We all need the time and will to express ourselves. We must come together as a people and understand that everyone has his or her own story, which is entitled to be heard. I will always take this lesson with me as I engage in creating better lives for youth in inner-city communities.

Note

1 All names of programs and projects are pseudonyms.

Chapter 6

An Art Inquiry into a Young Photographer's Artworks

Mark Dzula

The work of art invites us all, as perpetual students, to explore the world, our experiences, and ourselves. This chapter interrogates the artwork of a young man named Juan who participated in a photography module that I co-taught with a staff member at Journeys, an alternative to incarceration program (ATIP) in New York City.[1]

Digital technology has made the production, storage, and transmission of images ever more affordable and more abundant. What was once called a flood of images encountered in the course of daily life has swollen into an enveloping tsunami. Online, we encounter a multiplicity of images of friends, family, and even ourselves—often whether we are looking for them or not. As photographer Jo Spence (1983) contends, domestic cameras and family photos work to create a received sense of ourselves in relation to the world. These "slides of life" inscribe and confirm our position in the world before we are ever in a position to challenge it (Spence, 1983). Not content to simply receive a sense of his relation to the world, Juan engages with "slides of life" most salient for him. As such, his photographic artwork raises questions of aesthetics, constructions of self, and formative justice.

Received domestic images *inscribe* insofar as they seemingly capture and mirror the familiar world exactly as it once existed in an irreproachable past. In pictures, our smiles, our gestures, and our relation to others in and around the frame are all rendered in minute detail, evinced by the luminous grain of the photographic image. These likenesses *confirm* insofar as they haunt us as implicit, undoubted evidence of a past reality. These indexical and veridical qualities of photography are perhaps its essential qualities; it is as if a photograph points to its subject and states, "That has been" (Barthes, 1980). Most often, we didn't take the old family photos that we are found in; they were taken of us. Once, they sat in

shoeboxes, albums, or quietly on shelves. The effects of domestic images are amplified as they live and multiply in light, online.

As Spence argues, photography's work of inscription and confirmation has effects on one's developing sense of self. Who are you? Who do you take yourself to be? Who do others accept you as? What might you aspire to become? These are all questions of formative justice, issues of human potential. As outlined in the case below, Juan faces significant challenges throughout his life, challenges that reflect these very issues. Often, the person he is taken to be by others is at odds not only with the ways he would like to be seen, but also with the ways he sees himself. Other times, his familial relationships, social standing, as well as his position in the structure of his family and culture puts him in substantial danger. Formative justice asks about the degree of intentionality one has in life, the choices and investments people make in order to become all that they can be (McClintock, 2012). Received notions of self, such as the limiting "that has been" of domestic photos, can lead to detrimental effects on formative justice, especially if they are not interrogated and challenged.

More affordable technology makes it possible for many people to work as cultural producers, not just consumers or recipients; tools like cameras that were once too expensive to use and maintain have become nearly ubiquitous on handheld digital devices like cell phones. Instead of simply receiving images, many people now have the increased technological capability to take, manipulate, and share their own pictures. In the case described below, Juan works hard to represent and discuss his family, neighborhood, and experience via digital images. As artifacts of an artistic process, Juan's photos become rich talking points that open up unforeseeable avenues of the pedagogical relationship that I develop with him. As artworks, Juan's visually striking photos offer viewers a very personal glimpse into his life. He frames his world and experience, speaking to what he finds significant in them. As a cultural producer, Juan crafts moving re-presentations for others to see and contemplate.

Before reading the case, please take a few moments to look at and attend to the following photographs culled from his series. Consider them as best as you can; consider the young artist's process as he looks around his neighborhood and investigates his life. Apart from any contextualization I might provide, ruminate on your thoughts about Juan's work, your reaction to it, and what you then make of it:

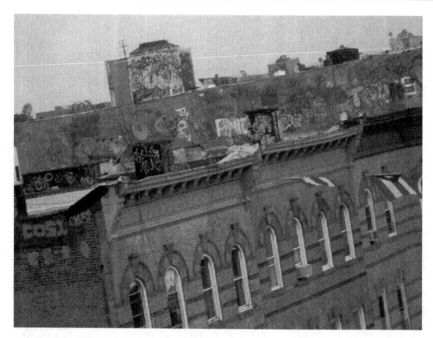

Figure 6.1. Photograph 1

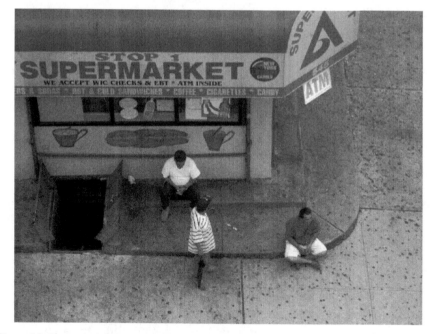

Figure 6.2. Photograph 2

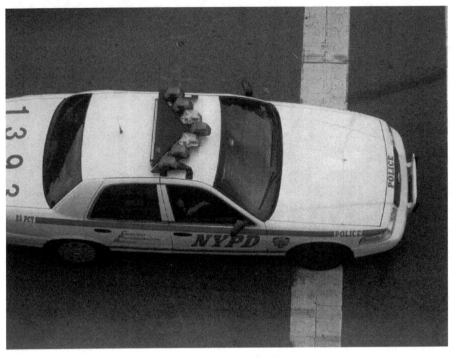

Figure 6.3. Photograph 3

Pedagogy and Course Design

The design of the photography module at Journeys was similar to other art courses I facilitate as an educator for cultural institutions and museums. This was a short-term, weekly program; we met for about an hour and a half in the afternoon on Wednesdays. I came from work at museums and Juan came from school. The course ran on a relatively slim timeline. We had about six weeks for the students to take their pictures, then select, edit, and prepare them for a culminating presentation in front of peers and other Journeys staff. These short-term projects are common at community centers and museums. In such a brief amount of time, it is essential to quickly create a clear sense of purpose and motivation for a brief period of intense work.

I am interested in nurturing student exploration and inquiry; I am not interested in explicating works for students, having them copy my masterly example, or having them follow my exacting directions. It is more important to set up situations that ask the students to engage in

exploration, reflect, then go back, revisit, and cultivate their initial work. What do they think of it? What do they make of it? Open-ended dialogue around the work of art and student process is integral to this pedagogic approach.

In this regard, I look to the method of universal teaching outlined by Jacques Rancière (1991) in *The Ignorant Schoolmaster: Five Lessons in Intellectual Emancipation*. According to his account, teachers have an opportunity to create educational situations that help to verify an equality of intelligence, that is, that all people, no matter who they are, have an equal potential to exercise intelligence, and don't need a master to lead them to an illusory sense of knowing. Instead of stultifying students and asserting power as a master explicator, an educator interested in promoting emancipatory educational practice interrogates students in the midst of their own inquiries and then verifies that their work is done with sufficient attention.

In pedagogical terms, an educator interested in this approach has no predetermined end to a student's engagement. An educator who values this pedagogic concept values multiple approaches and a multiplicity of results over one prescribed outcome. Granted, the final presentation at the end of our photography module was predetermined; the students would have to share something with the wider Journeys community. The tools we could salvage (i.e., cameras, computers, software, etc.) also placed real limits on what we could do. However, the path to the presentation was not predetermined; students were encouraged to work with the tools that they had to best prepare to show their work to the potential audience of their family, friends, peers, and teachers at Journeys.

The first class was dedicated to getting the young men acclimated to the tools and motivated to use them. In an initial exploratory session, they went outside of Journeys and searched the surrounding area to capture any instance of the color green that they could find with their digital cameras, which were supplied to the participants. Camille adapted this from an activity she had once done herself and called it "Gang Green." Exploratory activities are essential as motivations (D'Amico, 1953) for further art practice. A good art exploration has several characteristics: it is open-ended to encourage multiple and unique responses; it is loosely structured but with clear parameters to give students some sense of how they might approach the activity; it is easy to approach but can sus-

tain multiple levels of attention; and it also elicits enthusiasm, motivating the students to continue their processes.

Not only did the young men get to know their cameras and explore their new tools, they found a surprisingly large amount and variety of green. When I think of this iconic section of the city, the first colors I tend to think of are typically the cold grays of city buildings. However, the artists were able to find lights, leaves, signs, and shirts, among many other examples. After the exploration that day, they brought the cameras home and were asked to begin to take pictures about "My Life" to bring in and share the next week in class. "My Life" was taken to include anything that they might want to document to share with others about their friends, family, neighborhood, interests, or themselves. Camille made it clear that she did not want them to take pictures of things that could potentially get them in trouble with the program, i.e., pictures of weapons, drugs, criminal activity, or even large amounts of money.

Camille and I planned the overall structure of the photography module together before the start of the course. Although the general arc of activity was preplanned (e.g., exploration, work on the project, revisions, and the final exhibition) the actual shape of the class varied from week to week and was responsive to what the participants brought in as well as what class discussion was like. Generally, class time was structured in four sections: an initial check-in period, a time to share new work, followed by a time to develop older work, and then a final wrap-up period for reflection. Much of the class was conversation-based. The artists shared their work and led conversations with their peers, Camille, and me. We asked questions about images and ideas; the conversations had a very casual quality to them, enhanced by the intimate atmosphere of the small class and the benefits of often literally working with a 2:1 teacher-to-student ratio. The class wasn't required, so participants attended at their own volition. Some attended sparsely, checking in and out, while others decided this module wasn't for them. Ultimately, there was little to no competition for the teachers' attention. Questions about the work had a large range. Sometimes we asked about what was shown in the image. Sometimes we asked about the artist's process in capturing the image (questions of framing, composition, and point of view were often brought up). Sometimes instead of asking questions, we simply shared our reactions to what we saw.

When students weren't leading conversations about the work that they had brought in, they manipulated and sorted their pictures using the editing software in iPhoto. Students often experimented with levels, exposure, contrast, saturation, and cropping. Sometimes they experimented with built-in effects in the software, (e.g., changing the photo's tone to sepia). In these instances, the teachers acted as art assistants, sitting to the side and conferring with the students when they asked for help, guidance, or opinions. The iPhoto software is relatively easy to use, so although they had not used it before, the students were able to acclimate to it quickly.

The reflection periods at the end of class were used to brainstorm ideas for the next steps; sometimes we referred to student work, other times Camille and I brought in photos found in museum collections, art books at Journeys, or on blogs. All images, regardless of origin, became talking points around the students' interests and processes. For example, I brought in reproductions of photos by Dorothea Lange and Walker Evans after seeing the students' first round of work. They were most enthusiastic about the Walker Evans photo, *A Graveyard and Steel Mill in Bethlehem, Pennsylvania*. They noted its composition and enjoyed the fact that a large stone tombstone in the shape of the cross sits in the foreground against dark buildings in the background. In light of portraiture that the students had done, Camille brought in a book of portraits of people involved in the Civil Rights movement.

These iterative cycles of sharing, conversing, working, and reflecting occurred every week. If students had nothing new to share, we went back to revisit old work and edit it. If students had a lot to share, the editing period was likewise shortened. The case below describes in more detail the work of the one student who worked through all six weeks and exhibited his work for the Journeys community.

Photography and the Work of Art

Entering the alternative-to-incarceration program

While much of the work at Journeys is geared toward students earning their GEDs or passing some other test, modules like the photography module are meant as electives—something the students can choose to take and pursue on their own volition.

Students attended Journeys on court order, following an arrest and on recommendation from the judge and the program representative. The program offered educational courses along with other artistic, workforce, counseling support for participants with the dual goals of reducing recidivism and presenting the mostly young male population with alternative educational and employment trajectories. As a part of this program, I wanted the photography module to present the artists with positive activity, artful employment, and a process of exploration and inquiry that they could be proud of. Regardless of the court order forcing them to be there, the students attended willfully; through interviews and interactions I had with students, the mantra I kept hearing was, "I don't want to go back to jail." This desire was often followed by, "I screwed up," and then a declaration along the lines of, "I am changing my life."

It is important to note that the students I met all were involved in extraordinary circumstances. Although they often put the onus on the individual actions that brought them into conflict with the law, no one person can be held accountable for the situations the students found themselves in. Vicissitudes of urban life and poverty coupled with the mechanics of a vicious school-to-prison pipeline complicate any explication of responsibility and justice (Jordan, 2010; Smith, 2009).

The statement, "I am changing my life," has profound implications for justice. The ability to work against received notions of self, the ability to articulate what you'd like to become, the ability to recognize missteps towards that sense, and then the ability to act to change direction in life is essential to understanding formative justice. When someone asserts in volition, words and actions that they are changing their life, they are in the process of defining and realizing their potential. By offering students an open-ended opportunity to select, image, and re-present their lives artfully to others, my hope was to create a situation wherein they would have an opportunity to not only take stock of their situations (including their environment, family, and friends) but they could open up and develop their identities as artists.

I didn't know what to expect going to Journeys for the first time. I have plenty of experience as a museum educator teaching in high schools across the city as a guest. It is difficult to know exactly what you will encounter when you arrive. I have come to know the terrain and

learn which schools are in better shape than others. There is a palpable tension in the halls of the tougher schools; the personnel are on edge, the children dart in frenzied fits, and the yells of both faculty and the student body echo through the halls. When I arrived to Journeys for the first time, I was used to being greeted by guards and metal detectors; my brief experience in NYC schools made sure of that. Still it didn't do anything to ease my anxiety.

After a short ride up the elevator, I walked out into a calm hallway. Students clustered around doorways chatting. Artwork by students and teachers decorated the makeshift space. Students, in small groups in small rooms gathered around tables for study and discussion. One can tell a lot about a space by the immediate atmosphere. Journeys was a site that clearly valued safety and collegiality. These qualities are essential to creating situations where students can begin to open up, especially if they are so used to living perpetually on guard.

Meeting Juan, the photographer

Students at Journeys could rely on a series of supportive staff to work with them. If we are interested in promoting formative justice for our students, it is important for them to experience nurturing and openness in mutual environments, instead of constantly getting drubbed by the unfortunate circumstances of vicious situations. The room for the photography module was a calm extension of Journeys' makeshift space: a small annex in a back room with a couple of computers lined up against the walls. Only one of these really worked. From time to time, a staff member allowed us to unplug and borrow the computer from her office.

Several students came in and out of the photography class, but only one persisted throughout the entire course of the module. His name was Juan. From the first class he radiated interest and energy. Juan had carefully captured material that he wanted to share and discuss; his material elicited personal histories and commingled emotions. As an educator, it is enlivening to encounter a student who is excited to work, explore, and share.

I never learned why Juan had been incarcerated. I never asked. Our focus together was to explore the photographic work he did. That is where I learned most about Juan: from his presence, his artwork, and his own words. At our first meeting, it was clear that Juan had a profound in-

terest in the arts. He initially shared two photographs that featured his own artwork: one of a painting he had made of a girl's face and one displaying a graffiti technique he called "Chinese Wild Style." One of Juan's champions, an art teacher, put both of these artworks on display at his high school.

These photos were only the tip of the iceberg. Not only did Juan express an interest in art and art making, further photos also expressed aspects of his daily experience in the urban terrain of New York City. Many of Juan's photos first came from the subway system. Instead of simply documenting urban infrastructure, they were accompanied by rich personal histories. For example, when discussing photos taken in the subway, he talked about how he liked to help people out there, "even tourists." He related a story about a time when a tourist he had once helped with directions recognized him after having moved to New York much later; the tourist thanked him.

Juan specifically wanted to share this moment with me; he wanted to be seen and identified as a friendly, helpful person. In this first class, and throughout our work together, it was easy to see him this way. He was often quick to smile, thoughtful in conversation, and eager to do his work. After the course was over, he talked about how he liked the way that adults responded to him, especially when he acted mature and demonstrated self-respect, a nod to the identity work he was doing through his engagement with images.

He also demonstrated a daredevil bent in his work. Juan had a knack for taking off-kilter pictures; his skewed images took daring to capture. In one of his pictures, the ominous lights of an approaching train flare in the dark as the subway car hurtles toward the viewer. Camille and I both gasped and reminded Juan that he had to be safe when he took his photos for class; he assured us that he was. Even as he assured us he was safe, he still managed to take wildly framed shots. In his second round of photos, he brought back a group of pictures taken from the roof of his building. Some of the shots look as if they were taken hovering in midair; the play of perspective skews the side of his building as it plummets to meet the stoop below. Juan liked to evoke excitement as well, both visually and personally. He didn't just snap photos willy-nilly; his oblique framing belied a nuanced artistic approach and likewise indicated an active aesthetic sensibility.

Another image in his series seemed much tamer. A tile sign simply spells out "Delancey" on a subway station wall. As we looked at the photograph of the sign, it evoked different responses and called up vastly different memories for Juan, Camille, and me. The sign immediately reminded me of going down to the Lower East Side as an undergraduate to see late night concerts at Tonic, a now-defunct jazz venue. The sign reminded Camille of going to the Lower East Side to shop with friends in high school; this was the place where everyone bought leather jackets. Juan had many memories of the Delancey Street station as well. As a hub between Manhattan and Brooklyn, Juan travels there everyday. It is also the site of several stabbings he has been the victim of. Juan was first stabbed when he was five years old. His family was involved in the Latin Kings gang and dressed him up in the gang colors, which led to him being targeted and stabbed. As he said this, I had to suppress my shock; he related this history plainly and calmly. He told it with the same aplomb that I would when I tell people that I lived in Arizona when I was five years old.

This picture and Juan's candor impressed Camille and me. We noticed the way it spurred radically different memories and feelings in each of us. Roland Barthes (1980) writes about the punctum or the "prick" of a picture, i.e., what is it in an image that strikes and wounds you? In extension, James Elkins (2011) finds Barthes "prick" too slight, and instead refers to the "camera dolorosa," a more severe and searing version of Barthes' wound. Looking at Juan's photo, I initially felt a metaphorical prick from the familiarity of the sign and the flow of pleasurable memories that I associated with the place. Later, I felt doubly wounded, and ignorant, after hearing Juan's personal history in the very same station.

Seeing youth as cultural producers

What happens when we take young artists seriously as cultural producers? What happens when we don't dismiss their work and attention as simply "student" work? By seriously attending to their artwork, by doing the ignorant work of interrogation and verification, we have an opportunity to create a situation of dissensus (Rancière, 2010)—a moment in which youth might not only act outside of their accepted selves, but also a moment in which their communications might move a fellow human being.

Juan's photo of the Delancey Street station afforded us all a small moment of dissensus together in the small Journeys annex. That is, his image afforded us an opportunity to share and compare our distinct senses of the place due to our unique experiences and histories therein. Juan's photography brought the station "into" the classroom, which would otherwise remain disjointed and kept separate. By using this picture as a reference in our mutual conversation, we were able to relate our distinct senses of the shared space.

Our identities, who we accept ourselves as and who we might strive to be, are informed by these distinct senses of the world. Art lives in the act of expressing our experience to others. Dissensus is the outcome when we are all equally afforded the opportunity to engage in this work together. Photography affords us the facility to frame and re-present our worlds to others.

Further pictures that Juan took eschewed metaphorical wounds for actual wounds as well. He showed us a picture of a statue of George Washington where he liked to hang out and skateboard. It too was a site of violence; he often got in trouble here. He showed us a fenced-in park located close to his home; this had been the site where he had sustained (still evident) lacerations on his arms and wrists when he was snagged by the metal tops of the fence, running away from a threatening group. Since leaving jail and enrolling in this alternative to incarceration program, Juan received a reputation for being a "snitch," often understood as an informer or disloyal person, which led to problems between him and others, even people he once considered his friends.

Who we are, or are understood to be, greatly affects our ability and mobility in the world. Insofar as the world is policed, by anyone who would deign to exercise the power of policing on others, not just cops; insofar as bodies and objects are prescribed their functions and destinations; insofar as what is seeable/unseeable, what is sayable/unsayable, what is thinkable/unthinkable is set; a distribution of the sensible is at work (Rancière, 2004). If we take Dewey's sense of the reciprocal relationship between world and organism seriously, aesthetics is the work of making sense of the world (1934). A distribution of the sensible is an attempt to limit an organism's sense of the world, thus limiting a potential sense of action.

When people treat Juan as a "snitch," they are acting as police, attempting to prescribe his function and destination in the social order of the hood. As opposed to dissensus, this labeling is the work of consensus, a severe limit in the distribution of the sensible (Rancière, 2004). On the other hand, when people like Juan's high school art teacher make spaces for him to display his paintings and Chinese Wild Style, they open opportunities for dissensus, opportunities for multiple aesthetic expressions to exist in potentially contested spaces.

One of the most visually striking pictures Juan brought to class was of his mother. The image is simple—a woman folds her arms in a doorway and looks away from the camera, as if looking down the street. Her posture seems tough and impenetrable. She looks as if she's scowling. Juan made an edit of this photo and only focused on her facial expression. The frame crops out the top half of her brow. Below she is likewise divorced from her defensive stance. In isolation, the mother's face looks scared and upset; her eyes are piercing, but unsure; a slight frown pulls on her lips. Significantly, Juan chose the image of his mother as one of the three most important in his entire series. The other two included the photo of the George Washington statue, as well as one of the vacant lot that used to house his home as a baby, but has since been demolished.

Just as the image of the Delancey Street subway sign elicited deeply personal histories, so did the image of Juan's mother. Juan's mother didn't want her picture taken and it took some coaxing from him to get her permission. Juan adamantly identified his mother as a source of support. While he was in jail, she kept an account of money full for him to get supplies or whatever he needed. She visited him often and expressed her support and love for him. She visited him so often that the guards recognized her and would let her stay and visit for hours. Juan would talk about the importance of family and compared it to the unfortunate case of his friend in prison who had none. I would have liked to have met his mother. Unfortunately, she did not attend his final presentation of his artwork at Journeys, nor did she attend his graduation from the program; he brought one of his little brothers along.

Recognition and the work of art

The theme of recognition came up while discussing many of Juan's first batch of photos: Juan recognizing sources of love and support, the

guards recognizing his mother, the tourist recognizing Juan after he had helped him so long ago, Juan recognizing significant places and events in his life, even the gang recognizing five-year-old Juan dressed in Latin Kings' colors. Recognition implies familiarity and all of its consequences. Familiarity affords us many things. Making something familiar can be a method of incorporation; by recognizing the familiar in our experience we can rely on a certain state of the world and make meaning accordingly (Haapala, 2010). In this way, we are not forced to constantly remake the world and ourselves. Art offers us the opportunity to interrogate the familiar—to find, create, or play with tensions in our everyday sense of the world and ourselves.

Juan's second batch of photos came in several weeks after his first batch. For a couple of sessions, it looked like Juan might drop out of the module. He forgot his camera several times and complained of being tired. I was tired too. Remember, these sessions were held after a full day of school and/or work. As a way to reach out and emphasize my seriousness, I spoke in Spanish to him and said, "Entiendo, estoy cansado también. Pero, hay que continuar. Hay que trabajar." (translation: I understand, I am exhausted too. But it is necessary to continue. It is necessary to work.) We spoke in Spanish together throughout the course. Mostly, we spoke in English, but I shared my love of the Spanish language during our first session together, when I learned that Juan spoke it, too. As art works as a shared mode of communication, language has the possibility to likewise act in an inclusive way developing trust and confidence.

The next week, he returned with a camera full of images of his neighborhood, family, and friends. As Juan developed his particular cartography, the themes of familiarity and recognition continued to surface. In these images, his home world permeated the space of Journeys even further. This link between home-life and school is often discounted in typical educational institutions. Here at Journeys, he was able to incorporate more and share fuller aspects of his identities than might otherwise be possible in typical schooling situations. He took pictures of his brothers. They lounge, play video games, and take naps in these photos. He took pictures of his sister and her friends as they relax and hang out on the stoop in front of his home. Continuing his interest in vertiginous images, he took several shots from overhead on the roof, pointing down at the stoop; it seems as if the camera hovers in midair, high overhead.

The roof proved a fortuitous vantage point. He focused in on the bodega across the street. The awning, a bar of bright red, darts along the upper left hand of the frame and eventually slopes down. It parallels the form of the speckled gray sidewalk below, where several men sit and stand around the curb. Another picture shows the rooftops of the neighborhood. Puerto Rican flags swirl in the breeze under bands of roof-space flickering with graffiti and tags. The buildings jut skyward, sitting quietly, their windows dark.

From the rooftop, Juan also took a picture of a cop car. It cruises along the street, but thanks to Juan's eye-in-the-sky, we watch from above; in this photo the surveillants become the surveilled. This is one reason why the photo excited Juan. Juan rarely was at a loss for words, but as he talked about this image his rate and rhythm of speech increased. Several times over the course of multiple conversations, he referenced this picture and said that it was very typical to see cops all over the neighborhood since they were trying to stop drug-related activity. Juan contrasted this with his version of the suburbs, where cops don't come unless they're called. I appreciate that instead of simply being watched, Juan was able to use art to watch back, and watch back in a way that was distinct from the way he might without the camera, as resident of the block. Identifying as an artist has effects for formative justice in that it gives individuals license to act, sense, and react in ways that might not otherwise be expected. Artists' work in turn can become important talking points to discuss the community and local concerns.

Juan also used his photos to recognize people and places that he could count on for support. He took a picture of a teenage girl; he identified her as a supportive, close friend. Her child calls him "Uncle" although they are not related. The girl is artistic and encourages his art making as well. The pictures of his artwork on display at school led to discussions about his art teacher and her championing of his work as well. Besides supportive people, Juan also recognized one clearly safe haven in the neighborhood: a local church. He said that no matter what was happening on the streets, gang-wise or drug-wise, everyone put their problems aside in the church building, a peaceful oasis in the otherwise tough neighborhood.

Juan was very familiar with the cops in his neighborhood. In a photo of the police precinct near his home, he discussed how he would get

taken in for "being a smartass." Often the cops would take him in the back and beat him up. Juan told this story much like he told the story of being stabbed at the Delancey Street station. He was very matter of fact, but also laughed a little. Getting beat up by the police seemed almost normal, an accepted event in the course of life in the neighborhood. Through the use of art and digital photography tools to frame and re-present the nuanced aspects of his life, Juan was able to create cultural artifacts that spoke not only of his experiences, but indicated his interests, values, and concerns as well. In the final section below, I will discuss further the implications of creating these situations, offering tools to youth whose stories are often inscribed into the social consciousness without their input.

Conclusion

Our everyday experience affects how we see ourselves and how we might identify our potential. Consider the family snapshots that Jo Spence (1983) rails against—the ways in which we are pinned down and told who we are, perhaps before we are able to contest the situation. Consider five-year-old Juan dressed in gang colors as he enters the Delancey Street subway station with his family. Consider Juan as he runs from neighborhood gangs and catches his wrists on the fence. Consider Juan and his experience in the back of the police precinct near his home. Our everyday experience not only affects how we see ourselves, it also affects how we are seen and recognized in the world, by the world.

At Juan's graduation from Journeys, the featured student speaker mentioned how he had thrown out his old clothes that he had from before he had been arrested. Juan spoke with me afterwards; he loved this part of the speech and said he had done the same thing—except he had burned his old clothes. He talked about dressing more sophisticated and showing more self-respect. He appreciated the way that people responded to him when he dressed differently.

Juan's aspiration to dramatically discard old clothes, dress differently, and garner new recognition from the world around him expresses a desire for dis-identification (Ranciere, 2009). It's not that identity is as simple as an outfit that can simply be shed, thrown away, or even burned. However, there is something to be said about the reciprocity of recognition between an individual and the world. I like to think of art as

one way we might do this work—how we might examine the world and our relation to it, and how we might express that sense to others.

Taking pictures likewise has a metaphorical quality. Action is implied in *taking* pictures. It offers us the opportunity to re-present our view of the world back to ourselves. It allows us to re-present it to others. Opportunities for dissensus (i.e., challenges to the given distribution of what is sensible) are embedded in these processes of presentation; Juan's photos not only bring scenes of his life to us, the audience, but these scenes are brought to us in his own particular way, through his own lens, his distinct point of view. Processes of taking, capturing, framing, and cropping lend a sense of efficacy, choice, and judgment to the photographic work of art.

Juan thoroughly engaged in these processes, processes that asked him to attend to his life in a nuanced way. His daredevil framing, his focus on family, his surveillance of the cops—these all have links to his multi-faceted and developing sense of self, as well as his sense of aesthetic judgment. Through these images we get a sense of what Juan finds worth focusing on, seeing, and taking. His art and this aesthetic work increased his mobility in the hood, demanded his close attention, and provided him a sense of employment. This is not to imply employment as in job/wage, but employment in a richer sense of the word, an opportunity to invest one's time and develop one's potential. In this case, the camera was the tool that Juan used to pursue these ends.

The camera's ability to mechanically capture and reproduce likenesses with less effort and with more precision than human hands was once considered a liability to photography's potential for artwork. Walter Benjamin (1968) correctly chided people who wondered whether a photograph, or other mechanically reproduced work, was in fact art. Instead, he wondered *how* the process of mechanical reproduction would change art and the ways that artists did their work. A camera, like a paintbrush, pen, or any other art-making technology, is primarily a tool; artists use tools as it suits the pursuit of their process. That is, as artists engage with the world and consider their experience, certain tools will help them explore an idea or material in ways that may have been blocked otherwise.

Juan used the camera as a tool to capture and cull familiar aspects of his life. Editing and bringing these images together allowed him to ar-

ticulate ideas and relationships that might have otherwise gone unspoken between us. For example, Juan spoke in depth about his mother and spent considerable time working with her image. He likewise spent a lot of time working with images taken from the point of view of the building his family lived in as a baby. His family was evicted from that building, and the building was subsequently demolished. In talking about the photos, Juan shared that this building and the period of time his family lived there represent the happiest times of his mother's life. Juan skewed the frame from the demolished building's point of view; he compressed the colors in his mother's portrait so much that they crackled and distorted more than any other photo in the series. We came to refer to the process of color balancing as "lifting the cloud" together, to describe the process of eliminating the gray film that permeates many casual digital photographs. Juan's work with his mother's portrait goes far beyond simply "lifting the cloud."

John Lennon (Wenner, 1971) expressed a promiscuous sense of tools and artistry when he said, "I'm an artist, and if you bring me a tuba, I'll bring you something out of it." In Juan's work, this rings true. "I'm an artist, and if you bring me a camera, I'll bring you something out of it." Several of Juan's initial pictures were of artworks he had made in other mediums. He sought out art programs in high school, after school, as well as in Journeys. Without hesitation, Juan identified as an artist. The opportunity to reflect on his work with invested others helped him develop his inclination further.

Jacques Rancière (1991) lauds this sentiment. 'Me too, I'm an artist!' What might it mean when someone identifies and asserts himself as an artist? Rancière takes this to mean, 'Me too, I have a soul! I have something to express to humanity.'

> The artist's emancipatory lesson, opposed on every count to the professor's stultifying lesson, is this: each one of us is an artist to the extent that he carries out a double process; he is not content to be a mere journeyman but wants to make all work a means of expression, and he is not content to feel something but tries to impart it to others. (Rancière, 1991)

Juan is the kind of person who is not content to be a mere journeyman. He expressed pleasure in the fact that he got to go out and about to take photos—he liked going around the neighborhood, and doing art to

facilitate his self-expression. In discussion, he exuded a practically pal-pable excitement when he shared his photos and received feedback. He did express how at times it was a difficult project, especially when he took pictures of other people. Sometimes they would get upset or suspi-cious, but he explained the project to them and was able to reason with them. He appreciated his ability to resolve a situation without violence. In reasoning with neighbors and rejecting violence to make a point in these situations, Juan exercised several emerging identities as a non-gang member: as an artist, a neighbor, and urban citizen.

The arts help to nurture individuals and their relationships with/to a wider community and a wider world. The arts demand attention from both artist and audiences; if we allow ourselves to take our students seri-ously as cultural producers, new and unforeseen prospects will open up in educational situations. These prospects, we hope, will help us nurture jus-tice.

Note

1 I participated in this module as part of an ongoing teaching and research project. It was situated later in the workday after all of the required core courses at Journeys had run. The staff member was a full-time teacher at Journeys. Unfortunately, her position has since been eliminated due to budgetary reasons. Camille's (pseudo-nym) enthusiasm for the arts in general and her passion for photography in particu-lar is arguably why the module was allowed to run. It is also arguably why it ran well. Without the support of full-time staff, these kinds of projects would have no traction at Journeys. Camille maintained relationships with both the administration and the students that helped to ensure buy-in from all sides.

References

Barthes, R. (1980). *Camera lucida: Reflections on photography*. New York: Hill and Wang.

Benjamin, W. (1968). The work of art in the age of mechanical reproduction. In H. Arendt (Ed.) *Illuminations*. New York: Schocken Books.

D'Amico, V. (1953). *Creative teaching in art*. Scranton, PA: International Textbook Com-pany.

Elkins, J. (2011). *What photography is*. New York: Routledge.

Haapala, A. (2010) On the aesthetics of the everyday: Familiarity, strangeness, and the meaning of place. In A. Light & J. Smith (Eds.) *The Aesthetics of Everyday Life*. (39–55). New York: Columbia University Press.

Jordan, W. J. (2010). Defining Equity: Multiple perspectives to analyzing the performance of diverse learners. *Review of Research in Education, 34*, 142–178.

McClintock, R. (2012) *Enough: A pedagogic speculation*. New York: Collaboratory for Liberal Learning.

Rancière, J. (1991). *The Ignorant schoolmaster: Five lessons in intellectual emancipation.* Stanford, CA: Stanford University Press.

Rancière, J. (2004). *The politics of aesthetics.* New York: Continuum.

Rancière, J. (2009). *The emancipated spectator.* NewYork: Verso.

Rancière, J. (2010). *Dissensus: On politics and aesthetics.* New York: Continuum.

Smith, C. D. (2009). Deconstructing the pipeline: Evaluating school-to-prison pipeline equal protection cases through a structural racism framework. *Fordham Urban Law Journal, 36, 1009–1049.*

Spence, J. (1983). What is a political photograph? In D. Evans (Ed.) *Appropriation.* (107). Cambridge, MA: MIT Press.

Wenner, J. S. (1971). The Rolling Stone interview: John Lennon, Part I. *Rolling Stone, 74.* Available: http://www.jannswenner.com/archives/john_lennon_part1.aspx

Chapter 7

Stage as Street

Representation at the Juncture of the Arts and Justice

E. Gabriel Dattatreyan & Daniel Stageman

Arts educators working with court-involved youth face a set of complex and imbricated challenges. First, how do we gain the interest of the young people we would have participate in what we imagine are collaborative and mutually generative projects? Second, how do we mediate representational tensions when the project is not solely therapeutic but has a broader public pedagogical purpose—to disrupt the simplistic and pathologizing discourses of poverty and violence that so often capture young men and women of color in the United States? (Bourgois, 2002; Noguera, 2008). Third, and not least, how do we navigate the institutional settings where our arts programs are situated, given that the institutions might have overlapping and divergent interests in promoting the arts and arts education?

In this chapter we explore these questions by providing a retrospective account of our collective experiences in a theater program housed within Journeys, a large alternative to incarceration program (ATIP). The two authors of this piece, now graduate students, Dattatreyan a joint doctoral candidate in anthropology and education at the University of Pennsylvania and Stageman a doctoral candidate in Criminal Justice at The City University of New York Graduate Center/John Jay College, approach this chapter as an excavation into our shared experiences as arts educators who for a brief period had the opportunity to work together to organize and create what in hindsight (several years have passed since this project took place) each of us consider a significant chapter in our journeys as teachers and, subsequently, as academics. Indeed, the work we did in Journeys was, for both of us, the culmination of many years of pedagogical and curricular explora-

tion—and the impetus for us to think about how we might contribute to various policy, practice, and theory debates as scholars in the academy.

In addition to our ethnographically grounded observations originating from our experiences as staff members at Journeys and as founders of the Theater Initiative, we turn to the perspectives of the youth actor participants of the program, who, through interview data, journal entries,[1] and dialogic excerpts from the two original plays, provide rich context to our analysis. Ultimately, the exploration of our collective experiences is, in large part, to articulate and elucidate the pitfalls and possibilities of representation at the interstices of arts and justice work, specifically focusing on improvisational theater techniques we utilized to create vivid accounts of how "status" and "goal" unfold in the street and on the stage (Johnstone, 1981).

On the one hand these stage techniques, deployed during the production and rehearsal of the original plays developed by the company, create the possibility for self revealing dialogic engagements set in the context of "street." Actors are free to act, express, and explore alternatives that their day-to-day realities inhibit, or even forcefully reject. They do so even as they come to recognize the twin concepts of *status* and *goal*, improvisational terms used in short and long form improvisation to describe the positionality and possibilities for each actor in relation to her onstage partners; the concepts that, in effect, delimit the grounds for exploration (Boal, 1992). Using interview excerpts taken from our youth participants, we, in part, analyze how the performative repertoires of the youth who participated in the program produced the stage as street, creating what Taylor (2003) refers to as "a constant state of againness," where the embodied past is reformulated in the present theatrical moment. We suggest that staging these performances afforded the young people in the program an opportunity to reflect on their self-representational strategies in the street, offering the possibility for new repertoires to arise.

Yet, theater and the stagecraft that makes it a world unto itself is not complete unless there is an audience—a group to witness the telling of tales. The audience was both internal to the organization, comprised of staff members, the families and friends of participants and staff, and various staff at the courts, including judges; and an external audience. To engage this larger external audience we marketed the plays in collaboration

with a small theater company, as one of the broader goals of this project was to incite dialogue with the public regarding the complicated economic, social, and political structures that fashioned the quixotic yet quotidian dramas. To facilitate audience engagement we developed a talk-back format where the company (i.e., the youth actors, directors, producers, writers, and key members of Journeys staff) formed a panel that facilitated post-performance discussion. Realizing the stage as street allegory, if left undisturbed, leaves too much interpretative room for the reinscription of normative assumptions about the communities and the young people depicted, the talk-backs were designed to create dialogic encounters that once again opened the possibility for disclosure rather than the closure that a narrative, whether written or performed, inherently suggests.

What we didn't account for, and what becomes clear only in retrospect, is that in devising the plays precisely to strategically re-present (Spivak, 1988) youth lives in the margins, we would create tensions within the organization, as the plays' narratives tested the boundaries of what could be representative of the organization itself. Moreover, in encouraging youth participants to express unconventional or surprising narratives we challenged our own moral and ethical frameworks for possibility even as we confronted institutional limits. Using interview data from youth participants, transcripts from our audience feedback sessions,[2] and excerpts from the plays themselves, we will show the complicated nature of representation and reception when, for a brief period, the stage becomes street, and audiences are invited to purvey the lives of others—under the auspices of an organization designed to mediate the relationship between the state and the youth whom they serve.

The Paradox of Bureaucracy and Innovation— an Organizational Snapshot

The afternoons are particularly chaotic. The hallway, stretching approximately 75 yards in length with offices on either side, are filled with youth participants as they stream from one office to another or wait for their respective appointments on the wooden benches, which vaguely look like church pews. There they wait, languorously draped across the wooden benches, for meetings with staff members who expressly state they keep their participants waiting as long as they can so that they are not 'on the street.' And as they pass time participants speak to each other about their court cases, their neighborhoods, their friends, their experiences

in prison, and occasionally get into heated debates about who the best rapper of all time is—the cacophony of their voices making it difficult to follow, except in bits and pieces, any one conversation. From time to time a staff person walks through the halls and tells the participants to take off their hats, their voices stern and commanding. The young men with hats on roll their eyes and slowly take off their caps. On occasion, I sit on a bench and participate in their conversations. At first, it gets really quiet, particularly if the participants don't know me from the classes I teach. After a while, I am often included—though usually through provocative questioning. "Yo, G, isn't Tupac the best rapper of all time?" Or "yo G, you ever been to jail?"

<div align="right">

Dattatreyan, Fieldnotes

</div>

Sitting in my office behind the GED classroom...I had an ideal position from which to eavesdrop on the young clients killing time and shooting the breeze on "the bench." Akin to the waiting room in a probation office, this was an old-school church pew of darkly stained oak set against the wall of the office's main hallway. Here young men (and a few young women) regularly violated the conditions of their release by associating with known felons—each other, in other words—and I, whether I wanted to or not, often heard the minute details of their conversations. Most of these conversations were pretty banal, reflective of the universal boredom of vital young people forced to sit still. Sometimes conversationalists spun out their shared anger at wasted time and the anticipation of case management appointments in which they would be scolded yet again for failing to take part in activities that were spectacularly irrelevant to the things they valued in life. Invariably, however, these conversations turned to a single item of shared experience: [jail].

<div align="right">

(Stageman, 2010, p. 441-2)

</div>

The Theater Initiative (henceforth, TI), a project whose duration lasted about one and one-half years, was part of a larger, more enduring alternative to incarceration program that serves individuals of varying ages who are involved in the criminal justice system. The parent organization's historic programmatic remit was and is to provide an intermediary set of sentencing options for judges who are reluctant to assign jail time for certain nonviolent offenses, but have few other options afforded to them within state sentencing strictures. However, the persistent arguments justifying ATIPs, like this one, have not centered around the affordances such programs have provided judges, nor the corollary argument that ATIPs create the possibility for a more just sentencing that focuses on rehabilitation, but rather around their economic benefits. Indeed, ATIPs are argued to cost a fraction of what it would take to house a

single person in jail for an equivalent time (e.g., ATI Coalition, 2003; Patchin & Keveles, 2004). Over the course of the years we worked in ATIPs, we heard this economic argument time and time again from senior staff members who either served as the organization's interface with the city and state government, or who worked in the funding department.

This economic justification in some ways mitigates or at least diverts counterarguments that portray incarceration alternatives as a soft or lenient crime prevention strategy, with little or no deterrent value. However, to ensure that the state continues to fund ATIP programs, and that judges continue to sentence offenders to them without fear of political reprisal, ATIP programs have had to create bureaucratic procedures to surveil participants, such that there is enumerated evidence for their programmatic success or failure. Such data collection justifies these programs' continued existence as true alternatives to incarceration in disciplinary (and even deterrent) terms, and thus becomes a primary focus for ATIP staffing patterns, programmatic priorities, and client narratives—a point to which we will return in just a moment.

Structurally, the organization has various divisions that serve different target populations. The subdivision where we, the primary initiators of the theater program, were based focused solely on youthful offenders, between the ages of 16 and 21, who were charged with felony offenses. Program participants are typically recommended as good potential clients by sympathetic judges in the court system, or are targeted by the outreach efforts of the organization's court staff. The characteristics of a putatively good candidate for participation are both explicitly defined within the program strictures, as well as, to some degree, subjectively determined by program staff. The primary explicit criteria that our program model employed were that our prospective participants' felony charges were neither violent nor sexual in nature, and that the charge be a first offence.

The program operates utilizing a "case management" approach, where each intake is assigned a "case manager"—a counselor cum individual program administrator of sorts—whose primary remit is to shepherd clients through their six month "sentence" in the program. All of the youth participants, with the assistance of the case manager, develop a comprehensive plan with educational, health, and employment aspects. This plan is determined partially through conversation and partially

through assessment. Assessments are standardized for all participants: each intake has to take an educational assessment exam, the outcome of which is translated to grade level equivalents in reading and writing. In addition, participants are drug tested immediately after intake, and a regular but randomized monitoring schedule is initiated. What becomes interesting, indeed critical, when trying to understand the youth participants' involvement with the theater program (as well as other in-house arts and education and job readiness initiatives developed by staff), are how these regimented, numerative, bureaucratic assessments often determined the duration and depth of individual participation in the more therapeutic, educational, and creative aspects of the larger program. In many cases, these quantitative assessments take precedence over all other qualitative assessments when a youth participant has to appear in court. While the program has dedicated writers who create a qualitatively driven *narrative of progress* for each participant, often, regardless of how favorably the narrative might read, if urinalysis scores indicate continued use of illegal substances (which consists, in an overwhelming majority of cases, exclusively of marijuana use), then the participant is in danger of being remanded—sent back to the county jail—or, in cases where the participant consistently reports high positive scores, the possibility of assignment to an in-patient treatment center threatens to extract the participant from all other aspects of her programmatic plan.

However, the qualitatively grounded *narrative of progress* has a different role to play within the program, particularly in how the relationships between staff and youth participants are mediated. We suggest that this narrative of progress functions as a disciplinary device in and of itself, as it pushes participants into a self-production and self-representation that fixates on the future, on the salvatory aspects of education, and on normative notions of self-actualization. There are only a few spaces within the program where youth are allowed to express their narratives of regret, narratives of failure, narratives of pain, or simply narratives that revealed their complicated and enduring relationships with the community in which they live. Indeed, these unsanctioned narratives (what we call *narratives of endurance* following Povinelli's (2011) description of endurance as the possibilities afforded those left in the margins of the liberal state) are primarily relegated to the mental health division, where a small staff of art therapists and clinicians works

with program participants to self-consciously explore these potentially explosive and complex histories within the private confines of confidential counseling sessions.

Introducing the Theater Initiative

Stageman and I sat across from each other in my office. It was early summer, 2006 and the first time we were meeting. He was dressed for the occasion, wearing a button-down white shirt, a tie, and slacks. I, in contrast, wore jeans and a t-shirt, to mark myself as different from the court staff or case management staff, who were required to wear business casual attire. Stageman was interviewing for the teaching job vacancy left open after Mitchell, a teacher who taught in the program for over ten years, left the organization. I led with what I thought were the basic questions—was he comfortable/did he have experience working with young men and women from the marginalized communities of the city? Could he teach basic math, science, history, and writing? More importantly, what other interests did he have? What could he bring to the table that he was passionate about—that he felt could contribute to an education department that I envisioned would offer a variety of arts and academic classes, aside from the GED and literacy offerings, that were driven by the teachers interests and passions? He began to tell me about his background in improvisational theater.

Dattatreyan, Recollections

Objective 1: *Provide a safe creative space for clients to share their personal narratives and collaborate in the process of making meaning: It is one of our primary assumptions that a client must be the author of his own personal narrative if he is to effect positive personal change. [...] This program will give clients the opportunity not only to grapple with the process of advancing personal narrative, but also with the process of guiding that narrative into a positive relationship with community ideals.*

TI Program, original proposal, 2007

TI was conceptualized and developed by the two authors as a means to bridge the wide gulf between confidential, therapeutic confessionals, and the valorization of sanctioned narratives of success. Indeed, the program was meant to create an innovative space where youth could explore their past narratives while claiming a self-fashioning process that validated self-generated possibilities for the future. Further, the necessarily dialogic feature of the theater program was a departure from the more therapeutic construct of expert-patient dialogue, insofar as this dialogue took place, during our devising and rehearsal sessions, be-

tween participants and in front of other participants and staff. Moreover, because the program was outward facing, it forced whatever processual unfolding occurred for participants and staff into a dialogue with an "audience," a critical point we will return to in later sections of this chapter. The conceptual process described in short above began, as the vignette suggests, during Stageman's interview for a teaching position at Journeys. In the months that followed, Stageman and Dattatreyan would work closely to develop the vision and the specifics for this venture, and eventually presented it as a written proposal to senior management—who in turn successfully solicited a division of the state department of corrections for significant funding to support the venture within three short months.

The notion of innovation, or the development of experimental programmatic ventures, however, was not new to the organization. There had been many attempts to create new programming over the course of the organization's history; some experienced relatively sustainable success, others faltered soon after they began. For instance, the program division where the theater initiative was housed had a rich history of creating pilot educative programs that exposed participants to the arts and the outdoors. At the time Dattatreyan joined the organization (in early 2003), most of these initiatives had fallen by the wayside, the victims of funding restrictions and lack of organizational will. The fact that these innovations occurred in the first place was in no small part because of the management style of the program's divisional director, who had been in place for over 20 years and was very open to letting staff develop, design, and implement new programs. Because of the nature of our work and our relationship to the courts, only certain departments within the program had the latitude to innovate. For example, case management, because their positions required them to interface directly with the courts, didn't have much room for changing the systems they implemented. Nor did the drug reporting team, who essentially were mandated to collect, process, and report the drug scores of all participants. This left only two areas for creative programming: education, and workforce development. It is significant that in most of the formal interviews and informal conversations held with youth participants as a part of Vasudevan's longitudinal study[3] of Journeys' programs, participant narratives center around their experiences with the workforce devel-

opment program and their time in the education space, particularly in the arts education projects that were initiated during our tenure in the organization.

Innovations within these two areas, education and workforce development, were usually driven by individuals who brought previously developed ideas and expertise to bear on current programming. The new innovations that germinated in the program were overwhelmingly the products of individual inspiration, rather than collaborative generation between or across departments. This is significant for two reasons: first, because any project birthed through the efforts of one or a few people within a larger organizational framework is often sustainable only as long as those individuals remain with the organization; and second, that the support for the programming, because it is developed in relative isolation and is accorded legitimacy through the auspices of the director of the division, had the potential to create discord across the various other departments, most significantly between those who are responsible for ensuring that the numerative assessments of participants are in compliance and those who are attempting some sort programmatic innovation.

As we developed this project, we were quite aware of these limitations and strove to create a model that attempted to bridge these issues as well as other related issues regarding participant buy-in. For instance, we realized that case management would have to be convinced of how the Theater Initiative helped participants to author a narrative of success. To this end we "sold" the idea of participation as a form of job readiness, and devised a stipend system to attach monetary rewards for participation. In essence this was a two-pronged strategy, as we knew, partially from our own experience in the organization, and partially through prior experiences with youth work, that a stipend would attract and keep the interests of participants as well as be a sufficient incentive for case managers to buy into the merits of the program as a disciplining experience for future work or educational involvement. However, this strategy created unforeseen consequences. For example, because we offered a stipend, the job readiness program, which placed participants in internships and provided stipends, initially viewed the theater program as an initiative in direct competition with their already established programming. These types of political negotiations between and within departments, we argue, are tied to the tension inherent in the representation of the young

people we served. In the subsequent sections we will discuss how improvisation and theater games allowed youth participants the space to explore narrative, fall out of corporal convention, and create community with one another as well as with staff. We will then discuss the two plays produced under the auspices of the program and contrast how they were devised, and ultimately, whether they were received as legible narratives of progress.

Representation, Workshops, and Character Development

The room is cool, in contrast to the city streets where the early summer heat slowly bakes the asphalt. The walls are covered in mirrors—there is a piano in one corner, a set of sheet music stands in the other. It smells of pizza as TI participants have ritualized a slice just before rehearsal on the afternoons we meet away from the program site at a theater space we have rented. With pizza- and soda-filled stomachs we gather in a circle to begin to play warm-up games. At first there are a few audible complaints. Their bodies are slouched, their movements sluggish. I can't see their eyes. Then, as we begin to play they slowly begin to smile. We are all looking at each other and laughing as we pronounce ridiculous words or throw around imaginary balls.

 Dattatreyan, Recollections

[S]omething I did not predict accurately in my preparations for the project was the degree to which participants would take risks and allow themselves to be vulnerable during improvisations. From the very first class... every participant showed, to varying degrees, a real willingness to explore the possibilities contained within an improv framework. They were essentially fearless about risks as diverse as following other performers' physical lead (an improv which culminated in one performer pantomiming smashing the other's head into an arcade game ended in laughter, rather than injury or physical conflict) to exploring gender roles (a [male] participant took on a clearly—and playfully—feminine role while wearing an apparently female mask during mask work). This hoped-for bravery eliminated an entire area of expected work for me as a facilitator—and opened up a number of unexpected possibilities as the process progressed.

 Stageman, Fieldnotes

In almost all the conversations we had with the theater program's former participants, they suggested that the games we played in the workshops were among the most memorable activities. These games utilized a repertoire of vocal, kinesthetic and auditory exercises to facilitate a

multisensory reorientation meant to break the regular patterns of movement and oral communication. Traditionally, theater games are used to stretch the actors' communicative repertoire before the beginning of rehearsal. These theater games, sometimes referred to by participants with names which tend toward the absurd ("Zip, Zap, Zop" for example), epitomized the unconventional sociality of the theater program, and perhaps of the theater itself, as a conceptual space for rethinking the relationship between self and world, along with the underlying pretext of *play* as a means to delve into the complicated and often difficult stories that the youth brought into the theater space. The theater games offered these young people a chance to shed, if just for a moment, the postures of the street—often characterized by specific and highly stylized expressions of masculinity—and just play. Moreover, it offered them a chance to do this within a circle of their peers, all of whom were asked to shed norms and play games as well. Yet, shedding norms wasn't always easy.

Often, in our workshop sessions the young men (our participants were mostly male) would initially resist the games. Contorting their bodies into often ridiculous positions or annunciating gibberish "words" seemed ridiculous to them, and belied the consistently guarded and tough veneers they represented through their stances, clothing choices, and verbal repertoires. Still, the process of shedding norms, either in these often quite comical games, or in the more serious improvisational exercises (which we will get to in more detail in a moment) created an opportunity for participants to break away from the "selves" they felt constrained to portray in their daily lives. Take RJ's comment for example:

> You know, I'm a humble person. Um, I feel that, I feel that, it's hard, I feel that I don't always portray who I am. I feel like, you know, being a man and being in Brooklyn, I have to not portray something different, but I have to show a different side because I don't want to be taken advantage of. RJ

RJ clearly expresses that being a young man in Brooklyn forces him to represent a personhood that does not reflect who he really is. RJ portrays himself as a "humble person" who is not able to reveal his humility; or as he says later in this interview, that he is a "fun person." However, while the games offered a chance for youth participants to

break from convention, the games alone would not have been enough for participants like RJ to find opportunities for new means of representation that allowed them to be "humble" and "fun" within the context of street. This possibility—of breaking from conventions within a particular context, even if the context was itself a recreation or representation—required improvisation. Still, the work with participants' bodies as a means to develop physical awareness was clearly important as a first step. JC makes this evident, noting:

> Body language is hard. That's, that's like the hardest one, body language. JC

JC, in this interview, brings our attention to the inherent difficulty of consciously attuning oneself to habituated body language, to change the established, largely unconscious patterns of movement and carriage. Yet once invested, many of the participants found this physical reorientation uniquely liberating, whether in games or in the process of devising and playing a character:

> I don't know like, it's just cool like, acting like another person. Putting, really putting your whole self, like getting out of your body and jumping into that body. It's just, it's cool. CR

> Like I stepped into a new world. I knew that I wasn't JC no more. I came in [as the *Brazil* character] T. Like, I came in like, "oh how can I say this line" or "which way can I do this" and "how can I perform", you know—so it took me out of my own, all my troubles. I just left everything behind and I just became a new person, you know. JC

Despite such self-professed shifts from accustomed physicality and changes in self-perception, the introduction of narrative improvisation exercises seemed to quickly return participants to a default set of choices, defined and constrained by the hypermasculine representational expectations of urban youth "street" culture:

> Setting an improvisation in a public space, with protagonists who have little or no established previous relationship, will often lead to an improv that is brief, the action consisting of surface-level posturing that leads one character or another to employ simulated violence, or even walk offstage announcing his intention to "go to my car and grab the ratchet [gun]." (Vasudevan et al., 2011, p. 58)

In order to prevent narrative improvisations from defaulting to a violent conclusion, we used a number of strategies, perhaps the most successful of which was to establish for each scene's protagonists a mutual relationship (often in the form of a family bond or other intimate connection) that precluded violence as an acceptable means to resolve conflict. The result was often deep and compulsively watchable improvised scenes, in which two or more participant-protagonists worked their ways toward compromise on what were seemingly mutually exclusive short-term goals, often making use of ingenious shifts and subversions of the power dynamics they might otherwise have taken for granted.

(Re)scripting Narrative: Contrasting Tales, Differential Reception

There was an air of tension as two participants were facing off in an improvisational exercise that began quite simply by assigning each actor a status and goal—older brother, younger brother, privacy and money. The rest of us watched to see how they would resolve the conflict, which centered around whether the older brother, who was expecting his girlfriend to come over, could convince his little brother to leave the apartment without "lending" him any money.

Dattatreyan, Fieldnotes

This became especially problematic when attendance issues forced [TI Project Writer in Residence] Todd [Pate] and I into making executive decisions on the logical or compelling course of the narrative. One example is the scene in Bird's Eye View in which Slim Bag and Big Baby make the decision not to carry out a "hit" on David. This is a scene that Todd and I felt was thematically essential; however, due to the poorly timed absence of one of the principals, it was not possible to work through it in improvisations before it was scripted.

Perhaps for this reason, and perhaps, moreover, because it didn't "feel right" according to the ... "code of the streets," the scene was not well-received upon its first reading. We asked the participants to work with it for a time despite their misgivings; it was clear, however, that they continued to have trouble committing to the scene until they first performed it in front of an audience (at an invited rehearsal for [Journeys] staff...).

Stageman, Fieldnotes

The richness and depth of the improvisations made it possible for TI's directors—along with the constant attention and guidance of our writer-in-residence—to use them as the basic building blocks of our collective composition process, a creative approach commonly referred to as *thea-*

ter devising or *devised theater.* In this style of composition the entire company is actively engaged in writing a full-length narrative play or performance, and credit for the writing is shared. In practical terms, this meant numerous sessions dedicated to improvisation, out of which characters were gradually drawn, discussed, and defined; and a consecutive process by which each improvised scene, once concluded to the company's satisfaction, was set down on paper by our writer, who in turn brought into the rehearsal room a variety of logical and mutually interesting premises for follow-up scenes, etc. This process continued, successively building one scene upon the last, until the company came to a consensus that the play was complete; at which point it would be written down in its entirety, and subsequently rehearsed like any traditional written play until its two-week performance run.

Our success with precluding violence as a default conflict resolution strategy on a scene-by-scene basis did not, however, prevent it from becoming a constant reference point, theme, and foreboding offstage presence in either of the plays that TI eventually produced; on the contrary, the "code of the street" (as eloquently defined by Elijah Anderson in his 1999 book of that name), as well as the integral and inescapable role of violence within it, became overarching themes for both plays, weaving inextricably through the "official" themes ("honor," and "desire," in turn) that we assigned and returned to repeatedly in our company conversations throughout both rehearsal periods. In the climactic scene of our first play—*Bird's Eye View*—for instance, two caricatured drug dealers (wearing grotesque theatrical masks designed by the participants themselves and carrying the monikers "Slim Bag" and "Big Baby") approach the sleeping protagonist, David, with the intention of murdering him for quitting his position as a drug salesman for their organization:

(BIG BABY holds his "gun" to DAVID's head. He hesitates.)

 SLIM BAG

Maurice...

 BIG BABY

Shut up, Lawrence.
(Takes off his mask, hands it to SLIM BAG.)
Hold that, Lawrence.
(BIG BABY holds his "gun" to DAVID's head. He is about to shoot [...])

```
                    BIG BABY
Lawrence?

                    SLIM BAG
It's David, Maurice. That's David sitting there.

                    BIG BABY
Yeah, known him for a long time.

                    SLIM BAG
A long time, man. A long time.
(BIG BABY puts the gun away.)
Yo, man let's go.
(Lawrence and Maurice run off as DAVID seems to awaken.
He opens his eyes briefly, then settles back into
sleep.)
```
 (Bird's Eye View, 2008, p. 41-42)

Here, it is important to note that, while this scene as a whole arose organically in the course of the devising process, Slim Bag and Big Baby's culminating decision not to shoot David—arguably a *deus ex machina* of the most obvious sort—was the single aspect of the plot that was imposed from the top down by the program directors (and authors of this piece). This was not an easy decision—nor was it well-received by the participants—but ultimately we felt compelled by our roles as Journeys employees to reflect the roundly positive nature of the organization's preferred narratives in the plot and themes of the play itself. This led to a very traditional (and, by all indications, very satisfying) experience of catharsis for members of the *Bird's Eye View* audience; the performing company, however, continued to struggle with it even through the concluding audience "talkbacks" after the play's official performance:

Audience Questioner [AQ]: Because you didn't ... crack on [kill] the person ... Does that make him soft?

TW: Just cause they didn't shoot me, does that make him soft? No, that makes him, that makes him smart because, I don't know somebody told me that some people con—how do you say?

AQ: Convicted.

TW: Cool. Basically he's thinking about the consequences before you act.

AQ: So why y'all call him soft?

TW: Not that we call him soft, we just saying that, that's his real person. His real person is not a... gangster. But, when he put on that role... he is.

[...]

EF: It's not the fact that you're not sure that he's soft, it's the fact that....wait, hold on, hold on. Just cause you shoot him, you're not soft, but—just cause you did not shoot him, you're not soft, but if you shoot him, does that make you tough? Like...you're still that one person and like, doing what you do don't make you like no better than nobody else. So just, just think of what you gotta do and whatever you gotta do, you gotta do it at the right time, but just think about it. Yeah.

Bird's Eye View Audience Talkback, 5 August 2009

Bird's Eye View was—both in organizational terms, and in the traditional measures of the theater—a tremendous success. We sold out all six of our official performances in a small (50-seat) theater venue, with an audience that included almost the entire Journeys staff; drew numerous compliments for our performers, our writers, and ourselves; and began a number of interesting conversations within Journeys organization and between individual members of staff about arts programming, the TI program itself, and a number of issues of creativity and personal circumstances related to the youth we served.

To the extent that this final scene—and the audience catharsis that was its ultimate result—represented the colonization of Journeys clients' honest and unmediated personal narratives by an organizationally sanctioned narrative of progress, this success was compromised for the *Bird's Eye View* company: a promotional success for Journeys, certainly, and a professional success for us as its directors, but in some important respects a betrayal of the complex characters participants created in the course of the devising process—as well as the process itself. These characters—David, Uncle Jesse, J-Dub, Slim Bag and Big Baby—ranged from absurdly comic and often genuinely hilarious street archetypes, to flawed and deeply human reflections of the creators' fears, wishes, and experiences, often within the same character. Allowing these characters to engage in goal-oriented mutual struggles in the realistic urban setting with which our participants were familiar—to pursue *status* as defined by the code of the street, alongside such universal goals as security, comfort, reproduction, family integrity and love—ironically resulted in the scene of David's shooting as all but inevitable; he was, in effect, painted into a corner by the limited choices available to him in his pursuit of such broadly relatable, even admirable, goals. The fact that highlighting

this lack of options for its clients, mired as they are in poverty, the criminal justice system, and a web of failed urban institutions, was unacceptable to Journeys and the narratives of progress that justify its institutional mission, was obvious. Journeys essentially justifies its own existence as a positive choice—an option to break the habitus associated with criminality and a "street" value system—so that any portrayal of its clients as constrained by circumstance to criminality and the habitus of the street undermines its role as an entrée into the American meritocracy. Though it is unlikely we would have explained our decision this way at the time, we realized that such a portrayal was anathema to the organization for which we worked, that had provided the material support and institutional framework with which *Bird's Eye View* was created; we knew that we could not let Slim Bag and Big Baby kill David.

In retrospect, TI's follow-up to *Bird's Eye View*—a somber, kitchen-sink drama entitled *Brazil*—follows logically as a reaction to the narrative compromises surrounding its sister play; it was also the final script that TI produced in the course of its brief existence. From its conception, it was clear that *Brazil* would pose more challenges to institutional ideology: built around the core theme of *desire* (where the thematic glue of *Bird's Eye View* was *honor*), *Brazil* was bound to engage in narratives of longing, regret, and endurance, rather than institutionally palatable narratives of redemption or progress. And so it did:

> The next day I was hanging out on a rooftop with my homies. Everybody was on their phones. I pulled mine out...I had a message...from my mom. She was pissed off, said she paid the damn bill, and said not ever to ask her for nothing ever again. Said that I was nothing but a gang banger now, that I can get what I need from them now. Then, she said, "I am beginning to hate you, Kevin." I stayed out there on that roof top and listened to that message over and over...
>
> 'Kez the Don,' second monologue, (*Brazil*, 2008, p. 15)

> Well, basically some of the things is true. Like, I did run up my [cell phone] bill to $500 [laughter] and my mom did said I was [mumbled, inaudible] Certain things like is true but like I could relate a lot of it like but I ain't suicidal or I don't really do that cutting the wrist type thing but yeah I really had fun with this play.
>
> K, Brazil Audience Talkback, 18 December 2008

Despite K's profession to having had "fun" with *Brazil,* every aspect of the play—from the narrative, to the process that created it and placed

it onstage, to its reception by audiences and the institutional structures of Journeys—involved considerable struggle. The play dramatizes the responses of a half-dozen interwoven characters to a stabbing that takes place offstage before the story begins; each character spends his time onstage searching for something—revenge, a lost child, a connection, escape—that, by the action's conclusion, they have come little, if any, closer to finding. They question their own motives and those of others, they express their fear and grief and rage, they make human attempts to give and receive comfort; but there is no satisfying conclusion, no comforting arc of success or redemption, no *catharsis.*

Indeed, *fun* is perhaps K's concession to the language and expectations of the dominant cultural audience (including a fair few members of Journeys staff), expectations that, in his multitude of experiences of dominant cultural institutional environments, from school to jail to Journeys itself, he has internalized, at least to the extent of knowing how and when to perform them. The reality of K's experience in creating and rehearsing *Brazil* is much more complex and emotionally fraught:

> While Dan was directing K on how to approach and interact with C as a character on stage I saw that he [K] was getting a bit frustrated from being guided throughout the practice of the scene.
>
> EF, 11.10.08 Journal Entry

> [W]hen I see the participants reading through this script and acting out these scenes, I see the potential. But then after a while if certain participants are not being active, I start to see them become anxious and go onto basing their attention elsewhere. [...]
>
> I'm not sure why some participants choose to miss out on days of class. I see and realize that this is their way of getting through this rehearsing process...
>
> EF, 11.10.08 Journal Entry

> [T]he way that K carried himself today ... [w]hen he first arrived and went through the first couple of monologues was just fine. Then he took a bathroom break, which took a little too long. Dan had to ask me to leave the room and go find him. He was angry and all uptight for unthinkable reasons. It was his turn to do his monologue and he was up on stage. We all saw the difference in his act. After and during the run-through he simply kept saying, "This shit is washed" meaning that he thought the whole idea was now boring and he had some type of problem with it. He didn't say what was wrong but his negative energy was uncalled for, I believe.
>
> EF, 11.24.08 Journal Entry

K's experience of the composition and rehearsal processes of *Brazil* was typical in many respects, an experience of personal and collective struggle and endurance that reflected the play's narrative to an almost uncanny degree. Within this struggle, however, were the same moments of human connection, comfort, and joy that were portrayed so powerfully onstage:

> We went out to eat to celebrate our new President Barack Obama. There was some great conversation going on about some good "Gangster" movies. After that conversation ended for some reason impersonations began to take place in the restaurant. The participants started to do impersonations of the staff at [Journeys] also that of Dan and Todd. My goodness they were good and pretty funny. On that note we all stepped foot out of the restaurant to start heading to the train to go home, and who other than C came up with idea of singing. At first I was away from the group of participants while they began to sing. Then I jumped in and told them instead of all singing all awkwardly that instead they should harmonize. It was funny because everyone other than me and B knows how to sing and everyone singing together sounded so weird. It was hilarious. We sung old school songs, For ex: Boyz II Men—It's So Hard To Say Goodbye & Shai—If I Ever Fall In Love. We sung all the way until we got to the trains then everyone went their separate ways. We had a good time.
>
> EF, 11.05.08 Journal Entry

These were necessary and sustaining moments in the face of a creative process marked by the frequent loss of pivotal participants, rampant absenteeism, the failure to achieve practical and necessary goals of stagecraft (such as memorization or consistent blocking), and, not least, institutional resistance. For, unlike *Bird's Eye View*, Journeys' celebrated themes of transformation, redemption, and progress were, even if here and there present within the narrative and the creative process of *Brazil*, by no means the defining features of either. K's progress—his redemption—came when he showed up at the theater a few hours before our first official performance, after days incommunicado, after missing a dozen rehearsals, after being removed from TI, his biography deleted from the playbill. Yet he joined his fellows onstage to portray the character he originated; like the others, reading his lines off of scripts placed artfully around the stage on music stands.

Comparatively sparsely attended, these performances ended with chaotic talkbacks, in which audience questioners and performers alike struggled to dialogue about the experience just shared, often using lan-

guage (like K's "fun") much better suited to reaffirming narratives of progress than unpacking narratives of endurance:

> **Audience Questioner (AQ):** I want to know what—what you learned from this experience and what will you take away from this that you can apply to your life?
>
> **C:** Say no to drugs.
>
> **Dan:** [laughs]
>
> **C:** I could say that you know since I've been through a lot in my life you know I could you know just do, stay out of trouble, well, and do what I gotta do like if I could do this, I could make it anywhere, so why not you know take it—
>
> <div align="right">Brazil Audience Talkback, 18 December 2008</div>

In her response, C seems to recognize the themes of struggle and endurance, as well as the difficulty of encapsulating these struggles as a dominant-culturally acceptable "learning experience" containing a "life lesson." No doubt she had similar difficulties explaining the play and the difficult processes that produced it to her case manager; this may be part of the reason why Journeys staff were so little in evidence at *Brazil*'s final performances. The contrast between the receptions of *Bird's Eye View* and *Brazil*—the differing levels of support from Journeys staff, and the responses of general audiences alike—beg the question of where institutional space for young people's narratives of pain, loss, struggle, and endurance can be found—or created? What happens to these narratives when institutional support is reserved for institutionally approved narratives of redemption, progress, success?

Conclusion

> The stories came. Those stories came to life. It, it's... wait how do you say? The stories were... put into, put into place. They were presented....
>
> <div align="right">– EF</div>

In this chapter we have highlighted how the TI we developed strove to use theatrical tools to allow youth participants to explore social possibilities and their own corporally embedded historical narratives even as they brushed against their limits—limits partially delineated within the context(s) of the specific improvisations produced through the theater techniques we explored; limits that highlighted the contingencies of so-

cial interaction. However, as we have noted, the limits of what could be included in the narrative were also policed by the expectations of the non-governmental organization (NGO) and the larger audience who came to the performances.

These expectations, in turn, are couched in a larger discourse concerning what can be included within what Povinelli (2011) calls late liberalism. For Povinelli (2011) late liberalism describes our current historical moment, where, as a result of postcolonial social movements (i.e., the Civil Rights movement in the U.S., the anti-apartheid movement in South Africa, etc.), economically and socially marginalized populations have been recognized as an uncomfortable reminder of liberalism's boundaries. Moten and Harney (2011) have argued that in this context NGOs, like Journeys, function as the experimental arms of governance. They suggest that the NGO's role is to bring to those who are outside the liberal project what they are said to lack: *interests*. The notion of interests, of course, is intrinsically value laden and situated in notions of temporality that presume progress. Indeed, Povinelli argues (2011) one of the critical features of late liberalism is that marginalized populations continue to be imagined in the "waiting rooms of history" (Chakrabarty, 2002), and NGOs, as experimental arms of governance, are charged with the remit of bringing these populations into the folds of historical time. As we have shown in this chapter, participants in Journeys are encouraged to display their interests by adopting a particular narrative strategy that harkens to the future and prominently displays education as salvatory. The sanctioned narratives of progress, we argue, index how Journeys imagines its role in the rehabilitation of youthful "offenders" as well as how youth imagine they must perform themselves in order to successfully graduate from the program and complete their court-mandated sentencing.

It is no surprise, then, that stories that fall outside of what can be considered legible to liberalism's interests—narratives that compromise the organizational goals of Journeys—are primarily relegated to the mental health department. Povinelli (2011) suggests that it is precisely this species of narrative that serves as the remainder and the reminder of difference, the uncomfortable and not so easily confined tales that test the moral, ethical, and social borders of possibility. Povinelli (2011), describing her confrontation with difference explains, "I continue to feel the shores of liquefaction lapping at my breast each time I am con-

fronted by these competing claims; the terror and liquefaction doesn't kill me, nor do they lead to a simple distribution of master and slave" (37). In this interpretation, discomfort stands as the prerequisite for possibility, and the precursor to change; it is a state of inquiry to be embraced.

As educators working at the edges of the criminal justice system we are constantly confronted by the competing claims of our students. These competing claims are born of their experiences in their communities and with the institutions who seek to regulate their lives—i.e., schools, the prison, the courts, and so on (Foucault, 2010). When we give them pride of place in the educational endeavor these stories not only reveal systemic injustice but, as importantly, illuminate the ways in which the youthful narrators of these stories endure and create meaning in their day-to-day lives. These youthful stories, if taken seriously, force us to question how we, as educators, have to come to the moral, ethical, and social positions we hold. It also forces all involved to take an unflinching look at the uneven conditions of possibility in our current historical moment.

Arguably, the key point in Povinelli's confessional above is the recognition that any easily delivered cathartic script, any simple story that seemingly ameliorates discomfort in difference, simply papers over discomfort as a possibility and thus forecloses on the possibility of education as a deeply relational and thus political endeavor. However, as we have shown throughout this chapter, these stories, when emanating from within an institutional framework, not only confront what Povinelli suggests are personal, ethical, and social limits of the liberal subject as educator, but challenge the mandated agendas of liberal state institutions.

As a result, educational projects such as the Theater Initiative become exercises in confrontation at the personal and institutional level. The friction this doubling generates, in the most optimistic of readings, produces tremendous possibilities for dialogue and exchange across a diverse field of actors. Indeed, TI introduced new representational possibilities within and without the organization. For instance, TI created a window into which a larger public could participate in a dialogue with the participants of the program—a possibility previously unexplored in Journeys' long history, as it contradicts the confidentiality that the or-

ganization guarantees its clients. However, the productive friction we have described also undoubtedly has its political costs, and in our experience with TI, definitely took its toll on our ability to maintain and balance confrontation on two fronts.

The limits to personal and structural change make themselves evident when the stories made possible through TI end in the irrational rationality of catharsis, as the concluding scene of *Bird's Eye View* demonstrates. The type of catharsis exemplified by Big Baby's and Slim Bag's decision to spare David neuters the possibility of telling stories that inhabit the outer limits of what we consider acceptable within liberal worlds. Moreover, it limits the possibility to imagine any sort of change as a relational endeavor. In other words, catharsis produces spectators and actors, students and teachers, each of whom encounter unspoken strictures regarding the possibilities of representation. Boal (1994), in a dialogue with two anthropologists, Schechner and Taussig, argues against public pedagogies that ultimately proscribe a closed and singular reading that absolves the audience of questioning their own positionality. Moreover, these types of pedagogical performances release the "actors" from recognizing limits that are delineated by context.

> I am against Aristotelian catharsis because what is purified is the desire to change society-not, as they say in many books, pity and fear. No, pity and fear is the relation the spectator has with the protagonist. Fear because someone like you is destroyed; pity because the protagonist is a deserving person who fails. So what Aristotelian catharsis tries to do is eliminate the drive that the protagonist, and the spectator, have to change society. (Boal, Schechner, and Taussig, 1994, p. 32)

By contrast, the devising process, the resultant narrative, and the talkbacks that followed performances of *Brazil* stand as examples of both the chaos and constructive dialogue that can arise from the intention to eschew traditional catharsis. Witness Kez the Don, in his final scene, as he struggles (within the confines of a county jail clinic) to process the consequences of stabbing a friend in an act of drunken anger:

Kez the Don:

```
All this shit's very tiring. It's like I've been speed-
ing since it went down. And it looks like I'm about to
run right into a brick wall. [...]
```

(He struggles to go on.)

My whole life I felt like I never belonged anywhere. Even with my homies, I never really felt like I was in the circle. I always felt...unplugged...from everything. And everything passes me by so fast. I'm tired, man. Real tired.

(He sits quietly for a while. He looks at his wrists, then holds them up.)

I told myself I was gonna do this to buy me some time. Now, I'm starting to think that actually doing it wouldn't have been so bad. That's fucked up, isn't it?...

I just want...calm, you know. I want everything to slow down...and be calm. If I ever get out I'm going as far away from everything and everyone I know as soon as I can. If I make it out of here alive...I'll be on my way to Brazil.[...] I just want to lay on the beach and hear the waves roll in. Peace, you know? I hold on to that dream of Brazil. But right now I don't know how I'm going to stay alive.

(He struggles to finish.)

I just wanna stay alive.

'*Kez the Don,*' third monologue, (*Brazil*, 2008, p. 42-43)

In his final appearance, Kez is narcissistic, self-absorbed, suicidal, sad, struggling to stay alive and escape a fate brought about by his own decisions—and the constraints within which those decisions were bound. Actors, audience, writers, directors, ATIPs and the web of institutions in which they are enmeshed—all share in the responsibility for Kez's fate, along with Kez himself:

S: One of the, one of the things about the play in general that I got, um, was the unfortunate reality that young people such as y'all selves, this is really a reality. Like, it's not like this is something so far-fetched, where it should be far-fetched but this is a reality. You know, even the moral rules and the codes the kids gotta live by when they [in jail], you know it's, it's almost, it's like "Wow, man." And like how do you put something together like that? And it speaks to the culture and so what happened was y'all captured the culture, um, of, unfortunately y'all captured it in our community, you know, and the problems y'all, y'all pin-

pointed the problems, you know. And it takes some people getting PhDs for that, y'all just put it out there.

<div align="right">Brazil Audience Talkback, 18 December 2008</div>

Here, in stark contrast to Aristotelian catharsis, is Povinelli's deeply emotional distillation of "terror and liquifaction"—a challenge at once personal and universal, and a chaos that threatens institutional stability by challenging the narratives upon which institutions are built. Following the lead of the talkback commentator above, it is telling that both Dattatreyan and Stageman, in the wake of TI's successes and failures, turned to the academy—to "getting PhDs for that." In the face of chaos and possibility, tried and trodden institutional paths and the salvatory promise of education return the late liberal project to balance, and restore clinical distance to competing narratives of pain, struggle, and endurance. Against such acknowledgment of our personal and professional limitations, the authors hold out a sincere hope in the dialogic and dialectic possibilities of the memories and echoes that remain.

Notes

1 The participant journal entries utilized in this chapter are written by a participant/actor who transitioned into a staff role in the second cycle of the program. They are designated by EF, his initials.

2 Interview data and talkbacks were collected as part of the parallel documentation of the Theater Initiative conducted through the Education In-Between Project.

3 See description of the Education In-Between Project in Chapter One, pp. 14–15, in this volume.

References

ATI Coalition. (2003). Alternative to incarceration programs: Cut crime, cut costs and help people and communities. Retrieved on March, 2012: http://www.wpaonline.org/pdf/ WPA_ATI.pdf.

Boal, A. (1992). *Games for actors and non-actors.* London: Routledge.

Boal, A., Taussig, M., & Schechner, R. (1994). Boal in Brazil, France, the USA. An interview with Augusto Boal. In M. Schutzman & J. Cohen-Cruz (Eds.), *Playing Boal: Theater, therapy, activism* (pp. 17–35). London: Routledge.

Bourgois, P. (2002). Understanding Inner City Poverty: Resistance and Self-Destruction Under U.S. Apartheid. In J. MacClancy (Ed.), *Exotic no more: Anthropology on the front lines* (pp. 15–32). Chicago: University of Chicago Press.

Chakrabarty, D. (2002). *Habitations of modernity.* Chicago: University of Chicago Press.

Foucault, M. (2010) *The birth of biopolitics: Lectures at the College de France, 1978–1979.* New York: Palgrave MacMillan.

Johnstone, K. (1981). *Impro: Improvisation and the theatre.* London: Methuen.

Moten, F., & Harney, S. (2011). Blackness and governance. In P. Clough & C. Wilis, (Eds.), *Beyond biopolitics: Essays on the governance of life and death.* London, Durham: Duke University Press.

Noguera, P. (2008). *The trouble with Black boys and other reflections on race, equity and the future of public education.* New York: Wiley and Sons.

Patchin, J.W. & Keveles, G. N. (2004). *Alternatives to incarceration: An evidence-based research review.* Cable: Northwest Wisconsin Criminal Justice Management Conference.

Povinelli, B. (2011). *Economies of abandonment: Social abandonment and endurance in late liberalism.* Durham, NC: Duke University Press.

Spivak, G. (1988). Can the Subaltern Speak? In C. Nelson, L. Grossberg, (Eds.), *Marxism and the interpretation of culture* (pp. 271–313). Urbana: Illini Books.

Stageman, D. (2010) Entry, Revisited. *Dialectical Anthropology, 34*(4), 441–446.

Taylor, D. (2003) *The archive and the repertoire: Performing cultural memory in the Americas.* Durham: Duke University Press

Vasudevan, L., Stageman, D., Rodriguez, K., Fernandez, E., & Dattatreyan, E. G. (2011). Authoring new narratives with youth at the intersection of the arts and justice. *Perspectives on Urban Education, 7*(1), 54–65.

Chapter 8

The Path from the Fear-Based World to the Plain of Creation

A Theatrical Journey of Labor and Identification

Todd Pate

> *I could say that you know since I've been through a lot in my life you know I could you know just do, stay out of trouble, well, and do what I gotta do. Like if I could do this, I could make it anywhere, so why not, you know, take it.*
> —*Theater Initiative Member*

In 2008, I was hired as resident writer for Theater Initiative (TI) at Journeys, an alternative-to-incarceration program in New York City. Theater Initiative's goal was to articulate the life experience of the young men and women who chose to be a part of the project, in the form of a narrative Theater piece. Through a process marked with high peaks and deep valleys I'd never witnessed in other artistic endeavors I'd been a part of, we developed narrative plays that were singular to the collective experience of each cycle of the project. The results were compelling, truthful theater pieces in which the members also performed.

I knew, heading into the project, that any attempt to hold on to any perceptions I held of life for urban youth from economically rejected neighborhoods would be a severe misstep on my part. I am a white man from rural South Texas. I had to be willingly ignorant from day one. Listening with an open heart was my only hope. I can say, without arrogance, or, hopefully, without more ignorance, that I did indeed listen to the young men and women of Journeys and further, was able to adapt their truths into a written piece as accurately as possible. Perceptions of people, places and things that we know nothing about are only two-dimensional, no matter how liberal or progressive those perceptions may be. Until I spent time, communed with and listened to the artists of Journeys, I really had no clue about urban youth. By meeting with them,

and I hope, befriending them, I gained a personal connection to them. They and I transformed to We. Together we saw our similarities. Together we attained empathy for each other. As that empathy grew, more I's, Me's, Them's and They's became Us, and for 3 hours, three times a week, we shared the world. Together.

The key for me was to approach each and every member of TI as a human being carved from singular circumstances, even in the face of seemingly obvious and shared circumstances. As each member of TI articulated his set of singular circumstances, the similarities became glaring. They start out simple and tangible: they were all in trouble with the law, they live in public housing or decrepit housing, public schooling had been no help whatsoever, and most came from "non-nuclear homes," missing a father, mother, or raised by a grandparent or sibling. But underneath those surface similarities, as the process moved forward, we discovered the individual hopes, desires, dreams, and fears of each member: wealth/security, love, and escape from their surface circumstances. These circumstances were similar too, yet they come from the core of the individual, and articulated by a member as only they can, which takes vulnerability and effort to do so. Whereas the surface similarities can rouse competition between two people, to *not be like the other,* these deeper similarities bond individuals, guiding them to the ultimate similarity: we are all human. And, every single human being is capable of doing exactly the same things, provided the circumstances are right. By holding to the above, as best I could, I was able to shed my well-meaning yet flawed assumptions, and I was able to take the journey with the members of TI. *We* traveled *together.*

Art offers the human being salvation. A salvation in reality, or as I call it, our *Fear-Based World,* where the laws of survival underlie every single aspect of daily life, where status and ambition are attributes of survival, and fear is the key component to existence. Fear sharpens our eyes, keeps us on the watch for both predator and prey. Yet fear also dulls our hearts, and clouds our view to our own humanity, keeping us separate. The young men and women of Journeys traveled far beyond the grips of fear and arrived at what I have come to know as the *Plain of Creation*—a place of higher consciousness where truth resides and a greater understanding of Life is given to the artist. To gain entry to the *Plain of Creation,* and therefore, to achieve art, one has to practice willingness and openness—to let go of all they know, despite the fear of do-

ing so—and see the world with their hearts, and with their guard down. The journey into this unknown world was, at times, painful, dangerous and definitely uncomfortable to the members of the TI. And to me. Letting go of fear initially leads to emptiness and confusion because it has such a central position in reality. Yet, by not giving up, the hole that fear carved in all of us was filled with the courage we needed to complete the journey. The result was Art in what I believe to be its purest form: a collective articulation of Life through an unguarded and vulnerable exploration of our own experiences.

The following is the path we traveled to achieve Art, the path between the *Fear-Based World* and the *Plain of Creation*, a journey where we drop our armor forged from basic instinctual survival in trade for the loose-fitting garment the free heart and open mind offer. The road between the *isolated physical* and the *collective conscious.*

Strangers in an Empty Room

All these people's related somehow.

—Theater Initiative Member

Our rehearsal room is a vast underground chasm underneath a theater complex in Midtown Manhattan. It is empty, except for a few wooden blocks to use as set pieces, two folding tables and several folded chairs. Mirrors run the length of one wall and reflect the emptiness. The room is very cold, accentuating the room's sterile identity. The space is neither favorable nor burdensome. It is neutral.

The director and I finish up a few last minute preparations and the members of Journeys enter from their own worlds. *Their* life, *their* New York, *their* families, *their* friends, *their* joys, *their* hardships. The same goes for me and the director. In the beginning, we are individuals.

The young men and women scour the bare room for a place to call their own. They drop their bags or coat in a corner, marking their territory. Some grab a chair, some sprawl out on the floor. They all find their *safe* place, where they survey each other, consciously or subconsciously, sizing up the others. They make clear choices. Friend or foe, ally or enemy. Face out, eyes down, they hold their guard. They talk or text on their phones, listen to music through their ear buds. Isolation allows for more safety. They avoid each other, or, if they know one another, they at least act tough.

Once personal safety has been established, they interact with each other. Methodically, they exhibit the attributes they've cultivated to define themselves. One cracks jokes, finding his role as the clown. Another rhymes along to the song he's listening to, making sure that everyone knows that he knows the words to the song. Another paces the room with a well-developed strut, the tough guy at the top. The shy types sit quiet and alone.

An order of rank to the individuals begins to take shape. The tough and cool guys are clearly in charge, the jokers just below them. Awkward or shy individuals are outcast, sitting in the far corners of the rehearsal room. All the men perform for the women, whose status is just underneath the tough guys, but clearly to the side of the male ranking. All find their place, that is, at least, who they are in the *Fear-Based World*, where placement is integral to survival. Further, each member must be clear when claiming his space in the order, so he sticks with what he knows. A joker has to be a joker, because if he can't strut and tries to, he faces ridicule and possible banishment (at least socially, if not physically) from the group. It goes for everybody. The same will happen if a tough guy tries to sing, and can't. The others will be onto him and he will soon lose his placement at the top of the mountain and be left to wander alone in the cold empty room. Some, especially the outcasts, may hate their rank or social positioning, yet it's a rank they are used to, and that makes the hate comfortable. Comfort, no matter how painful, equals safety, and puts one in a position *to survive.*

However, we are not in the jungle of the *Fear-Based World.* We are in a cold, empty room, far from the thorns and fangs the *Fear-Based World* uses to sink into us. The room is *nothing,* and the laws of the jungle do not apply. The "safe" order the Journeys members have established doesn't quite feel safe enough. A few hold a conversation about how stupid the idea of theatre is, and nervous laughter echoes off the walls of the cold, empty room.

Yet they chose to be a part of it. Why? Why did they consciously decide to embark on a theatrical experience that will take them far away from everything they know?

"Alright ladies and gentlemen," announces the director, "we're about to get started."

They look around, wide eyes, wondering what they've gotten them-selves into. The laughing, the joking, rhyming and strutting escalates as the young men and women lean hard on their survival techniques, des-perately clinging to their safe perch where they know who they are. But as we get started, their known worlds begin to disappear, their hands grasp at nothing and they fall. The cars horns and various rattling, bang-ing, and shouting of Midtown fade out, becoming harder to hear as they fall. When they land they see once again they are in a cold empty room, much the same as before, yet they face a direction they've never faced before. For the first time, they are seeing beyond the *Fear-Based World.*

By the way, I was able to document the above only from my own safe perch in the room. Head up, eyes down, in the comfort of my own fears. My artistic past doesn't make me any different. I wake up everyday in the *Fear-Based World* like everyone else. I have to fall and reach out into nothing to find out who I am, too, every time I begin an artistic endeavor.

In the coming weeks, we will travel along the path from the *Fear-Based World* and the *Plain of Creation.* At times, some members will rebel, turn and go the other way. Some will leave the project, totally. Some will get ar-rested and their probation officers will send them back to jail. And some come back, not knowing why. A confusing and compelling urge to move further to unknown territory takes hold of them. They will ultimately crave to step further toward the *Plain of Creation.* It is a human need to walk this path, although the quest of Art is generally suppressed throughout the world, even to the point of being relegated as an indulgent hobby. Yet art offers the salvation from getting lost in the *Fear-Based World.* Getting lost "out there," to see reality as the end all be all, only leads to despair. That despair, I believe, was at the root of the members' cravings. They escape despair, to be able to see what may be beyond the demoralizing public housing, conveyor belt public school system, and their status as criminal to the state. At least, that is what I saw from my perch.

For Journeys, the path to the *Plain of Creation* was paved with **Labor** and **Identification.** We engaged in physical labor (exercise, rehearsal) and personal identification (open explanation of who we feel we are and vulnerable storytelling). As we did so, we gave our identities to each other and watched them fade away. We ultimately became one entity. We told one story that articulates our collective connection in and to the Universe.

Labor

You know what's is money, you know where I'm from, I'm from Flatbush, you know what's is money, hahahaha. Nah but, I really didn't feel pressure cuz that's was something that I really like to do, like I told you guys I used to talk to myself in the mirror, so I was like, oh my god, acting, Theater Initiative Project and I feel like I should express myself to you. While I was um doing this I had got incarcerated for three weeks. But you know Dan the man (the director) didn't kick me out, let me come back in, and then I did the damn thing.

—*Theater Initiative Member*

The journey begins with the body.

The director guides the members through a series of exercises to build up energy and to sharpen the senses. Most of the exercises are simple and familiar stretching techniques that most of them have performed since early grade school and they perform these with ease. The director and I participate in the exercises too. We are all on the path together. We stretch our limbs, groan, and shake off the day.

Warming up is paramount to the rehearsal process. The young artists must detach from their lives if they are going to interpret them. Getting the blood pumping cracks the exterior of a fear-based persona. They may laugh and joke while they reach down and touch their toes, but *they are performing the same action together.* The finished, theatrical piece at the end of the process is nothing more than a more detailed and focused version of these very simple exercises.

After warming up, we perform more complex exercises. The director walks us through simple yoga positions. We stretch our bodies, much like before, only now, measured breathing is incorporated along with specific poses, which relax the muscles yet stimulate the nervous system. Yoga, or any specific multi-position stretch, develops focus. We breathe in and out, while arching our backs, raising a leg. We hiss or groan as we synch body to mind. However, unlike the earlier exercises, most Journeys members have never tried in yoga. They laugh and joke. Some get so distracted they can't finish the exercise. They should be instructed to commit, yet lack of commitment should be expected. The process is new to them, odd, therefore uncomfortable. Joking and slacking are defense mechanisms against the discomfort. They are merely protecting themselves.

Some of the clients do commit, however. The jokers notice them and usually complete the exercises. They have to, after all, because failure to complete the project will not look good for them when they see the judge again. The stakes of participation are much higher for them than the average actor. Besides, they chose to be part of the project as part of their tenure at Journeys. Though they may not know why, they want to be in this cold empty room which is beginning to grow slightly warmer.

Our bodies relaxed and minds alert, the director takes us through vocal exercises. We stand, feet planted, and "throw" our voices across the room. "Throwing," or projecting to fill the space we are working in is a great tool for an actor to get used to performing in larger spaces. In our daily lives, most of us speak just above a whisper. We clinch our stomach muscles during the day—a subconscious effort to protect ourselves from predators. By "throwing" our voices, we relax these muscles and begin to learn how to control our voices with breath, and to speak normally at a higher volume. After these exercises, and for the rest of the rehearsal, Theater Initiative members speak with a fuller voice, with less effort. They also seem more confident and not afraid to be heard. Collectively, there is more willingness to participate. We've let go of a piece of primal armor, the clinched abdomen. Literally, we've opened ourselves to everyone in the room. We are holding on to less fear and experiencing the early stages of freedom that an artistic project provides.

After vocal warm-ups, we sing. Even if it's just a line or two from a song, the director instructs each artist to stand in front of their fellows and sing as best they can. Many members are hesitant, for some are still holding on to their rank from earlier in rehearsal. Joking and laughter interrupts as others sing. This is expected; however, it is important that everyone finish singing what they said they would sing. The director and I participate. I get nervous, too, even chuckle a little, but I give myself to the others and sing. This is not a talent search. Singing is a bonding exercise. We allow everyone in the room to see us at our most vulnerable, doing our best at the same action. Some members have a clear talent for singing, yet for now, singing to each other is a tool to loosen our chains from the *Fear-Based World*, where openness is weakness. On the path to the *Plain of Creation,* openness is fuel for the journey.

"What's next?" asks a young male TI Member.

"Next, we dance," replies the director.

Laughing, joking, etc. Again, this is expected. It is growth. The goal is to dance together. Some may show a real talent for movement, but again, the exercise is more for learning to move our bodies in ways that are foreign to normality, and to move together as a group. We don't perform any specific type of dance, more of a synchronized movement to a beat. Fear of dancing is a fear many people have, a fear of looking stupid, of displaying weakness or inadequacy. Having everyone dance to a beat the best they can, the same way, helps to break down that fear. It makes us equal. *Fear is the only obstacle on the path.* Anything used to attempt to dissipate fear is valuable.

It is highly important that, in the labor stage, no one feels singled out due to talent. Talent is useless this early in the process. *Willingness* is the only requirement. Everybody stretches, sings and dances. We laugh, joke, get embarrassed, and when it's over everybody knows each other better.

Next, the director instructs us to form a circle and we participate in communal exercises. Communal exercises are designed to build a collective focus. They are not complex exercises. Walking around the room in different directions, shifting speeds in unison is a good exercise to begin with. The clients are forced to negotiate with each other, to avoid bumping into each other. They make eye contact with each other.

Trust exercises are also valuable. The director instructs two members to lean back to back, trusting each other to keep them from falling. We rotate with one another during this exercise, so, when it is completed, we have all leaned on one another. These very simple exercises may seem pointless in the beginning. However, early on, they are far more important than any display of talent. They are the ingredients to the foundation that will support talent.

We take a break, move around, lighter than before. We begin to connect with each other. Ultimately, we will become each other, become one.

Just as we are making great progress, the director announces our rehearsal is over. The car horns resume and shouting by the homeless people on 41st Street can be heard. The *Fear-Based World* suddenly reappears and resumes its dominance of the physical world. Collectively, we prepare to resume our place in it, gathering our things, turning our cell phones on, checking our voicemail. We will enter the cold empty room tomorrow and start over. Art is a *daily* search, yet with daily prac-

tice the *Fear-Based World* can be dissolved with more efficiency, and for longer periods.

The labor portion should never be skipped in rehearsal. A personality is a set of well-cultivated survival techniques and it is deeply planted in the individual. It takes work to uproot it. If time is a factor, even an abbreviated version of Labor can be helpful. It is easy to skip Labor in order to begin the "real" rehearsal. Yet without Labor, there is no "real" rehearsal. We will not be able to move further on the path to the *Plain of Creation* if our feet are still in the *Fear-Based World*. A sound physical presence is paramount, especially when it becomes time to "act."

Identification

Well, basically the play it started from nothing like we all just came in one day and um came out with these wonderful ideas... um... My role, I basically, you know, had some experiences you know being incarcerated so you know I gave em that idea, that's how we came up with the whole jail thing and that's you know everybody character that they played, they came up with that character, basically.

—Theater Initiative Member

For the next several rehearsals, after completing the Labor portion of the rehearsal, we move into the Identification portion of the process.

Though we've already given simple introductions at the beginning of the first rehearsal, our names, where we're from, etc., we now get a little deeper.

"What do you want to be?" Asks the director, to each member. "What is your dream? Desire?"

Each member hesitates to answer, each looks around at the others. The director instructs the participants to answer truthfully and without guard, refraining from answering the questions as to what, say, parents may think, or what a judge may think. There is no moral to this exercise. The purpose is for the members to look in and see what they find that is theirs, and not constructed from their relationships in the *Fear-Based World*. The themes of family and law will naturally surface during the improvisations, later, as they, for most of the Journeys members, are overwhelming components in their daily consciousness.

The director and I also open up to the group about our aspirations in life. We are beginning to move into territory that will lead to a great deal of vulnerability. Trust will be at a premium. If everyone, including the director and myself, is open about themselves early, the bonds will be strong enough to entrust our even deeper selves to one another when the time comes. The director directs, and the writer writes, but no one leads, and no one falls behind. We will all carry each other, and allow ourselves to be carried.

Everyone is given equal attention. It boosts the confidence of individuals in the group to see that everyone is listening to what they have to say. Some may feel they've never been taken seriously when it comes to these topics. In the cold empty room their hopes, dreams, and desires are the desires of the group as a whole and held to the highest regard. Whatever they express cannot be wrong.

"What about you, K?" The director asked a male member. "What do you desire? It can be anything."

K sat for a moment, shifted his eyes across the room, then said, "Brazil. I'd go to Brazil."

"Why?"

"Shit, the women, dog. The beach. You don't have to have a lot of money. I'll get the money. Then bring my homies down there, give 'em jobs. I know everything there is to know about it. If you showed me a picture, I could tell you if it was Brazil or not."

It seemed like such a small and narrow dream, but K was truthful. I noted the dream, keeping it as an ingredient to have on hand during the improvisational rehearsals. Some of the members have no problem telling the group what they desire. However, some are unable to really search from within. This is alright. What they say can still be of use for a story line. Furthermore, if someone is lying, that's alright too. A lie can be very telling, and the member shouldn't be called out on it. It simply may be a step toward truth.

Daily, as the clients continue to open up, characters, settings and scenarios surface. Concern over a mentally ill uncle, worry over eviction or incarceration may naturally find their way to the group as each discusses their hopes, dreams, and desires.

The clients begin to feel more at home in the space. They still mark their own territory, yet move freely in and out of each other's space.

They orbit closer to each other. They are beginning to articulate the experience of life together.

Rehearsal

Real scenarios of like, most, mostly the participants' lives. Like each story, like, each scene or character you seen in this play has something to do with actually somebody's life or something. It's all kind of things, it wasn't like just a something written down, it was kind of real like, a lot of the things was real, that happened.
—Theater Initiative Member

The members of TI, clear and open to the needs of the theatrical piece they are nurturing, are now ready to take actions to bring their story to realization.

The director sets up improvisations with small goals. Most are simple, two-person improvisations based on the themes discussed during the Identification part of the process. We keep the improvisations short, only a few minutes. A wealth of creative material can be found in these early improvisations. Artists' inclinations that surface will "color" the finished product. Family members, homeboys, girlfriends are all the components of The Street and naturally surface. The director encourages the artists to explore The Street in the improvisations. The Street is home to Shakespearean drama, where the themes of brotherhood, loyalty, and honor play out intensely. Hopes, dreams, and desire can lay the groundwork for heartbreak or redemption. Yet, The Street has simple rules—don't rat, don't check out, get them before they get you (these were explained to me by members of Journeys, many of whom are wearing the colors of either The Bloods or The Crips)—perfect for the unsubtle world of theater.

For example: One character saw a crime. The other character believes he or she should report it. However, the perpetrator is a cousin to the witness. Maybe the criminal protected the witness when they were younger. The friend feels that withholding the information can hurt someone or possibly make him an accomplice. What does he do?

The success of the improvisation does not depend on finding a "right" answer. The improvisations are for the artists to become acquainted in role-play, to get them to be willing to play along, to make choices. These choices will lead the actors to their natural talents. The same talents they used to hide behind in the *Fear-Based World* are now

valuable tools they use to find truth. Anything that happens in the cold, empty room during the improvisations should not be judged or altered for morality's sake, provided it does not threaten or cause harm.

Since most Journeys members have never acted before, the ability to separate reality and drama may be difficult. They may get "too real," and get lost in the emotions the improvisations may trigger. Frustration occurs and frequently leads to anger. A great deterrent to anger during the improvisations based on personal hopes, dreams, and desires is having actors improvise the hopes, desires, and dreams of other actors. This keeps the actor slightly removed, thus more objective, from the subject of the improvisation. Another actor may see someone's story clearer. Further, this tool places the actors in each other's shoes. This also helps to "stir" together the lives of the members. Our story is becoming one and the theater piece naturally takes shape.

The artists bond together more and more. They combine their consciousness by acting out scenarios that are similar to each other's experiences. Every member is in and out of the other members' lives, experiencing them and gaining empathy. Empathy obliterates all differences. The reds and blues worn to ally the clients to certain gangs disappear. They may enact those gangs in improvisations, but they are now on the *Plain of Creation,* far away from the *Fear-Based World* that creates gangs, that separates. They experience a new reality as one. A shared reality.

Specific characters appear again and again, gaining more dimension. Scenes and scenarios develop naturally. They know the people, places, and conflicts that make up the improvisations. The once cold and empty rehearsal room is now a street corner, a hospital, a moment of death, of love. We are firmly on the *Plain of Creation.* The artists are listening, seeing, and picking the fruits creativity offers.

The image of their work, from my perch, is close to surreal. I see them work as one being. When the director sets the scene for an improvisation, the participants step into it almost effortlessly. They simply "give it a shot." Everything said is exactly what needs to be said and everything done is exactly what we should see, when we watch performers work in the moment. I still see individuals, yet they are swirling together, an alloy of humanity. Some of the improvisations that I witnessed through TI were some of the best I'd ever seen, including the

professional improvisational actors I have had the privilege of knowing. Amazing storytelling can develop with only a willingness to pretend.

The Writer's Task

Now, my work really begins. My task is to take the input from the improvisations and blend them into a coherent narrative.

The characters are easy to see and I weave the story lines around them. The artists' individual talents—musicianship, singing, dancing, clowning, etc.—which surfaced during the improvisations will be implemented into the piece. I must not judge the piece or steer it to make a statement. I looked into my notes from early on. I find K's dream of Brazil. Again it was a small description of a dream—a beach, money, women and loyal "homies"—but it was truthful. During one of the improvs, K portrayed a man in jail who cut his wrists to escape a group of cellmates out to get him. I put the dream into the hands of the character, to the best of my ability. Here is what we shaped out of the experiment, which ultimately became the beginning of our play:

```
(Kez the Don sits in a folding chair. He is in a hospi-
tal robe and has bandages on both of his wrists. He has
bruises from being beaten. He cut his wrists himself.)

                    Kez the Don:

Brazil. I want Brazil. You asked me what I saw in the
box, what I want. It's Brazil. I know everything about
it. The beaches. The females, dog. You can hold a pic-
ture of a beach up to me and I can tell you if it's in
Brazil or not. Shit, yeah, man, I want the girls, mad
bread but that's just small shit. They all tiny things
that fit into Brazil. Brazil is the big picture, you
know? I'll start my own business down there. I'll have
my business and pleasure all the same, you dig? Bring
all the homies down there, give them jobs...and we'll
party everyday. Me...Kez the Don...and my homies. I'll get
money. I'll do what it takes. It's a future of wealth,
being the boss...and relying on nobody. Brazil is my
dream...that's what's in my magic box, man. A dream of the
future. That's what I desire.

(Kez looks at his wrists.)

What?  This?
```

(Kez holds out his wrist to whoever he is talking to.)

Shit man, they got there the same way Brazil did. Desire, man. Desire.

K, the director and I reworked the script a few times in rehearsal and ultimately agreed on the above monologue. A little dream, a little guidance, a little writing. But a deep search.

In one of the rehearsals, the director asked C, a young woman of TI, to portray a woman waiting for her aunt, who'd been missing. When the aunt finally arrives, they argue, yet at one point C burst out.

"Just stay away from me, you need AA or some shit!"

I asked C what she knew about AA, she said not much. I stopped short of asking her if she had a family member with a problem with addiction. Besides I wouldn't have to. She knew enough to bring it. I felt AA had settled somewhere in her experience, so I played with the idea of a character, a woman named Shelly, trying to get sober, and drafted the monologue below:

(Shelly sits in a folding chair. She is talking to a group.)

Shelly:

Hi, I'm Shelly and I am an addict. I'm an alcoholic, too, I guess. But it wasn't really alcohol that brought me in here. But I guess that don't matter. I'm here, right? Well, I got 90 days clean. Today. Thanks. This is not my first time around. I been to a rehab. Twice. I was successful with it both times, but…it didn't take. I didn't take it. Things were so messed up. They just as messed up now, I guess…but…you know, I don't know. I'm just trying to keep things together, you know what I'm saying? Keep myself together and try not to think too much…about anything. But sometimes…everything just hit me and it gets hard. I made a lot of messes, you know. Lost all my friends, and my family…well, I lost all my family too. Or they lost me. Things got so messed up I don't know what really happened. I just know what is right now. It ain't all roses, you know. If I think about getting high, it's only a few seconds before I want to get high, then I need to get high. Then I'll do whatever it takes to get high. I want to use. I feel

real good over these last few days…and I still wanna
use.

(Shelly stops talking, just looks around.)

I bought the piece to C, and, like with K, she, the director and myself worked on the piece until it rang true for all involved. From one sentence about AA, a character was born that would be more truthful than any "thought up" story I could come up with. Truth trumps any and all talent or skill. Art is truth.

If a writer opens his or her self and listens to what is available to them (for me, it was Theater Initiative), he or she will find his or her writing to be nearly effortless. The writer, in a devising process, is only the glue between ideas. The search for the story took the effort. This kind of process is a great and much needed exercise in selflessness for a writer.

Kez the Don grew, one idea at a time, given to us from the *Plain of Creation*, into to a truthful human character:

(Kez the Don sits calmly in his chair. He is in the same place he was earlier, talking to the same person.)

Kez:

Personal. Alright, I'll give you something personal. I think…that you think…that I am psychotic, right? Come on, man, you know you do. 'Cause, you don't think I am suicidal anymore do you? Huh? You never thought I was, did you? I know your type, man. I am not dumb. I'm a smart dude. But I guess it don't make a difference if you are dumb or smart in here, right? This place don't discriminate…it welcomes all of us.

(Kez takes a look around the room. Takes a look at robe and wrists.)

I ain't crazy, man.

(Kez takes some time before he begins to speak.)

Alright, let's get personal. I'm about to tell you something, alright? I'm in a gang. I'm a Crip, you know what I mean? I've been in it for years. I jumped in as soon as the o.g.'s would let me. They practically raised me. They are my family. I've done some good things, some

bad things, man, got locked up...more than once. But I guess you know that right, you been taking a look at my file. I don't want you to think I'm a liar. I don't care if you think I'm psychotic...but I ain't a goddamn liar.

(Kez picks at his bandages.)

That's what I can't stand man...lies. And that's what I didn't have to worry about with the Crips. Somebody do something, you do something to them. Somebody do something to your homie, you bang 'em out. Somebody do something to you...you body 'em. If you are loyal somebody's got your back. You snitch...well...it all comes down on you...and that ain't a lie. It's pure and simple living...

(Kez struggles a bit to continue.)

Better than what my real family offered me, anyway. My pops, hell he split. It didn't matter, he was an asshole anyway. My moms...that's not so simple. She's a pain in the ass. She got six more kids after me to take care of...but she can still find a way to get on my ass. Shit, a while back...I messed up and ran up a phone bill. Something like $500 dollars. She had been paying it, but when she found out the bill I thought she was going to push me out the window. It wasn't even my fault, it was like, the plan was messed up or something, you know? All she had to do was call the damn company. But she wouldn't and she damn sure wasn't going to pay it. I need the phone on, you know what I'm saying? I asked her for a little bit of money to help me with it. She told me that I was a grown ass man now. That if I want a phone, then I pay for it. She was right, you know...I saw her side of things. She's got too many mouths to feed as it is. I love her, but damn, she is a pain in my ass.

(Kez struggles much with the rest of what he has to say.)

The next day I was hanging out on a rooftop with my homies. Everybody was on their phones. I pulled mine out just so not to look like a lame without a phone. I turned it on and had service. And, it said I had a message. I remember wondering from who. When the phone was working I got messages all day and didn't think twice. But that day, with that message, I stopped and honestly wondered who it would be from. It was from my mom. She

was pissed off, said she paid the damn bill, and said not ever to ask her for nothing ever again. Said that I was nothing but a gang banger now, that I can get what I need from them now. Then, she said, "I am beginning to hate you, Kevin." I stayed out there on that roof top and listened to that message over and over...

(Kez sits in his chair, deep in thought.)

My name's really Kevin. You know that, right? I just didn't want you to think I was lying to you or anything.

The character of Shelly developed, also:

(Shelly sits in a folding chair. She is at an AA meeting.)

<div align="center">Shelly:</div>

I hit someone the other day. I didn't even know that I did it until after it happened. So, I guess I got anger. No, I know I got anger inside. I mean, the dude did try to rob me. So, maybe its legit, but...I don't know. He...he was a guy I knew. A guy on the block where I'm staying right now. I met him in these rooms, too. Yeah, we even got along. But, he stopped coming around to the meetings, you know. Now he just wanders around like a zombie. I still say hello to him, though, you know. I don't want to judge him. But right after I said hello to him the other night, the dummy reached out tried to take my purse. It made me angry. He's a good guy and I love the nigga, but a lady's purse is a lady's purse, you know? So, maybe he had it coming, I don't know. I don't feel terrible about it. And I wasn't scared. The poor dude weighs about as much as a paper bag.

(Shelly struggles a little to go on.)

What scared me was...that I lost control of myself. I got mad, then saw red, man. Just...red. If I had a knife I would have killed him...I really think I would.

(She lightens up a bit.)

But you know...I laughed all the way home. I just laughed and thought, wow, I have a purse! Back in the day a purse was not in my vocabulary, you know. Having a purse was about as possible as owning a mansion. I'm taking

care of myself, now I can have a purse. Buying clothes is such a big deal…and they're clean! Back in the day the laundry mat might as well have been a country club. I wash clothes…that is a big deal, yo. I'm taking care of myself. I look good! Take a look at me! I look damn good. I got a seventeen year old boy and look how good I look! He should be seventeen. I…

(She struggles a little more.)

I haven't seen him since he was a baby. If he's not a miracle, then there's no such thing. I was so messed up by the time he was born. I dream about him. They are so real. I'm dreaming that I see him…outside of the school he goes to. And…he's walking out after the bell rings. He sees me, and he runs up to me…I run up to him. He hugs me and tell me he loves me…and to come home. I wake up and I…it feels real for a few seconds after I wake up. Then, I start to see the room I'm staying in, and the realness of who I am hits me over the fucking head. I don't even know what he looks like…but in that dream I know exactly who he is.

(She struggles to go on.)

I…I want to go to schools around town and see if I can find him. Sometimes I know it, I just know it…that I will pick him out and know who he is. I think I am crazy. Is that crazy? I really asking you people? 'Cause I don't know anything right now. I feel that need so bad, to go out and look at every boy in school, grab him by the collar and ask him if he's my boy. But how would he know, right? He never knew who I was. I just get crazy believing that he will recognize me. Shit. I take a look in the mirror nowadays, and I don't even recognize me.

We work with other characters as well. I go home at night and script the improvs into narrative. The director guides the actors through the script.

The artists may find working with a written script not as enjoyable as the free form of the improvisations. They may become stilted, unmotivated. That is to be expected. It is merely a rock to climb over on the path. The director leads the actors through the murky early period with a script. It is important for them to know it is natural to feel the way they

do. They are now working with specific boundaries. Yet they will get used to those boundaries and understand the story line more as they keep working with it. They already know the story, now it's simply a matter of *practice,* day by day. No matter the results, they must continue through the difficulty. They will come out of this slow period successfully.

As the tough days drag by, the script begins to feel like home to them. They feel the story as they work with scripts in hand. They gain confidence.

Then they run into another bump in the road. Memorization. They will need to work on the lines on their own time in the *Fear-Based World* which can dull the beauty of creation, and it may be very tough for some to work on their own. The project may seem silly to them outside the rehearsal room. They just have to be encouraged and prodded.

"Well," the director tells the actors, "it'll look silly if you forget your lines up there."

Memorization will remain an issue throughout the rest of the project, but the actors work even harder. Again, the members chose to participate in Theater Initiative. They need to see the project through. This can be the most chaotic part of the process, when the first performance is on the horizon and the work seems far away from "show-ready." We can only continue down the path each day and trust each other. We cannot afford to look too far ahead. Theater is about the moment. An artist's only hope is the moment.

Despite all the issues, a clear unity is seen by the artists. Repetition creates a strong glue for the production. They move with a kind of frenetic rhythm. Their relationship with one another is no longer halted by self-preservation. There is no "self" on the *Plain of Creation.* The actors gave their selves to each other and together, they now are one, living, breathing entity whose purpose is to tell a human story through multiple characters. They have achieved a *shared reality.* No matter how much they stumble, they move as one.

The first performance is on the horizon. The actors' identities in the *Fear-Based World,* "criminals" in the eyes of the Law and even worse or "clients" by the powers that be at the alternative to incarceration program, are obliterated. They are now Artists. They have sought and found truth. They are open and ready to present that truth to their audience. The

actors feel nervous and even nauseous while waiting to go on stage in front of that audience. They accept the nerves, step out onstage, and invite the audience to watch them articulate truth— to watch the play they found through searching deep within their selves, a play called "Brazil." Kez the Don, Shelly, and the other characters wrestle with life in urban America, its tragedy and heartbreak, and fight for their places in it, and, just maybe, their redemption and salvation.

(Kez the Don paces back and forth, frantically. He pulls his bandages every now and then.)

Kez the Don:

I feel it! I feel it coming down! All of you are gonna send me to general soon...and it won't take long. The word made it to the rock about what happened.

(Kez sits down.)

All this shit's very tiring. It's like I've been speeding since it went down. And it looks like I'm about to run right into a brick wall.

(He sits quietly.)

I can't tell you exactly what happened. I knew about Lou and my girl. I knew for a few days. And I gotta tell you, I wasn't that mad over it. Then one night I was on a rooftop with my homies and drinking, and everything's fine. Then all of the sudden I was wavy...then angry. And I just kept thinking. I remember people on the roof talking to me...but I don't know what they were saying. Something happened and a switch went off...and all of a sudden I couldn't think of nothing except finding Lou. I remember thinking when I was looking for him that night, that how the fuck could he ever have been my friend. All these years I've known him...he was never my friend. Then it became very clear to me that I ain't got nobody...no homies...nobody. I remember that. As far as what actually went down, well, I found Lou...I saw red...then I saw my own blood leaking out on the sidewalk. I heard the footsteps of the niggas that stomped me. Then I saw Lou bleeding next to me. Then I saw nothing.

(He struggles to go on.)

My whole life I felt like I never belonged anywhere. Even with my homies, I never really felt like I was in the circle. I always felt...unplugged...from everything. And everything passes me by so fast. I'm tired, man. Real tired.

(He looks at his wrists, then holds them up.)

I told myself I was gonna do this to buy me some time. Now, I'm starting to think that actually doing it wouldn't have been so bad. That's fucked up, isn't it? It's gonna be kind of hard to hide the scars from the goons in general, ain't it?

I just want...calm, you know. I want everything to slow down...and be calm. If I ever get out I'm going as far away from everything and everyone I know as soon as I can. If I make it out of here alive...I'll be on my way to Brazil. Fuck the money, and all the partying I can do there. I just want to lay on the beach and hear the waves roll in. Peace, you know? I hold on to that dream of Brazil. But right now I don't know how I'm going to stay alive.

(He struggles to finish.)

I just wanna stay alive.

(Lights fade.)

(Lights up. Shelly sits in a folding chair at a meeting.)

I am really an addict today, I'll tell you that. So much that I got really scared.

(Shelly settles in to tell the story.)

I volunteer to speak at a hospital in the city on Fridays. I came in earlier than usual, and started thinking what it would be like to go to the old neighborhood. Now, I know that kind of thinking won't take me further away from a crack pipe, but I couldn't resist, you know. I had to go, I had a desire to see old places so bad...and I had the time, so, I went. I thought I would check out the old building, the old block. But it has changed so much. The apartment building we lived in isn't even

there. It's some kinda new, steel looking, rich people's apartment.

(Shelly laughs a little.)

I guess everything's changed.

(Shelly becomes distressed as she continues.)

I went there to find my son, pure and simple. For some reason I thought I would see him right there, on the front stoop of the old place. He'd be older, and we'd just pick up right where we left off. I'm almost glad the old building wasn't there…cause I started to get real scared. The things that did look familiar…started to remind me of old times and then I started thinking of the old me. And, suddenly, it was back…that desire to get high. I wanted to get high so bad, that for a while I couldn't move. Really, I just stood there and I couldn't remember how to walk. I just stood there and cried and shook. I was looking down the street for dealers. Nothing I have learned over these past few months mattered…I just wanted to get high. Thank god I froze, cause if I was able to walk, I wouldn't have been strong enough to get out of that neighborhood.

(Shelly takes a moment to gather her thoughts.)

Something happened, though. The next thing I knew I was running down the hallway in County Hospital, tears running down my eyes. I almost knocked some poor kid down in the hallway. I only saw colors again, that's where I go when I lose control of myself, to a place that has no shapes, you know what I'm saying? I just…see colors, everything's blurry and I can't make nothing out.

(Shelly calms down.)

I cried through that whole damn meeting. Not because of what happened earlier, but because of my son. There were so many young people in that meeting who are in such…pain. They're too young to have to go through addiction. They're too young to have to fight to keep from destroying themselves. They need happiness in their life, right now. They are too young to be like me. But what scared me the most in that meeting, was that I was afraid that I would recognize my son. I was talking away

in that meeting, but in my head I just kept praying that my son wasn't in that room.

(Shelly wipes her eyes.)

I can't believe I still have a desire to use. I just hope that other desire I got is stronger. That desire to live.

Did Kez the Don survive? Did Shelly stay sober? We don't know. The story ended. The characters did live for that day, however. Which mirrored the search for the Theater Initiative. Moment by moment, we found a story made of truth. Further, and like life, there were no easily digestible answers or assurances that everything will be ok forever. On the *Plain of Creation* an artist is only shown what they need to see to tell their story.

The play ends and the actors bow. The *Plain of Creation* begins to fade away and the audience comes into view, and before the actors know it, they are back in the *Fear-Based World*. We are physical beings, therefore we must live in the physical world. We are not meant to live on the *Plain of Creation*. It is there for us only to visit, where we can learn something new about ourselves, so that we may resurface in the *Fear-Based World* with a better understanding of ourselves and our fellow human beings. The journey to the *Plain of Creation* is much more arduous and takes much longer than it does to leave it, and at times can feel like it never happened. Yet in the faces of their audience, the actors of Journeys saw honest acknowledgment of their travels. They were able to articulate humanity, but with truth as its core, instead of fear. Humans need to see the fearlessness in others to let go of their own. We need others to show us that there is a place other than our fear-based reality, alone, and that we are not lost in it. The members of TI showed me and enthusiastic audiences that place. I don't know what happened to most of the members of TI, including K and C, but I know they know now, that salvation from despair is attainable, and the journey toward it begins with one simple willing step. The *Plain of Creation* is forever open to those who are willing. And once someone has taken that trip, they will never see the *Fear-Based World* the same again. In fact, they may see it without fear at all.

Audience member, performer, and former felon: *One of the, one of the things about the play in general that I got, um, was the unfortunate*

reality that young people such y'all selves, this is really a reality. Like, it's not like this is something so far fetched, where it should be far fetched but this is a reality. You know, even the moral rules and the codes the kids gotta live by when they on Riker's Island, you know it's, it's almost, it's like "Wow, man." And like how do you put something together like that? And it speaks to the culture and so what happened was y'all captured the culture, um, of unfortunately y'all captured it in our community you know and the problems y'all, y'all pinpointed the problems, you know. And it takes some people getting PhD's for that, y'all just put it out there.

Chapter 9

New Windows into "Museum Art"

Youth as Contributors to Collective Understanding

Olga Hubard

Over the last couple of years, I have had the honor of learning from the Reimagining Futures research team. Through casual conversations, work-ing meetings, and a conference presentation in which I responded to their papers, I became acquainted with their collective and individual projects, and with the unique ethos of their joint work. In particular, I have been inspired by the deep respect that the team's members have for the youth with whom they work. Implicit in their endeavors is a firm belief that all young people can be art-full meaning makers and active constructors of culture if they are only provided with a fertile space.

The team's example led me to revisit some old research data with fresh eyes, remaining open to aspects that had remained obscure before. The resulting reflections are the impetus for this chapter. I thank each member of the Reimagining Futures research team for reminding me to always honor the offerings that young people, regardless of background or experi-ence, bring to the joint growth project that we call education.

I

I often hear myself talking about the luxury that we, art museum educa-tors, are afforded through our work—the luxury of getting to know art-works in deep, intimate, and multilayered ways. To be sure, we learn from curators' talks and by reading scholarship on the works with which we work. But perhaps the deepest and most rewarding learning comes from seeing individual artworks come to life, time and time again, through the insights of the diverse visitors that participate in our programs.

I agree with those who contend that the meaning of a work of art is potentially infinite, that it continues to reveal itself each time a person en-counters the work (Barthes, 1977; Gadamer, 2000; Rosenblatt, 1978). And

like John Dewey (1980), I also believe that a work of art is not the object itself—the physical painting, sculpture or photograph, for example—but what that work does "in and with human experience" (p. 3). As museum educators guide visitors through their encounters with art, we have the unique privilege of bearing witness to the ever-evolving significance of individual artworks—of seeing art "happen," as Dewey would have it.

But even though museum educators often enjoy learning from the ways spectators bring artworks to life, our first responsibility is to the audiences we serve, saliently youth. We seek to facilitate meaningful encounters with art not for our own rewards (though these rewards are indeed welcome), but because of what these encounters might offer viewers.

Engagements with artworks can invite contemplation of humanly significant themes such as life, death, fear, loneliness, love, and despair (Burnham, 1994; Greene, 2001). In addition, engagements with art can integrate different dimensions of the self: they invite logical reasoning (Danto, 1986; Housen, 2002) while also eliciting preconceptual, body-rooted responses such as perception, sensations and emotions (Arnheim, 1969; Langer, 1953; Merleau-Ponty, 1964; Sontag, 1982). Because of this integration, the contemplation of human themes that occurs with art viewing can be particularly powerful. It is perhaps for these reasons that John Dewey (1980) contended that encounters with art can throw off the covers that routine and convention breed, rendering people wide awake to themselves and the world around them.

But back to audiences and the ways they illuminate works of art. I recently found myself browsing through data from a museum-based study I conducted years ago; transcripts of a series of one-on-one conversations with 14-year-old youth responding to a Northern Renaissance painting housed in the Metropolitan Museum of Art: *A Goldsmith in his Shop, Possibly St. Eligius* by Petrus Christus.[1]

I remembered Melissa, a 14-year-old research participant with minimal school-based art experiences who, prior to our session at the Metropolitan Museum, clarified, "Miss, my family doesn't go to museums." I also thought of young Bruno, who upon seeing the Metropolitan's imposing staircase (mistakenly) asserted that this was the place "with all the dinosaurs." These comments, and what they reveal about their interlocutors' formal knowledge of museum art, can easily fuel skepticism: How

can youth with such negligible experiences in art museums possibly illuminate an artwork?

In spite of what skeptics might think, years working with youth and art have convinced me that, as museum educator Rika Burnham wrote, young people already know a great deal about life, and this life experience "is tremendous preparation for looking at art" (1994, p. 522) Additionally, most youth

> have not yet "learned" to see art through the narrow lens of art historical and formal analysis. On the threshold of an adult world, they bring new eyes to art. They have not learned to fear being labeled "corny" or "nerdy" for expressing the thoughts about the human condition such as life, death, fear, loneliness, love, despair, inclusion, exclusion, the acceptance of ambiguity, that they find expressed in so many of the works of art in the museum. (Burnham, p. 522)

Youth's insights about specific artworks can be astoundingly sharp. Because of their freshness, they can also invite us to unlearn conventions about what to look for in artworks and what to ignore. As we unlearn, we are invited to enter artworks with fresh, unabashed eyes and minds, opening windows for new kinds of understandings.

II

Fourteen-year-old Melissa, the young woman who stressed that her family doesn't go to museums, stands inside the Metropolitan Museum of Art for the first time. In front of her is *A Goldsmith in His Shop,* an oil painting by Flemish artist Petrus Christus. I ask Melissa to take a long, hard look and to comment on the painting.

> [The sitting man is] balancing. [The standing man] is like looking at those rings or whatever to see how much it's worth. So maybe those two [standing up] are a couple 'cause they're trying to buy a ring....The couple are barely smiling and the other guy is really mad. Not mad but he's not there, I don't even think he's there. I think that he's not in this world or here because his eyes are not looking at them; he's like looking somewhere else. It's like he's looking right here or something, you see my hand? (she points in front of the canvas, slightly to the left).

Later in the conversation, Melissa asserts that the central figure is "a jewel seller," that the "the girl has a lot of designs in her clothing," and that "the other guy up there in the blue, he's a bit fashionable, I guess."

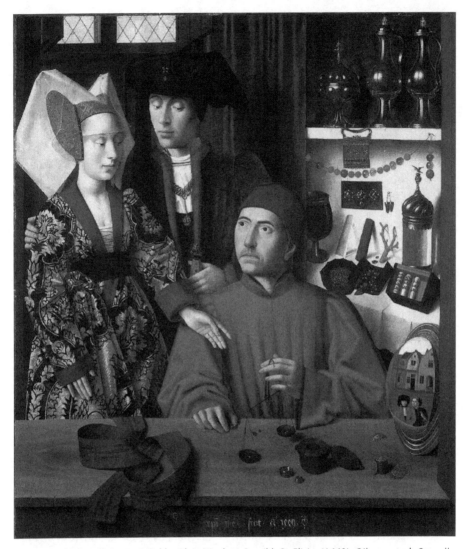

Figure 9.1. Petrus Christus, *A Goldsmith in His shop, Possibly St. Eligius* (1449). Oil on wood. Overall 39 3/8 x 34 3/4 in.; painted surface 38 5/8 x 33 1/2 in. The Metropolitan Museum of Art.

Art history tells us that this painting depicts a "view into a gold-smith's stall where a fashionably dressed couple chooses a wedding ring" (Metropolitan Museum of Art, n.d.). The overlap between this information and Melissa's reading is evident. On one hand, this is no surprise; the painting is quite detailed; didactic, even: it shows people dressed in a particular way, engaged in particular actions within a spe-

cific kind of setting. On the other hand, Melissa's comments are testament to the keen observational and interpretive skills that youth "unschooled" in museum art can have. Beyond her accurate description of the general gist of the scene, Melissa remarked that the sitting man is "not there;" that "he's not in this world" because he's gazing somewhere outside the canvas. For years, this same observation undergirded the interpretation of experts, who thought the goldsmith in this painting was of a holy figure—Saint Eligius, who brought Christianity to Flanders, and who was associated "with the guilds of the gold- and silversmiths, the blacksmiths and metalworkers" (Metropolitan Museum of Art, n.d.).

Today, A Goldsmith is believed to be a vocational painting that depicts goldsmithing as a profession, and possibly one of the first genre paintings of its time. This, too, is an insight that Melissa considered. "Why did the artist paint this in the first place?" she wondered. I invited her to elaborate. "Well," she replied, drawing upon school learning,

> I guess that back then it was very popular to do [certain] kind of paintings, you know, but I don't know about this one. Like [back then] there would be paintings about Catholic stuff or whatever, but this is just like everyday life; I don't know why he did that.

Melissa's comments substantiate that youth with little formal art museum experiences, far from being illiterate in the realm of art interpretation, can make meaning of works of art in valid, meaningful ways. As museum educator scholars have stressed, museum visitors like Melissa are not "just" to be educated in the museum by those who "know more;" they are individuals who can be, in their own way, active constructors of culture (Burnham, 1994; Hooper-Greenhill, 1994; Hein, 1998).

The ideas Melissa constructed in response to A Goldsmith were new to her (even if not to the broader culture). Constructing valid knowledge in response to artworks is in itself rewarding. In Melissa's words, artworks "make you think, just like when you read a book; it helps you." She explained, "I mean, you [don't] just walk around and look at a picture, 'Oh, okay, that looks nice.' [You know] it has meaning; it's supposed to have a meaning." Expanding on Melissa's thoughts, one of her peers expressed that artworks can "be related to your life....I think that pictures inspire people," he said, "even if you don't know in the beginning how [they will be] inspiring you."

When youth construct meaning from artworks, their responses can also open new windows of understanding for the rest of us. As I reread my research transcripts—this time unencumbered by the research question that guided my original study—I was delighted to gain new insights into *A Goldsmith in His Shop.* Take the following comments on the central figure, uttered by different participants:

(a) "The one in red, he's maybe thinking about something....He's putting his eyes like up and actually when you're thinking you put your eyes up."

(b) "It looks like he's surprised, as if they barged into his house and everything, something like that. So that's why he's surprised, 'cause his eyes are wide-open and bulging down, and [the others figures are] all calm and looking down and everything."

(c) "[He has] a combination of surprise and confusion on his face. Like, his eyes are fairly wide open while the other two people's are fairly closed, or [a] little [closed]."

(d) "I think that he's not in this world or here because his eyes are not looking at [the other figures]. He's like looking somewhere else. It's like he's looking right here or something, you see my hand?" (pointing at an area in front of the canvas, slightly to the left).

As I read these comments, I found myself going back to the painting and discovering that all the emotions the youth ascribed to the goldsmith are not only feasible but also convincing. I saw the goldsmith thinking, his eyes gazing into nothingness and his hand still in midair. I saw him somewhat surprised, holding himself back in response to the gesture of the woman's arm (I confess I cannot envision the couple barging into his space, though). I then saw his confusion, with those eyes wide open and the tight, downward lips. The goldsmith's otherworldliness also seemed convincing, as I have already implied.

It struck me that all these interpretations, different as they may be, are compatible with the broader narrative the painting suggests—a well-to-do couple buying a ring from a goldsmith. Each reading adds a different nuance to the narrative, though; each brings it to life in a particular way. How does the story vary when the goldsmith is surprised from when he is thoughtful? When he is confused from when he takes on an otherworldly stance?

The expression on the face of the standing male figure also elicited a variety of feasible responses from the young participants,

(a) "It looks like he's examining the man that's working on the thing, and he's not too sure the man is working on it correctly because he looks kind of suspicious. He's looking down on him like, I'm not sure, but like the way his eyes are, yeah, like curious."

(b) "I think that she wants the [object on the table] and then [the standing man is] trying to tell her that she can't just take it like that; she has to pay, she has to buy it. Cause he's looking at her like, 'No sweetie,' like that, 'No, don't take it.'"

(c) "Maybe he's looking at [the object on the table]. Maybe he wants to steal it or something cause he looks suspicious, the way he looks."

What is going on with the standing man, then? Is he scrutinizing the work of the goldsmith? Is he trying to control his partner and protect the goldsmith's goods? Is he hiding devious intentions? And how might this shape the narrative the painting suggests?

As for the woman, there was some disagreement regarding why her arm is reaching out. Some participants believed she was trying to take something from the goldsmith.

(a) "The woman is like trying to take something from the man with the scale, away from the man....The reason [the sitting man is] frowning...is he's not [the one] carrying it to her; she's the one reaching [for] it."

(b) "She's looking at [the sitting figure] to tell him to give her the thing that he's making. His face looks like he's surprised that she wants it and he doesn't want to give it to her."

By contrast, other participants believed the woman's gesture was one of offering.

(a) "The lady seems to be speaking with her eyes to the [sitting] man. The man seems to be impressed because his eyes are like surprised.... His eyebrows are raised, that's the way you do when you're surprised....I can see that the girl is offering."

(b) "She's like... It's like she wants to say something to him, like to hand this over, or whatever she's telling him."

Again, both these alternative visions on the narrative seemed plausible to me.

I consider the plethora of interpretive possibilities that emerged as the young viewers zeroed in on the characters' gestures and expressions. I can't help but think of da Vinci's Mona Lisa with her famously enigmatic smile, and of the questions it has sparked over the years. Is it really a smile? Could she be hiding something? Nicu Sebe from the University of Amsterdam went as far as testing Mona Lisa with emotion-recognition software he developed with researchers at the University of Illinois. His quest to quantify Mona Lisa's emotion—almost tongue-in-cheek from an artistic, interpretive perspective—determined that she was 83 percent happy, 9 percent disgusted, 6 percent fearful, and 2 percent angry (CNN Tech, 2005). Having engaged with *A Goldsmith* through the youth's eyes I wonder, what sort of reading might Petrus Christus' complex characters receive from this software?

With this question, aside from having a little fun, I hope to emphasize the expressive ambiguity in Christus' characters and its suggestive potential—a compelling aspect of the painting that the youth's responses brought to life. An official thematic essay from the Metropolitan Museum, nearly 2,000 words long, presents the scene depicted in *A Goldsmith* through the straightforward narrative that all the young respondents were quick to recognize: an opulent, fashionable couple purchases a wedding ring from a goldsmith (Metropolitan Museum of Art, n.d.). The essay also offers biographical information on Petrus Christus, an overview of the sociopolitical and economic situation of Bruges in Christus' time, and a sense of how Christus' work and its estimation have evolved over time. Also highlighted in the essay are some stylistic and spatial devices the artist favored, the relationship of his work to other Flemish art of the time, and speculation on the identity of the sitters in *A Goldsmith*. All of this is worthwhile information, indeed.

But the youth's comments, in all their freshness, invite us to go **inside** the world of the painting; they take us deep into the elusive psychological world of the characters—their emotions, actions, intentions and interactions. If we take the youth's observations seriously, far from leaving *A Goldsmith* with a resolved vision of the painting, we leave it with questions that are alive and real; questions about the human condition that the official discourse does not answer—or ask. What is going on in-

side these characters' minds? What are the dynamics between them? What sort of drama are they participants of? What really is going on inside the goldsmith's little workshop?

III

Proponents of visual culture education have cautioned against overemphasizing the virtues of museum art in education. Kevin Tavin wrote,

> While art educators place art from the museum realm at the center of their curriculum, their students are piecing together their expectations and dreams in and through popular culture....By focusing upon certain "art" objects and authorizing what counts as legitimate culture, art educators help subjugate students' experiences with everyday life. (Tavin, 2003, p. 128)

To be clear, in this quote Tavin is not advocating against engagements with museum art per se. Instead, he is taking issue with those who position museum art as the "legitimate" or "more desirable" culture while disregarding the relevance of manifestations such as television programs, music videos, movies, and fashion merchandise to youth's lives. Tavin's point is certainly an important one, yet its nuances can easily get lost in practice: many educators who espouse visual culture tend to exclude museum art from their curriculum on the grounds that it is irrelevant to students' lives.

In *Art and Experience* (1980) John Dewey proposed that the objects housed in museums are not in themselves separate from everyday living; after all, these objects were originally the product of actual social and cultural forces. What has rendered them distant for people, Dewey suggested, is their segregation into temple-like institutions (museums), with their specialized discourse and codes of conduct.

In spite of this separation, as we have seen, today's youth are well equipped to find meaning in artworks from different times and places. Simply placing an artwork in front of a young person does not necessarily lead to insightful meaning making, however. Engaged art viewing entails a going out of energy, to use Dewey's (1980) language again; a back-and-forth exchange that allows viewers to take in what the work has to offer, to relate it to what they know about the world, and to engage in conversation with it. How can educators create spaces that invite this kind of exchange? How might we help build bridges between the experi-

ences of contemporary youth and seemingly distant works, rendering them meaningful?

Contemporary museum educators concur that this sort of bridge building occurs more readily when spectators are invited to interact with works of art in a dialogic fashion, whether this occurs through group dialogues, drawing, creative writing or other processes. Far from being top-down conveyers of information, then, museum educators see themselves as facilitators whose role is to support personally and culturally relevant meaning making in relation to works of art. There is, in fact, a growing body of literature that explores effective strategies, methods, and approaches employed in art museum education (see, for example, Barrett, 2003; Burnham & Kai-Kee, 2011; Herz, 2010; Hubard, 2007a; Hubard 2007b; Rice 1995; Villeneuve, 2008; & Yenawine, 1999).

In what follows, I will highlight some attitudes and beliefs that, in my view, underlie the work of great museum educators. I am deliberately using the term "great" to denote those educators who are able to create particularly fertile spaces for engagement, which in turn allow visitors' responses to art to flourish. Why focus on attitudes and beliefs? Strategies and methods are extremely important in education, indeed. However, the beliefs and attitudes an educator enacts are perhaps even more relevant. Imagine, for example, an educator who has mastered the skill of phrasing questions in an inviting way but who does not *really* care about art or youth viewpoints. Most likely, this educator's audience would sense her disinterest, which would in turn influence their responses and overall experience.

The inventory of beliefs and attitudes that follows is informed by the literature on interactive art museum education as well as by my experiences in the field. Far from being intended as exhaustive, prescriptive, or universal, this inventory is meant to trigger reflection and invite conversation.

Attitudes and beliefs of great museum educators

Welcoming viewers. Great museum educators know how to make their audiences feel welcome and comfortable in the galleries. This is not always easy. Imposing architecture, metal detectors, uniformed guards, and other museum security measures can easily intimidate youth. In addition, visitors can feel self-conscious around museum art. They (erro-

neously) sense there is a particular, correct way to behave and speak in front of artworks and feel they don't know how to do this. Ironically, museum educators themselves can potentially exacerbate the anxiety, as they are often seen as representatives of the museum's authority. Great museum educators believe it is important to empathize with the visitors' position and act upon a genuine desire to make them feel at ease.

Belief in artworks' ever-unfolding meaning—and a thirst to "get to know" the work. Great museum educators understand that one can never exhaust an artwork, much like one can never exhaust knowing another human being. They realize that one may see a work anew with every new visit and through each new insight—whether this insight is offered by the artist, by an art historian, or by a visitor "unschooled" in art. Not only do these educators recognize that a work's meaning is inexhaustible; they also cherish witnessing this meaning unfold through each new interaction.

Appreciation of various perspectives. Great museum educators understand that, as is often the case in life, attending to various perspectives can help us understand an artwork better—its nooks and crannies, its nuances and subtleties, its facets and its complexity. They welcome each visitor's viewpoint, because they sincerely believe in its import (and not just to promote active participation or help build self esteem). Far from being uncomfortable with unforeseen responses, great museum educators are excited by them and by the ways they help expand understanding.

Listening and observing. As they facilitate dialogues about works of art, great museum educators don't just go through the gestures of listening: they *really* listen. They attend to the nuance and complexity in each viewer's response precisely because they believe in the worth of each contribution. Great museum educators also believe it is essential to observe artworks, their subtleties and intricacies, with intent attention. They observe long and hard as they prepare to teach, and they nurture viewers' observations during extended viewing sessions.

Embracing play and exploration. Great museum educators understand that meaning making in response to art is not a linear, efficient process, but one that involves exploration and play. They know that speculating about various interpretive possibilities, even unfeasible

ones, can be an important part of the process. They also know that arriving at a pre-determined epistemic endpoint is not the purpose of engaging with an artwork—at least not in the broader humanistic sense—and that each viewer might find the experience of a particular work significant for different reasons. Additionally, great museum educators recognize that people can interact with artworks through various modes of meaning making, including verbal and written discourse, visual manifestations, sound, movement, etc.

Joint appreciation of process and (emergent) content. Great museum educators value the habits of mind that are nurtured as viewers make meaning of works of art (observation, imagination, evidential reasoning, empathy, and so on). As well, they value the contents of the interaction: the specific meanings that emerge through viewers' responses and the significance these meanings may hold. Moreover, great museum educators understand that the process and contents of any meaning making experience are inseparable, equally educative, and fully dependent on one another.

A wish to share. Ultimately, great museum educators are so excited about the experiences that art can breed that they have a genuine desire to share them with others. Often, this excitement is the source of their call to teach.

By enacting the beliefs and attitudes above, museum educators create spaces for encounters with art that are playful and inviting even as they are thoughtful and conscientious. They also convey that, regardless of where these encounters take place, youth need not check parts of themselves at the door, so to speak, in order to engage productively with an artwork (L. Vasudevan, personal communication, July 29, 2012). Far from this: it is when youth bring themselves to the encounter as whole people; as individuals with particular backgrounds, personalities and experiences; as viewers with specific questions and insights, that their responses—and our collective understanding—can flourish.

The emphasis of this essay has been on how youth can contribute to collective understandings of art and on how educators can create spaces for this to happen. But as Amelie Rorty asserted, interpretation can also entail self-revelation "because the reader brings herself—her habits, attitudes, and mentality—to everything she does, centrally to her manner of reading, her interpretive frame." "As we read," Rorty suggested, "we

too are read: and sometimes we discover ourselves by reflecting on the patterns of our interpretations and misinterpretations" (1997, p. 85). Pondering Rorty's words, I cannot help but wonder how the youth that engaged with *A Goldsmith* might have discovered aspects of themselves through the encounter—and how museum educators might help facilitate self-revelation through art viewing. This, however, is a subject for another time.

Note

1 The purpose of my original study, which is irrelevant in the present chapter, was to compare youth's responses to a painting when this was presented in different formats: a postcard, a digital image on a computer screen, the original painting. For more details, please see Hubard, 2007c.

References

Arnheim, R. (1969). *Visual thinking.* Berkeley and Los Angeles: University of California Press.

Barrett, T. (2003). *Interpreting art: Reflecting, wondering, and responding.* New York: McGraw-Hill.

Barthes, R. (1977). *Image, music, text.* New York: Hill and Wang.

Burnham, R. (1994). If you don't stop, you don't see anything. *Teachers College Record, (95)*4, 520-525.

Burnham, R., & Kai-Kee, E. (2011). Teaching in the art museum: Interpretation as experience. Los Angeles: The J. Paul Getty Museum.

CNN Tech. (2005, December 16). Computer decodes Mona Lisa's smile. Retrieved August 31, 2012, from http://articles.cnn.com/2005-12-16/tech/mona.lisa.smile_1_mona-lisa-computer-software-portrait?_s=PM:TECH

Danto, A. C. (1986). *The philosophical disenfranchisement of art.* New York: Columbia University Press.

Dewey J. (1980). *Art as experience.* New York: Perigree. (Original work published 1934)

Gadamer, H. G. (2000). *Truth and method.* New York: Continuum, 2000.

Greene, M. (2001). *Variations on a Blue Guitar: The Lincoln Center Institute Lectures on Aesthetic Education.* New York: Teachers College Press.

Hein, G. E. (1998). *Learning in the museum.* New York: Routledge.

Herz, R. S. (2010). *Looking at art in the classroom: Art investigations from the Guggenheim Museum.* New York: Teachers College Press.

Hooper-Greenhill, E. (1994). *The educational role of the museum.* London: Routledge.

Housen, A. (2002). Aesthetic thought, critical thinking and transfer. *Arts and Learning Journal, 18*(1), 99–131.

Hubard, O. (2007a). Complete engagement: Embodied response in art museum education. *Art Education, 60*(6), 46-53.

Hubard, O. (2007b). Productive information: Contextual knowledge in art museum education. *Art Education, 60*(5),17–23.

Hubard, O. (2007c). Originals and reproductions: The influence of presentation format in adolescent responses to art images. *Studies in Art Education, 49*(3), 247-264.

Langer, S. K. (1953) *Feeling and form: A theory of art.* New York: Charles Scribner's Sons.

Merleau-Ponty, M. (1964). *The primacy of perception and other essays on phenomenological psychology, the philosophy of art, history and politics.* Evanston, IL: Northwestern University Press.

Metropolitan Museum of Art. (n.d.) *Heilbrunn timeline of art history: Petrus Christus.* Retrieved August 31, 2012, from
http://www.metmuseum.org/toah/hd/petr/hd_petr.htm

Rice, D. (1995). Museum education embracing uncertainty. *The Art Bulletin, 77*(1), 15.

Rorty, A. O. (1997). The ethics of reading: A traveler's guide. *Educational Theory, 47*(1), 85–89.

Rosenblatt, L. M. (1978). *The reader, the text, the poem.* Carbondale: Southern Illinois University Press.

Sontag, S. (1982). *Against interpretation and other essays.* New York: Octagon Books.

Tavin, K. M. (2003). Wrestling with angels, searching for ghosts: Toward a critical pedagogy of visual culture. *Studies in Art Education, 44*(3), 197-213.

Villeneuve, P. (2008). From periphery to center: Art museum education in the 21st Century. Reston, VA: National Art Education Association.

Yenawine, P. (1999, September). *Theory into practice: The visual thinking strategies.* Paper presented at the Aesthetic and Art Education: A Transdisciplinary Approach conference. Retrieved August 20, 2012, from http://vtshome.org/pages

Afterword

The Art (and Play) of Alternative to Incarceration Programming

Yolanda Sealey-Ruiz

Each year, nearly 500,000 youth are placed in detention centers throughout the country (Holman & Ziedenberg, 2006). The United States must begin to answer some difficult questions about how it treats its young people, particularly males of color, who bear the brunt of this zeal to incarcerate and are disproportionately represented in American prisons and detention facilities. Alongside any initiatives to decrease the number of children imprisoned each year, there must be a national agenda focused on the value of the education youth receive while they are under the control of the criminal justice system. The narratives in this book provide examples of what a good quality education looks like. The two programs featured in this book are examples that effectively push back against the erasure of arts in public schools across America, and they present a strong argument for the inclusion of the arts in programs seeking to make a positive impact on youth in the criminal justice system.

Alternative to Incarceration programs (ATIPs) and Alternative to Detention programs (ATDPs) can be restorative justice pathways for persons convicted of a crime to work out their sentence in other ways besides serving prison or jail time. With effective programming in these spaces, court-involved youth can learn strategies to cope with their status of being someone "in the system," while also finding ways to envision a future for themselves that moves them beyond their past mistakes. The work presented in this volume provides invaluable examples of research-based, highly effective alternative to prison programming.

This book doesn't just start *and* end with stories of youth in the criminal justice system; it summons our empathy and illuminates how

many of them became so entangled in the first place—from zero tolerance policies to school-to-prison pipeline practices. In the pages you just read, you became acquainted with youth who attended two alternative-to-prison programs which used art, writing, and improvisation to help them create new scenarios for their circumstances and constructive pathways for their future. You also witnessed some of the ways in which working with these youth was transformational for the facilitators in these programs. Thus, these pages present a gathering of voices—the youths' and the authors'—that create an artful experience for readers; offering multiple mental and emotional entry points for them to reflect on their lives and those lives spotlighted in this book.

The Art of Community, Storytelling, and Play

In this book are narratives of yearning, being, and knowing. The youth and the program facilitators use art and play for self and societal exploration, and engage in curriculum and pedagogy which centers art, emphasizes community, and uses storytelling and play towards the goals of self-discovery and preventing the youth from recycling in and out of the criminal justice system. This volume eloquently serves as a response to the narrowing of curriculum in schools, and the limited ways in which court-involved youth are framed in classrooms and society. Through centering play in multimodal, digitally mediated spaces these youth are recast in a whole new light: presenting themselves as artists, and inviting us to be the audience to their work. Through a meshing of public and private worlds, from writing Fanfiction to the improvisation of everyday life events, the work presented in this volume displays a range, and seemingly indefatigable examples of engaging youth in meaningful discourse about the world around them. The performances use the languages of joy, anger, frustration, vulnerability, and hope to confront stereotypes about people marginalized in American society. The display of honesty and vulnerability on the part of the young people and their program facilitators in telling their stories is what distinguishes this work, and therefore marks this text as different and noteworthy. The innovation in teaching led to transformational learning, a disarming and suspending of traditional expectations by the adults involved in this work, and a commitment to being open for the unexpected. This work implores immediacy, and offers a message to educators and others who

work with court-involved youth: be willing to show your vulnerabilities, be experimental in your teaching without a fear of failure, and embrace responsibility for the unfinished business of bringing equity for *all* who attend America's public schools.

The work being done within these two programs amplifies the need for human connection and safe spaces that allow youth to publicly reflect on and inquire into possibilities without the weight of expectations of pre-fabricated answers and presentations of "rehabilitated selves." They instead, provide opportunity for a deep examination of trauma and ways to rise above the harm trauma inflicts on the mind, the heart, and the spirit of an individual and their community. These two programs sought wellness and wholeness—of the participants and the facilitators. Ultimately, these programs allowed both participants and facilitators to see and understand differently what they have known.

Rupturing Stereotypes, Seeing Anew

When I reflect on my K-12 public education, I realize that the classrooms where I learned the most were ones where I could freely express myself without judgment; they were also supportive spaces where teachers allowed me to be playful and use my mind as well as my body as part of the learning experience. The youth whose stories fill these pages are given welcoming safe spaces so that they can define their own identities and ways of knowing. They offer powerful counter-narratives to persistent stereotypes about youth involved in the justice system, as their facilitators offer innovative models of engagement that serve as great examples for classroom teachers and facilitators in after-school programs serving court-involved youth.

The pedagogically focused facilitators who authored this text, like the teachers I fondly remember, understand the power and purpose of play as a pedagogical method that fosters deep learning, self-confidence, and self-development. Great teachers of young children understand that play is the primary work of childhood, and great students of life, including the youth and their facilitators whose narratives grace these pages, embrace and execute what Pat Kane (2004), author, musician, and cultural commentator tells us: "play will be to the 21st Century what work was to the industrial age—our dominant way of knowing, doing, and creating value."

References

Holman, B & Ziedenberg, J. (2006), *The dangers of detention: The impact of incarcerating youth in detention and other secure facilities.* Washington, DC: Justice Policy Institute.

Kane, P. (2004). *The play ethic: A manifesto for a different way of living.* London: Macmillan.

Contributors

E. Gabriel Dattatreyan has been an arts educator and community activist for over ten years. He is currently pursuing a joint doctorate in education and anthropology at the University of Pennsylvania. His current ethnographic research in India and in the U.S both focus on how the arts—poetry, theater, music, and dance—are mobilized in politically grounded, grassroots education projects.

Tiffany DeJaynes received her Ed.D. in Communication and Education at Teachers College, Columbia University. Her research involves participatory, ethnographic methods for engaging youth in research with and through media, technologies, and literacies. She currently teaches qualitative research in the New York City public schools and teaches graduate courses in practitioner inquiry at The City College of the City University of New York.

Mark Dzula has a background in music education and a passion for the arts; he teaches with museums and cultural institutions. Mark directs Jukebox Radio, a children's performance group that creates customized shows for family events and children's programs at museums. He teaches at Teachers College and is pursuing a doctorate in Communications and Education. His doctoral research focuses on artists' acts of appropriation and their aesthetic, political, and educational implications.

Eric Fernandez is a soon-to-be college student majoring in Psychology and Social Work. His interests are in people's life stories and how they are influenced by their societal culture. Eric currently works as a life coach and a mentor working with youth in foster care in the city of New York. Eric is also a Research Assistant to Lalitha Vasudevan of Teachers College, Columbia University studying the dynamics of the connection inner-city youth have with education, media and arts.

Melanie Hibbert currently works as a media producer for Columbia University School of Continuing Education, producing videos for online

course content. She is also a doctoral student at Teachers College, Columbia University in the Instructional Technology and Media program. She has a B.A. in media studies from the University of Florida and M.Ed. from the University of Alaska Fairbanks. She was an Alaska Teaching Fellow for two years and taught in a village school located in rural Alaska; she was also an Arthur T. Zankel Fellow for two years, working with youth involved in the criminal justice system in NYC.

Olga Hubard is Associate Professor of Art Education at Teachers College, Columbia University. Her scholarship focuses on meaningful art-based inquiry and the spaces that help promote it. Dr. Hubard has years of experience as a school- and museum-based art educator, and continues to collaborate with museums nationally and internationally through talks, professional development workshops, and consulting. A native of Mexico City, she maintains an active art practice.

Glynda Hull's research interests include writing in and out of schools; multi-media technology and new literacies; adult learning and work; and community, school, and university collaborations. She is Professor of Education at University of California Berkeley, and in 2003 she received the Berkeley campus's Distinguished Teaching Award. She has twice received the Richard Braddock Memorial Award for the best article of the year in *College Composition and Communication*. In 2001 she also received from the National Council of Teachers of English their award for best article reporting qualitative or quantitative research related to technical or scientific communication.

Kristine Rodriguez Kerr is currently pursuing an Ed.D at Teachers College, Columbia University in Communication and Education. Before returning to graduate school, Kristine taught English Language Learners in the Boston Public School system to first-year high school students. For the last four years, she has been part of the Reimagining Futures: Digital Arts and Literacy project in New York City. As a facilitator of creative writing and digital literacies workshops, Kristine encourages youth to create portraits of their lives and reflect upon their future goals through multiple modes and to a variety of authentic audiences.

Ahram Park is a doctoral student at Columbia University. Ahram's research focuses on how digital artifacts can highlight awareness, raise

questions, and catalyze dialogues about the issues facing the communities in which she participates and beyond. She holds a masters in International Educational Development from Columbia University and bachelors in business administration and communication from The Ohio State University.

Todd Pate's short story "An American Ghost Murder" was published in the online literary and cultural magazine *The Straddler* (Fall 2008). Early excerpts of his novel, *This Land Is Whose Land?* (Due November 2013), were also published in *The Straddler* (Spring 2012, under the title "Down the Road with the Rest of America"). Since 2006, he's authored 7 plays, all produced in New York. He contributed another fiction piece to *The Straddler*, "After the Election-PLAN 12," in December of 2012. Mr. Pate writes a weekly blog, El Jamberoo, Adventures in Americaland, chronicling life in New York City and wherever else the road takes him. He earned a Bachelor's Degree in Communications from Texas A&M in 2000.

Yolanda Sealey-Ruiz, Ph.D., is Assistant Professor at Teachers College, Columbia University. Her research interests include racial literacy development in urban teacher education, critical English Education with Black and Latino male high school students, culturally responsive pedagogy, and the narratives of African American college reentry women. Her work has appeared in *Teachers College Record, Journal of Curriculum & Pedagogy, Urban Review, English Quarterly, Adult Education Quarterly*, and she is co-editor of a special issue of *Journal of Negro Education* on teacher preparation and the Black community.

Daniel Stageman is the Director of Research Operations in the Office for the Advancement of Research, John Jay College of Criminal Justice, and a PhD Candidate in Criminal Justice at the City University of New York Graduate Center. He has worked in a variety of settings as an educator with serving and ex-prisoners of all ages, as well as middle and high school students in the New York City Public schools. He works to incorporate everything he learned about racial and social justice during his years as a practitioner into his research agenda, which currently focuses on the influence of political/economic context and profit motive on federal-local immigration enforcement partnerships.

Lalitha Vasudevan is an associate professor of Technology and Education at Teachers College, Columbia University in New York City, in the Communication, Computing, and Technology in Education Program. She engages participatory, ethnographic, and multimodal methodologies to study how youth craft stories, represent themselves, and enact ways of knowing through their engagement with literacies, technologies, and media. Lalitha is also co-editor of *Media, Learning, and Sites of Possibility* (Peter Lang).

Index

Colin Lankshear & Michele Knobel
*General Editor*s

New literacies emerge and evolve apace as people from all walks of life engage with new technologies, shifting values and institutional change, and increasingly assume 'postmodern' orientations toward their everyday worlds. Despite many efforts to take account of such changes, educational institutions largely remain out of touch with the range of new ways of making and sharing meanings that increasingly mediate and shape the lives of the young people they teach and the futures they face. This series aims to explore some key dimensions of the changes occurring within social practices of literacy and the educational challenges they present, with a view to informing educational practice in helpful ways. It asks what are new literacies, how do they impact on life in schools, homes, communities, workplaces, sites of leisure, and other key settings of human cultural engagement, and what significance do new literacies have for how people learn and how they understand and construct knowledge. It aims to challenge established and 'official' ways of framing literacy, and to ask what it means for literacies to be powerful, effective, and enabling under current and foreseeable conditions. Collectively, the works in this series will help to reorient literacy debates and literacy education agendas.

For further information about the series and submitting manuscripts, please contact:

Michele Knobel & Colin Lankshear
Montclair State University
Dept. of Education and Human Services
3173 University Hall
Montclair, NJ 07043
michele@coatepec.net

To order other books in this series, please contact our Customer Service Department at:
(800) 770-LANG (within the U.S.)
(212) 647-7706 (outside the U.S.)
(212) 647-7707 FAX

Or browse online by series at:
www.peterlang.com